# THE

# DEVIL

## IN THE

# GALLERY

HOW SCANDAL, SHOCK, AND RIVALRY
SHAPE THE ART WORLD

## NOAH CHARNEY

**FOREWORD BY MARTIN KEMP**

ROWMAN & LITTLEFIELD
*Lanham • Boulder • New York • London*

*To AnnAnn, who is a devilish angel, and to Sue, who is . . . well . . .*

Published by Rowman & Littlefield
An imprint of The Rowman & Littlefield Publishing Group, Inc.
4501 Forbes Boulevard, Suite 200, Lanham, Maryland 20706
www.rowman.com

6 Tinworth Street, London SE11 5AL, United Kingdom

British Library Cataloguing in Publication Information Available

**Library of Congress Cataloging-in-Publication Data**

Names: Charney, Noah, author.
Title: The devil in the gallery: how scandal, shock, and rivalry shape the art world / Noah Charney.
Description: Lanham : Rowman & Littlefield, [2021] | Includes bibliographical references and index.
Identifiers: LCCN 2020052102 (print) | LCCN 2020052103 (ebook) | ISBN 9781538138649 (cloth) | ISBN 9781538138656 (epub)
Subjects: LCSH: Artists—Professional relationships. | Art and society. | Art publicity. | Scandals in art. Classification: LCC N8351 .C49 2021 (print) | LCC N8351 (ebook) | DDC 701/.03—dc23
LC record available at https://lccn.loc.gov/2020052102
LC ebook record available at https://lccn.loc.gov/2020052103

Distributed by NATIONAL BOOK NETWORK

Printed in India

# Contents

# List of Figures

# Foreword

## ARE ARTISTS A BIT "BIZARRE"?

*Martin Kemp*

"Yes" was the answer given in the mid-sixteenth century by Michele Savonarola, learned uncle of the turbulent priest Domenico Savonarola, who was to become a major agent in the violent overthrow of the Medici in Florence. In a similar vein, Federigo Gonzaga, great patron of Andrea Mantegna in Mantua, warned the Duchess of Milan, "typically these excellent masters have something fantastic about them." The model of creative capriciousness they had in mind was derived from the poets of antiquity. Plato believed that poets created their verses when "not in their right minds." This notion was taken up by Seneca, the Roman philosopher and playwright, who tells us that "there has never been a great genius without some touch of madness." Shakespeare says much the same thing.

The assigning of specific temperaments to individual painters and sculptors in the Renaissance went hand-in-hand with their increasing recognition as members of the creative elite rather than craftsmen. Alongside this went greatly increased remuneration for practitioners with top reputations. What I have called the "super-artists"—Mantegna, Leonardo, Michelangelo, Raphael, and Titian—needed to be humored if a patron was to receive the finest fruits of their labors. Michelangelo's famed *terribiltà* pushed to previously unthinkable limits his relationship with powerful patrons, not least with the equally "terrible" Pope Julius, patron of the Sistine ceiling. We thus have the four factors that drive the rise of uppity artists—the idea of "Artists" as inspired creators, their upwardly mobile social status, their quest for fame, and their demands for high remuneration.

However—and it is a big however—two of our grand "super-artists" were well mannered and consummately professional in their dealings with patrons. For every jumped-up "rogue" we can find one or more examples of exemplary "gentlemen." The courtly Raphael and the ennobled Titian (the first pan-European star in the visual arts) are conspicuous cases in point. In the next century, the much-traveled Rubens indulged in artistic and political diplomacy at the highest international level. His greatest pupil, Anthony van Dyck, was described as "living magnificently, more like a prince than a painter." The contrast with the belligerent and licentious Caravaggio could hardly be sharper.

What is true is that the idea of the unruly artist provided a framework within which artists could sometimes get away with more than ordinary mortals. Benvenuto Cellini, virtuoso goldsmith and sculptor, owed his life in the face of his violent crimes—even more serious than those to which he confessed in his autobiography—to his merits as a great artist and to the sense that wayward geniuses might be excused bad behavior, as was Caravaggio, to a degree. However, in the end, Caravaggio's excesses caught up with him.

The example of Cellini reminds us that violent artists do not necessarily produce violent art. Caravaggio's personality and art seem to match. However, Cellini's metalwork is sumptuously suave, and even his *Perseus with the Head of Medusa* (a violent subject) is gracefully poised and stands on a stylishly decorative base as a rhetorical manifestation of "Art."

Even if an artist were, for the most part, well-behaved and tractable, the quest for fame, as reflected in the rise of biography, could all too readily provide a source of bitter rivalry. The collision of Leonardo, Michelangelo, and Raphael provides the first major public episode that is well-documented—though professional rivalries have always existed, like that between Ghiberti and Brunelleschi during the construction of the Dome of Florence Cathedral. Leonardo and Michelangelo notoriously disliked each other—most acidly when Michelangelo aggressively dismissed Leonardo's arguments that painting was superior to Michelangelo's beloved sculpture. Even the more diplomatic Raphael was drawn into rivalry with the "difficult" Michelangelo.

When Giuliano de' Medici, Pope Leo X's brother, simultaneously commissioned altarpieces from Raphael and Sebastiano del Piombo, he was in effect setting up a competition between Raphael and Michelangelo, who had agreed to provide designs for the latter, his Venetian protégé. Letters between Sebastiano and Michelangelo in Florence document the bitterness. In one of the letters Sebastiano wrote:

> My more than father and most beloved, I am sorry that you were not at Rome to see two pictures by the Prince of the Synagogue, which have just been sent to France, for I believe that nothing more opposed to your views could be imagined. I need only say that the figures look as if they had been smoked, or were made of polished iron, all bright and black.

Given the nasty climate of antisemitism, Sebastiano's slur about the "Prince of the Synagogue" was about as unpleasant as it could be. The "smoked" style was a wholly unflattering allusion to Leonardo's influence on Raphael.

Cellini's rivalries were at least as acid. His enmity with Baccio Bandinelli, the sculptor, was very bitter, as was his dislike of Giorgio Vasari, who had come to assume general dominance over artistic activities in the Florence of Grand Duke Cosimo I. The verbal picture of "little Giorgio" in Cellini's autobiography with his "filthy claws" was viciously designed to undermine the stature and refinement to which the ambitious Vasari aspired.

What we witness after the Renaissance is a steady progression of the idea that artists might well be expected to behave badly and even in a scandalous manner. Those who did so were more likely to be noticed and find their way into historical records than those who acted with propriety. Sin is generally more picturesque than virtue. There is also at least

some sense that those artists who were temperamentally inclined to erratic relationships found some kind of encouragement from what was becoming the popular image of the artist. In the grand theater of international art, artists could play up to their anticipated roles.

The rise of the academies under noble or royal patronage, beginning with Vasari's Accademia delle Arti del Disegno in Florence in 1563, worked in the other direction, cultivating an aura of learning and the highest national and international values in the service of rulers. It would not be hard to accumulate plentiful stories of artists rising toward social respectability, assuming intellectual merit, and acquiring material gains. But any resulting book would not have the appeal of this one, an anthology of antisocial activities.

It is, paradoxically, the solid establishment of the academies that was to foster the context for rebellion. The stuffy complacency of the academies was a factor in their being progressively bypassed during the nineteenth century. The rise of new kinds of critics, patrons, dealers, and auction houses changed the environment for art. The traditionally great patrons of the Church, the Court, and aristocrats no longer held unrivaled primacy. The annual exhibitions of the academies played a role in this social revolution in the market for art. The rule of the academies was most dramatically challenged when Gustave Courbet set up his own "Pavilion of Realism" adjacent to the official art show during the grand international exhibition in Paris in 1855, a story likewise told in this book. A belligerent realist and socialist, Courbet knew how to shock with his art and political beliefs, and he clearly relished doing so.

During the Paris Republican Commune in 1871, Courbet proposed that the huge Vendôme column, immortalizing Napoleon, be disassembled and moved to a less conspicuous location. In doing so, the whole column was brought crashing down ruinously. After the collapse of the Commune, Courbet was condemned to pay a massive sum for rebuilding the monument. He opted to go into self-imposed exile in Switzerland, and the French government sold off the artist's paintings cheaply. Courbet was to die in exile in 1877.

Courbet's example of forthright independence from the standard institutions of art and the empire was vital for the younger generation. The Salon des Refusés and successive rebellions by groups of modern artists coming together as self-proclaimed revolutionaries stands in direct line of descent from Courbet's "Pavilion." We are witnessing a move from rebellion being rebellion to it becoming something of a standard stance in today's art world. To be involved in a bit of scandal is a good career move. Art institutions, including the academies, have come with slow and often ponderous agility to embrace rebellion and artistic scandals as a kind of norm, in which artists become self-aware actors in what have become stereotyped dramas. The popular press plays its oddly duplicitous role—being shocked and relishing the process of being shocked.

We are no longer surprised to be surprised, even if we are (sometimes) surprised by what the surprises are.

# Preface

Rivalry, scandal, and shock are negative things, aren't they? While in most fields they are, in the history of art they have actually been beneficial motivating factors for artists.

Famous rivalries have helped elevate art to new levels. That Cimabue painted a *Maesta* led to his two star pupils from rival cities, Duccio and Giotto, each painting the same subject, in direct competition with each other (and with their master) for who would paint it best. Bernini and Borromini vied for mastery of architecture in seventeenth-century Rome, while an overt competition in Florence led to Brunelleschi coming up with a way to complete the world's largest dome when no other architect could. The animosity between Delacroix and Ingres, the Impressionists, and the academics of late nineteenth-century Paris, and countless other examples brim the edges of this book you hold in your hands. The history of art is chockablock not only with fascinating and dramatic stories but with rivalries that pushed the boundaries of what art could be and inspired genius to further heights.

Scandals more often are the unmaking of individuals than the moment they establish themselves. But in the art world, scandal has almost always been a good thing for the artist and for their art. This has been so obviously the case that many artists have courted scandal intentionally, from Picasso's wave-making *Guernica* to Courbet's undermining expectations with his monumental paintings to Whistlers that were deemed too hot for Victorian viewing.

Linked with scandal is shock, the intentional overturning of expectations in order to be talked about. From Damien Hirst's shark to Marcel Duchamp's urinal, from body art involving letting one's own blood to statues of Christ immersed in urine, shock has been a key promotional tool. But shock in the art world is not only the realm of the twentieth century. Caravaggio intentionally created works that he knew it would be deemed indecorous and rejected by their commissioners, for instance, when he used the corpse of a drowned prostitute that he'd seen fished out of the Tiber River as his model for the Virgin Mary in his *Death of the Virgin*.

What would our history have looked like stripped of rivalry, in a world in which everyone got along and maintained the status quo? And what role does the public play as recipients of the stories, as the ones who are scandalized and the ones who are shocked?

Over three distinct sections and covering more than two thousand years of art, the case studies in this illustrated volume will look at when negatives resulted in positives and how dipping into the darkness and playing dirty upped the game of artists and benefited the course of art.

Art is filled with individuals for whom rivalry, scandal, and shock seemed integral parts of their DNA. Caravaggio and Bernini were rarely at peace and seem to have been regularly asking for trouble, an attitude that ran parallel to the passion that stoked their artistic genius. The three categories frequently overlap, in individuals and incidents. *The Devil in the Gallery* examines how these antagonistic actions, moods, and tendencies, which we tend to think of as negative and destructive, actually helped shape and elevate the course of art, where something beautiful grew out of the weeds and ruins of the drama.

# Acknowledgments

Books do not simply appear. They evolve. Ideas become articles, articles loop together to become concepts for overarching narratives or theses. These become book proposals, which undergo countless drafts; then, once the proposal is acquired by a publisher, the dialogue begins between the author and the new editor that might change the book dramatically. The idea for this book began with three sources. First, I was asked by art historian Clayton Schuster to write a foreword for his book *Bad Blood*, which tells cinematic narrative stories of eighteen famous art rivalries. I enjoyed his book, which reads like a series of novellas, and from reading it saw that all of those rivalries actually proved beneficial for the course of art (and in most cases for the artists involved). Second, among the dozens of articles I write each year for magazines, I cover subjects that most appeal to popular publications: scandal and shock in the art world. These themes are of interest to readers who are otherwise not interested in art (or think they're not), and so they are good "hooks" for articles in the cultural sphere. As I wrote more of them, I realized that these dramas that we think of as negative were actually beneficial for (almost) all involved, and certainly for art itself. Third, my former editor at Phaidon, Diane Fortenberry, suggested that I might write a book along these lines, on scandal in the art world. Piecing together these elements led to the book before you.

I came to this publisher thanks to having been asked to write a foreword for Nancy Moses's book *Fakes, Forgeries, and Frauds*, also published by Rowman & Littlefield. Correspondence with the wonderfully kind and enthusiastic Charles Harmon, who expressed interest in doing a book with me, led to my shifting from Phaidon to Rowman & Littlefield for this book plus two others (and hopefully more in the future). I'm very grateful to all who helped bring this project to life.

Thanks to my family and friends, particularly the artsy ones—I'm looking at you, Nathan and Jaša—for reading chapters and offering suggestions. Thank you to Martin Kemp, a rock star of art history whom I've long admired, for penning the foreword, and to Odette Lopez for kindly assisting with fact-checking and Meghann French for her excellent, friendly, and necessary copyediting.

If you are interested in learning more, please join me through my website (www. noahcharney.com) or on Facebook or Instagram. You might also consider studying with me on the ARCA Postgraduate Program in Art Crime and Cultural Heritage Protection, which is run every summer in Italy and was the first academic program in the world on the study of art crime.

A warm thanks to you for reading, and may only beneficial devils cross your path . . .

—Dr. Noah Charney
Slovenia, 2020

# Introduction

## SYMPATHY FOR THE DEVIL

Caravaggio lived a violent hot fist of a life. It was brief, full of angst, upset, blood, and death, featuring a total revolution in painting on a scale only rarely approached in other periods in the history of art. Michelangelo Merisi, who got his nickname from having grown up in Caravaggio, near Milan, is one of just a handful of artists who completely changed art, shifted its continuum in a new direction. Along with the likes of Giotto, Masaccio, Donatello, Michelangelo, Turner, Picasso, and Duchamp, Caravaggio was a game changer, invoking a level of naturalism, drama, cinematic use of lighting, and surprising interpretation of religious scenes that turned the art world on its head. But while his art is, rightly so, the subject of reams of scholarly and popular writing, it sometimes slips between the cracks that Caravaggio was perhaps art history's most notorious criminal. He was a difficult character—someone who courted disaster, provoked it—and his life was a series of outbursts, incitements, scandals, rivalries, and shocks.

But what if those very negatives were actually part of what made him great? The talent and genius were there, of course, but perhaps what we consider to be destructive in fact pushed his art to greater heights.

We know far more about Caravaggio than most premodern artists because he was brought to trial so often. Court records have a habit of surviving far better than most, particularly in Italy's impressive archival system. So, while we do not even know the birth year of Hieronymus Bosch, or what Rogier van der Weyden did for the first dozen or so years of his life, we can track Caravaggio's exploits in impressive detail, even to the day. He was also the subject of multiple biographies, including those written by people who knew him—and sometimes hated him. These riches mean that we have a far more three-dimensional portrait of him, and it isn't pretty.

In colloquial terms, Caravaggio was a major-league asshole. He was also probably sociopathic, as so many people remark about his choleric, ill-tempered, jumpy, unpredictable personality—even those, like Cardinal del Monte, one of his earliest admirers and patrons, who wished him well. His roguish behavior is attested to in the many pages of court documents from at least eleven different trials.[1] He was a world-class bad tenant: He threatened his landlady, called her names, and pelted her with rotten vegetables and

stones. He poked a hole in the apartment wall, ostensibly to let in natural light, but with it came snow, rain, and swarms of pigeons. He was almost certainly bisexual, involved in relationships with many women (most of them prostitutes). He probably also worked as a young male courtesan in the service of several cardinals who enjoyed such company—he would paint portraits of these consorts and of himself in a similar pose. He was likely in a physical relationship with one of his adolescent male models, Cecco da Caravaggio. His sexuality is not really relevant to the discussion of his criminal activities, other than to say that accusations of homosexuality and sodomy were cast around him, as both were illegal at the time. But it is often difficult to tell whether accusations were real or fabricated—to get someone into trouble in Baroque Rome, an enemy might accuse you of homosexuality, whether or not it was true. That he was a magnet for trouble, much of his own devising, is beyond doubt.

He threatened to beat up painters who imitated his style. He did beat up a waiter, ostensibly for having served him a plate of overcooked artichokes. He had to flee Rome after having killed a rival in a fight and spent the remainder of his brief life traveling in hopes of a papal pardon for the murder. Both his pugnacious manner and the murder were impediments to his artistic career, as they forced him to lead so unsettled a life that his artistic production was limited due to his constant travel, always on the lam, getting on the wrong side of all who took him in. But other "negative" characteristics may have spurred his art forward.

We tend to think of painters as perhaps somewhat effete, low-key types. but Baroque painters were a badass bunch. There were street gangs of painters, with a particular rivalry between Dutch painters living in Rome and local boys. Caravaggio was involved in gangs and gang street fights. He carried a sword, which was illegal at the time if you were not an aristocrat, and he had it inscribed with a decidedly badass phrase that translates as: "Without hope, without fear." It was likely a gang dustup, coupled with affection for the same prostitute that led to his maiming, and the subsequent death, of Ranuccio Tomassoni. It was recorded that the fight was over a tennis match, but scholars have found that it was not a straightforward murder but rather a very personal attack.[2] Tomassoni's genitals were mutilated, and he subsequently died from the wounds. Caravaggio was obliged to flee or face trial for murder, with the penalty capital punishment. He was under the protection of some powerful aristocratic patrons, including the Colonna and Del Monte families, but there was only so much they could do. In Rome, only the pope, who was the equivalent of the king, had the power to pardon a murderer. And so Caravaggio fled, always hoping to return if a papal pardon could be secured.

He first set off for the Colonna family estates outside of Rome. He continued on to Naples, where he scored major, lucrative commissions thanks to interventions by the Colonna family. Even while on the run for murder, Caravaggio was still the most popular avant-garde painter of the time, and his work was welcomed wherever he went. He might have remained in Naples, but his friend Fabrizio Sforza Colonna was about to set off for Malta. He was the general of the galleys of the Knights of Malta, a medieval Crusader order (the Hospitallers) populated with members of Europe's finest families and with huge influence, particularly at the Vatican. Caravaggio saw membership in the order as his best

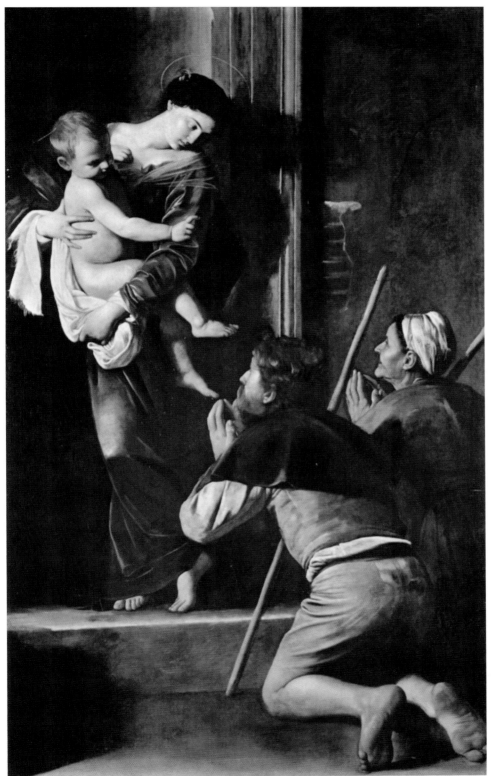

Caravaggio, *The Madonna of Loreto* (1603–1605).
PHOTO COURTESY OF WIKICOMMONS FROM YORCK PROJECT.

chance for a pardon, so he joined Colonna and sailed for Malta. There, he was immediately welcomed by Alof de Wignacourt, the Grand Master of the Knights of Malta, who was delighted that so famous an artist should rock up on the shores of his rocky island. While another knight, Malaspina, commissioned religious works—Caravaggio's *Saint Jerome* and *Beheading of John the Baptist*—Wignacourt had his portrait painted, as did some other illustrious knights. Things were looking good for Caravaggio—until, Caravaggio being Caravaggio, he got into trouble.

The exact nature of it is not clear, but it seems that he got into a fight with another knight, an aristocrat to boot, in which he broke down a door and beat up his opponent. Having arrived in 1607, by mid-1608 he was cast out of the order, referred to as a "putrid and fetid member," and thrown in prison. Alas, history does not record just how, but he managed to escape from prison and make his way to Sicily. When his winding path led him back to Naples in 1609, he was jumped by a gang of toughs who beat him so severely that he was permanently disfigured and died not long after, possibly from malaria but just as possibly from the wounds inflicted. One theory suggests that the gang had been sent to kill him by order of the Vatican, in revenge for his fight with the knight on Malta.[3] Violence and temper, therefore, were his enemies. But did he benefit from the rivalries, scandals, and shock of his career that did not involve fists and blades?

A close examination of how he chose to create art in a manner designed to shock leads to some surprising conclusions. He used, as a model for the Virgin Mary in his *Madonna of Loreto* painting for the church of Sant'Agostino in Rome, a prostitute friend of his named Maddalena Antognetti, nicknamed Lena, who liked to call herself "la donna di Caravaggio" (Caravaggio's woman). Lena solicited clients on the street in front of the church of Sant'Agostino.

This didn't go over so well when the locals walked past her on Sundays on their way to mass, then saw her portrayed as the Madonna inside the church. Caravaggio could have chosen anyone as a model for his Virgin Mary, but instead he made the proactive decision to select someone whom the congregation would recognize as the polar opposite of a virgin. This was a volitional act, a sort of painted middle finger hanging over the altar inside his local church.

His *Death of the Virgin* employed as the model for the body of Mary the corpse of a prostitute that Caravaggio saw dredged out of the Tiber River.

He could have chosen anyone. His desire for naturalism made him select a corpse as the model for the deceased Virgin Mary, but that the corpse was of a prostitute, and that the finished painted figure still suggests a body that had soaked in dirty river water, was a proactive shock tactic.

Some have theorized that he intentionally made works that church commissioners would find "indecorous," not appearing as they had expected, and which they would reject.[4] This meant that Caravaggio kept the advance on his commission but then could quickly sell the finished, rejected painting to a private buyer for far more money than the church was offering. In this way, he financially benefited from intentionally creating edgy, "indecorous" works—effectively employing shock to his own end, for shock may be defined, for our purposes, as the intentional creation of a scandal through an action (in

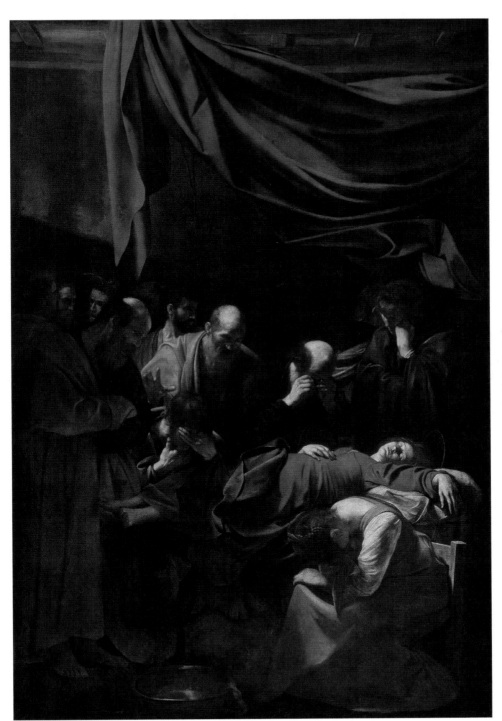

Caravaggio, *The Death of the Virgin* (1601–1606).
PHOTO COURTESY OF WIKICOMMONS FROM JOCONDE.

this case, creating an artwork) that, by design, surprised and dismayed many. An example comes in his work for the Cerasi Chapel in the church of Santa Maria del Popolo. He was commissioned to paint *The Crucifixion of Saint Peter* and *The Conversion of Saint Paul*. According to his first biographer, Giovanni Baglione (about whom more later), he painted versions of each that were rejected by the patron as "indecorous." Both were then sold to private collectors, while he painted a second version of each, which were accepted and remain displayed in the chapel.

To understand how Caravaggio could get away with defying, in an almost aggressive way, the expectations of his patrons, we must keep in mind just how popular he was and how recognized was his talent. After the appearance in 1599 of his Saint Matthew Cycle of three monumental paintings, his first large-scale public commission, Caravaggio was the toast of Rome, the most celebrated avant-garde artist in central Italy. The painting style that he essentially invented had no direct precedent. The revolutionary aspects were a strict break from the two leading schools at the time, one of which idolized Raphael's High Renaissance classicism, in which particularly biblical scenes were idealized, stripped of emotion, carefully posed in balanced, harmonious, calming compositions and with a general, overall diffused daylight (without shadows and with no obvious single light source within the painting). Raphael painted the happiest crucifixions one can imagine, for example, with no visible suffering, tableaux vivant that look more like models standing in poses than snapshots of real life. Each model's face likewise was idealized into a generically lovely visage, but not someone you would recognize if they walked past you on the street.

The other preferred painting style at the time was Mannerism, a movement launched by the followers of Raphael's great rival, Michelangelo. This employed a similar general diffused lighting and idealized faces, but the painted bodies were intentionally contorted, extended, and twisted into anatomically incorrect, unnatural positions for dramatic effect. Caravaggio apprenticed in Rome to a B-level Mannerist painter, Cavaliere d'Arpino, for whom he largely painted still life elements in the background of paintings: flowers, baskets of fruit, architectural elements. Most artists throughout history studied under a master and continued or lightly varied that master's style. Not Caravaggio, who conceived of a radically new way of painting in terms of concept, basic technique, and execution. Caravaggio did not use underdrawings, for instance, and he may not have even made preparatory sketches for his paintings, which was standard practice at the time, as none survive (whereas numerous examples do survive for other major artists). He would incise his canvases with the back end of his brush, pushing against it to make a general curve to delineate where he would paint his figures, but nothing like the normal method of carefully transferring preparatory drawings onto canvas or panel and building up by adding layers of paint to a drawing that would remain buried beneath the finished painting (and visible to modern conservators using infrared reflectography). To contemporary painters, this was like building a house without a set of blueprints.

Conceptually, his works differed radically. He used models who were his friends and were known figures in the street life of circa-1600 Rome, usually from the fringes of society—jailers, soldiers, and male and female prostitutes. Artists regularly used models, but most at this time, except in the case of portraits, altered the faces of their models,

idealizing them and shifting them away from recognizability and toward some Platonic ideal of beauty. Caravaggio's models were painted as they appeared, often in all their haggard, ugly glory, which meant that viewers of the time recognized them, and many found it distasteful that these "lowlife" characters were used as models for biblical protagonists, as in the models used for his Virgin Mary paintings.

It was also shocking that Caravaggio painted biblical figures in contemporary clothing, rather than the Early Modern idea of what people in Christ's time would have worn—togas and loincloths and the like. Yet Caravaggio was extremely religious and followed the recommendations of the Council of Trent—a series of emergency meetings of the Catholic Church to determine how to combat the Reformation—to an extent that was beyond what commissioners expected. The council encouraged a deeper meditative

Caravaggio, *The Calling of Saint Matthew* (1599). PHOTO COURTESY OF WIKICOMMONS, PHOTOGRAPHER UNKNOWN.

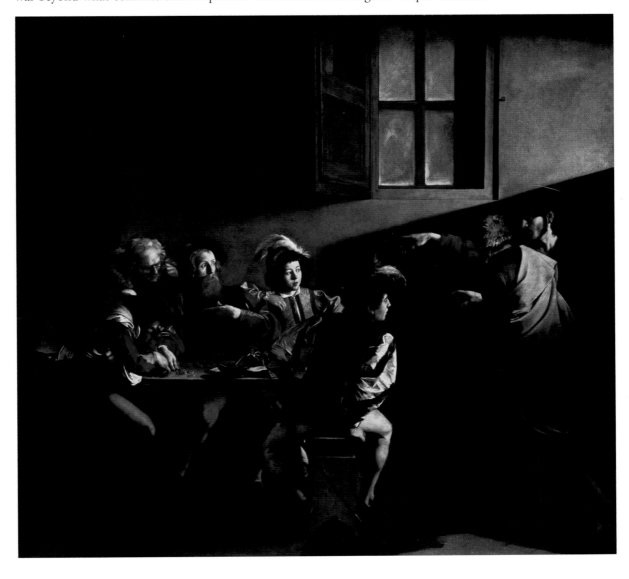

experience by imagining a biblical scene in the present day. This was why Caravaggio painted biblical figures in the attire of his contemporary Rome. But he was the first artist to take the Council of Trent's ideas on meditation and realize them in paintings, and it was upsetting for many viewers.

His paintings also differ in terms of which moment in a biblical story he chose to depict. Raphael's and Michelangelo's works show a posed moment after an action has finished or before it has begun. Crucifixion paintings normally showed Christ on the cross after he had died. Caravaggio preferred a moment after an action has begun but before it has ended; for example, his *Crucifixion of Saint Peter* shows the saint alive, having just been fixed to the cross, while his executioners struggle to raise it upright. In his *Calling of Saint Matthew*, part of the Saint Matthew Cycle that secured his renown, he shows Jesus pointing toward Matthew, but Matthew has not yet seen Jesus because he is in the midst of trying to steal money from his colleagues.

In *The Martyrdom of Saint Matthew*, from the same cycle, we see a moment after Matthew has been stabbed but before he has died, with his murderers escaping and the slaves he was in the midst of baptizing when he was attacked reacting in horror and seeking to defend him. There is an extreme example in *Judith and Holofernes*, where he painted Judith severing the head of Holofernes, head half detached from his body, spurting blood every which way, but with Holofernes not quite dead yet. Unlike the High Renaissance posed scenes, Caravaggio's paintings are rich with movement, dynamism, and potential energy: If we imagine them as a paused screenshot from a film, were we to "unpause" them, lots of movement would follow—blood spatters, baskets fall off tables, stools are knocked over, bodies tumble to the floor.

Such was Caravaggio's popularity, his status as the talk of Rome, the artistic center of Europe at the time, that artists and patrons inevitably lined up as for or against his revolutionary approach. There remained a classicist school of painters who still considered Raphael the greatest of all, and who continued his style, with only gentle "updates" to keep with the times. This was most evident in the Carracci family, three Bolognese painters (Annibale, Agostino, and Ludovico) who founded an academy that trained the leading Italian painters of the mid-seventeenth century, including Domenichino, Lanfranco, and Guido Reni. Their work is far more Raphaelesque, with only a limited aesthetic nod to Caravaggio through their painting of darker scenes with more dramatic lighting and shadow play (chiaroscuro). Annibale Carracci, in particular, was the closest thing to an artistic rival to Caravaggio, the two competing for some of Rome's most lucrative commissions. (We will visit their rivalry and his argument with Giovanni Baglione in the conclusion.) Artistic competitions, whether formal (like the contest to design the dome of Florence's cathedral, won by Brunelleschi) or more casual (patrons considering which artist to hire, sometimes requesting a cartoon, or preparatory drawing, on the basis of which they would make their choice), created naturally stimulating rivalries. Each competitor wished to do the best they could in order to outdo the others and receive the commission, thus elevating their game. This is the most obvious way in which rivalry advanced art.

Fleeing from scandals, especially the murder of Tomassoni and the fight on Malta, brought Caravaggio to Sicily, where his art changed. This late-period shift had to do with

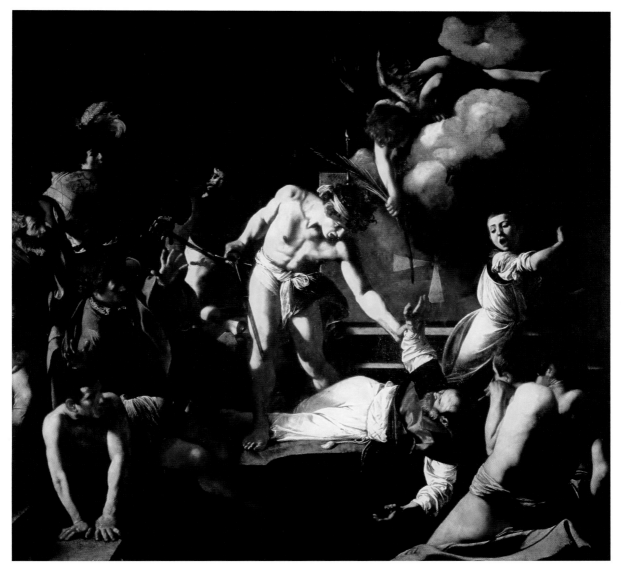

the fact that he was constantly on the move, fearing for his life. He finished his paintings more quickly, with thin enough layers of oil paint that you can see the weft of the canvas through the pigment, as he didn't have the luxury of waiting around for oils to dry. This sort of layer-light oil painting had been done before but was still relatively new. Titian pioneered the method in his late works some seventy years earlier, but Titian's late use of few layers did not launch a trend.

Despite a relatively meager output of paintings during his tumultuous, nomadic life, Caravaggio was so hugely influential that painters pilgrimaged to see his works, to absorb their new ideas, in both concept and technique, and they sought to imitate and riff off

Caravaggio, *The Martyrdom of Saint Matthew* (1599). PHOTO COURTESY OF WIKICOMMONS FROM USER RAOLI.

of them. An informal group of painters contemporary to Caravaggio are now referred to as the Caravaggisti, stalwarts of seventeenth-century Italian art. They include his former roommate Mario Minniti, rival and biographer Giovanni Baglione, Orazio Gentileschi, Carlo Saraceni, Mattia Preti, and even Dutch painters like David de Haen, all of whom carried on his style, despite his protestations whenever he felt someone was imitating his work. Unlike most artists, who developed studios and cultivated apprentices and assistants and were honored when their pupils carried on their artistic style, Caravaggio worked largely alone and actually threatened or sued artists who emulated his paintings.

At the age of just thirty-seven or so, his red-hot life caught up with him. Despite having been a colossally lousy roommate, in Sicily Caravaggio was taken in by former flat-mate Mario Minniti. He moved around the island until he learned of a new opportunity for a papal pardon. A new pope was on the scene, and in particular the pope's nephew, Cardinal Scipione Borghese, was a great art lover and a great admirer of Caravaggio. Armed with several paintings intended as gifts for Borghese, in hopes that the cardinal would intervene on his behalf and arrange a pardon, Caravaggio set off for mainland Italy. When he landed at Naples, however, someone was waiting for him. He was attacked and disfigured so badly that his face was beyond recognition. It is not clear whether the attackers were stalking him in revenge for the death of Tomassoni or in revenge for the assault and flight from Malta. Caravaggio had plenty of enemies.

He barely survived and was determined to move on. He made his way back toward Rome, at this point with no more possessions than what he carried with him, including the paintings he hoped to swap for his pardon. Somewhere on his way through the marshes south of Port'Ercole, he grew ill and died in 1610, aged thirty-eight, before reaching Rome where, in all probability, a pardon did indeed await him.

What killed him remains a mystery. The most likely culprit was malaria, contracted from a mosquito during his travels, but others have theorized that his wounds became infected, that he had lead poisoning from his art materials (which might explain some of his erratic, violent behavior), or that one of his many enemies (probably sent by either the Vatican or the Knights of Malta) caught up with him and finished him off. Indeed, two of his premodern biographers wrote that he was constantly being "followed by his enemies," without specifying to whom they referred. Caravaggio was his own worst enemy, pursued by karma, living a criminal's life on the run, but changing the face of art in the process. But he is an example of one artist in whom rivalry, shock, and even scandal elevated his artistic output and propelled his career forward. And through the influence of his revolutionary paintings, the history of art was, likewise, the better for it. That which was negative proved to be a sort of propulsion, like the flames that fire beneath a rocket ship, burning all they touch as they launch it to greater heights.

\*    \*    \*

Basic economic theory tells us that rivalry—more specifically, competition—is good for business and good for the consumer. But it is not self-evident that rivalry in competition is necessarily beneficial to the creative arts, beyond driving down the price for patrons. Setting the market aside, can rivalry stimulate the quality, originality, ingenuity of artistic

production? What of scandal and shock? The key difference between the two is, for our purposes, that shock is a volitional, provocative act that "makes waves" and churns the mill of gossip, fueled by the "can you believe they did *that*?" reaction, whereas scandal provokes this sort of response as a by-product of what happened, not as the main intention of the actor. Both are generally considered detrimental, sometimes catastrophic, to businesses and individual careers. Involvement in a scandal can turn a politician's career into a smoking ruin. Aside from surprise reveals of new innovations and the occasional low-level celebrity who decides to heighten their visibility with a "shocking" sex video, shock is not considered a positive thing when it comes to most fields of work.

But these potentially disastrous "negatives" can and have spurred the world of fine art to new heights. A look at the history of art tells us that rivalries have, in fact, not only benefited the course of art, from ancient times to the present, but have also helped shape our narrative of art, lending it a sense of drama that it might otherwise lack and therefore drawing the interest of a public who might not be drawn to the objects alone.

Rivalry has forced artists to push their limits. Michelangelo's insufferable boasting and supreme draftsmanship spurred his fellow art student, Pietro Torrigiano. One day, while sketching Masaccio frescoes at the Bracacci Chapel in Florence, Torrigiano was fed up and punched young Michelangelo in the nose, breaking it. This led Torrigiano to eventually leave Florence, leaving Michelangelo with his distinctive boxer's face and indirectly resulting in Torrigiano's great success in London, where he was the lead sculptor for the wondrous statues in Westminster Abbey. England has this sense of rivalry and jealousy to thank for some of its most beautiful statuary and for the introduction of Italian Renaissance traditions to the British Isles.

Scandal has likewise helped propel and promote the art world in a way that cannot be said of other fields. The saying goes that there's no such thing as bad publicity, but that is not always the case, and scandals more often are the unmaking of individuals than they are the establishing moment. But in the art world, scandal has almost always been a good thing for artists and for their art. Tired of being refused entry into the great annual salon of contemporary art in Paris, a group of artists whose style fell outside of the confines of what was considered academically acceptable opened a Salon des Refuses (1862–1863), an exhibition for those who had been refused participation in the main event of the Paris art world. This became a key launching point for many of the Impressionists and proved far more interesting than the original salon. The very fact that a rival salon was launched was taken as scandalous, and the gossip around it helped raise its profile and fill its halls with curious visitors. Whistler's *Symphony in White, No. 1* (1863) and Manet's *Le Déjeuner sur l'herbe* (1862) are some key works that provoked scandal among those who saw them, as they defied expectation and the muted morals of the era, but they, and the salon in which they were featured, managed to propel art in a new and more interesting direction.

That scandal is good for exposure has been so obviously the case that many artists have courted it intentionally, which we will define as shock: intentionally overturning expectations of the majority in a way that traditionalists find dismaying or upsetting but a certain minority avant-garde find exciting. From Damien Hirst presenting the public

with a shark embalmed in formaldehyde and entombed in a glass case to Marcel Duchamp trying to convince the art community that a urinal is a great sculpture, from an artist sculpting a self-portrait out of his own blood to immersing a statue of Christ in urine, shock has been a key promotional tool, particularly for artists of the post-1917 conceptual period (which Duchamp kicked off with his *Fountain* urinal sculpture).

But shock in the art world is not only the realm of the twentieth century. As we have seen, Caravaggio intentionally created works that he knew would be deemed indecorous and rejected by their commissioners. Giotto shocked a papal emissary by offering, as part of a competition for a major commission, not a complete cartoon but a simple red painted circle—which just so happened to be a *perfect* circle, drawn by hand. The emissary was dismayed, but the pope understood perfectly that this was an indication of the artist's ability, both in his craftsmanship, able to draw a perfect circle, and in his think-outside-the-box audacious ingenuity.

There is also a shadow component to the rivalries, shock, and scandal. That is on the part of historians and critics, who embrace sexy stories for their dramatic value and tend to focus on them without necessarily asking whether these dramas did positively affect the course of our history. What would our history have looked like stripped of rivalry, in a world in which everyone got along and maintained the status quo? And what role does the public play as recipients of the stories, as those who are scandalized, as the ones who are shocked? When stories of artistic rivalries were reported in the press, in books and circulated by word of mouth within the art world, they had the effect of adding to the cachet and intrigue surrounding the artists in question, amplifying the interest in them, and essentially becoming a promotional aid. Michelangelo and Leonardo's rivalry in Florence circa 1505 led to the commission of both to create frescoed battle scenes on walls of the same room in the Palazzo Vecchio, the commissioning Florentine Republic relishing the idea that visitors could stand in one room and decide for themselves which of the two local greats had "won" this intentional duel of artists. In the contemporary world, the breaking news that onetime lovers and creative partners Ulay and Marina Abramović were now at loggerheads, with Ulay suing Abramović, spurred popular and trade interest in their work, resulting in enhanced sales and a great deal of fresh press on both artists. This perspective, the positive outcomes of artistic rivalries, has rarely been discussed.

This book is a guided tour of the history of art through it scandals, rivalries, and shocking acts, each of which resulted in a positive step forward for art in general and, in most cases, for the careers of the artists in question. In addition to telling dozens of stories of such dramatic moments and arguing how they not only affected the history of art but affected it for the better, we will also examine the proactive role of the recipients of these intentionally dramatic actions: the art historians, the critics, and even you, the general public.

The devil likes to lurk in dark corners of the art world, morphing into many forms.

Let us shed light upon him.

# CHAPTER 1

# Scandal

Scandals bring about downfalls, don't they? In the world of business and politics (certain twenty-first-century American presidents aside) this is the general rule. When was the last time you heard about a scandal that was not detrimental, much less truly benefited the individual implicated? Scandals can sometimes be beneficial in that they can summon up enough fury that a necessary sea change comes about. The scandal around the 1986 Woburn, Massachusetts, water contamination case that led to the book and film *A Civil Action* is but one such example. When the story broke, it triggered outrage.[1] The public rightly considered it scandalous that major companies were dumping toxic chemicals that entered the groundwater and led to numerous illnesses and deaths among residents. The scandal severely damaged the companies involved: It made the companies household names, but in an entirely and lasting negative context. It also led to a broader crackdown on industrial chemical disposal—a good thing for all involved, aside from those found guilty and the bottom line for major companies with toxic materials to get rid of.

A more recent example may be found in the 2015 Volkswagen emissions affair, in which around eleven million cars were programmed to misrepresent their emissions levels to appear ecologically acceptable when they were not.[2] This was clearly an illegal action that a major company sought to get away with. When it came out, there was widespread moral outrage, and laws had been broken. The result was 100 percent disastrous for Volkswagen—the CEO resigned, governments investigated, $19 billion was spent fixing the issue. The brand was hugely damaged, though it was established and powerful enough, and the damage-control PR response was sufficiently believed that the company remains a power player in the long run. The affair remains a black mark on the company, but its sales are back up and the public doesn't seem particularly bothered anymore.[3]

These two examples are, of course, unrelated to art, but represent what we tend to associate with the only good that can come of significant scandals (as opposed to gossipy ones driven by curiosity, like the "leaked" sex tapes of quasi celebrities). Outrage leads to punishment of transgressors and hopefully a sea change for the better—certainly no plus for those outed, but perhaps a resulting positive shift more globally.

Politicians and public figures seem to suffer from scandal. Anthony Weiner's sending photos of his nether regions, Harvey Weinstein's sexual assaults, Mel Gibson's antisemitic outbursts, Lance Armstrong's doping. All harmed the one scandalizing, either irrevocably or for an extended period. There are, of course, people who seem to hover through life with a Get Out of Jail Free card in their pockets,[4] but it cannot be said that their scandals really benefited them in the long run, merely that they did not suffer repercussions to the level that the objective viewer might deem appropriate. It is important to distinguish scandals from shock. "Accidentally" released sex tapes can make beautiful people who were not previously famous into household names. Most such examples so benefited the naked person featured that they look more like a shock tactic, a publicity stunt. For it to be a scandal, by our definitions, it must lack intentionality on the part of the person at the scandal's heart.

There are several types of possible reactions to scandal, and they tend to vary based on whether the scandal rises from (A) someone trying to get away with something and having that scheme revealed, (B) someone going about their business and a resulting explosive response seems, to the public, disproportionate or inappropriate, or (C) something private being leaked and resulting in public moral outrage. Outrage is the most frequent response to a scandal, but some "lighter" affairs, particularly those that qualify more as gossip (or sexual escapades) rather than objectively harmful and widespread, can provoke a luscious giggle ("Isn't that just *scandalous*," perhaps mentioned by ladies-who-lunch over their martinis). But whether dealing with lighter gossip or a powerful organization or individual caught trying to get away with something, scandal almost always destroys, doesn't it?

In art, things function in a different way. Art is its own bizarre microcosm, with rules that follow their own paths. Scandal can help its protagonist by generating promotion—this is the point of intentional actions that shock. Do something that will get you talked about, and you will remain recognized and in the public mind beyond that shock event. But as we will see, scandal—unintentional and apparently detrimental—also seems to help advance the course of art as well as the careers of individual artists.

There are too many examples of art world scandals to attempt an encyclopedic approach. Instead, let us examine a selection of incidents that represent categories of beneficial art scandal.

## *Guernica* and the Monumentalizing of Scandal

An art world example of version A comes in Pablo Picasso's seminal *Guernica*. This was a scandal when it came out because it revealed a scandal the perpetrators hoped would be forgotten.

On April 26, 1937, during the Spanish Civil War, a swarm of fighter planes attacked the Basque town of Guernica, killing hundreds of civilians. The town was an important strategic center for the Republican forces, who were fighting against the Nationalist forces, the ultimate victors, led by General Francisco Franco. Guernica was the traditional

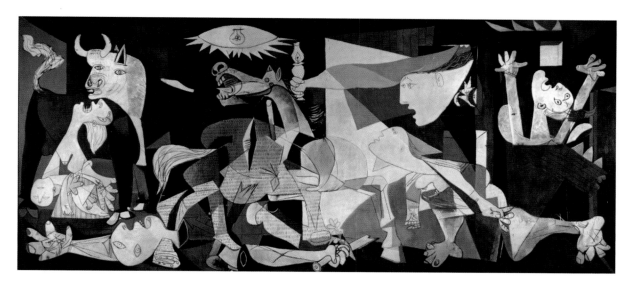

meeting place for a Basque governmental body, but it was also the last defensible town for the Republicans, standing between Franco's forces and the Basque capital, Bilbao.

Franco's Nationalists were aided by German and Italian Fascists, and it was planes of the Italian Fascist Aviazione Legionaria and the German Luftwaffe Condor Legion that provided the aerial assault ahead of Franco's infantry, in an attack that was called Operation Rügen. In terms of military history, this was an important strike because the target was not military; it was, rather, a terror bombing assault on civilians in a town with no military presence. The world looked upon the action with horror, recognizing that innocent civilians would not be protected from war. The attackers even chose Monday, the local market day, for the strike, to maximize potential civilian casualties.

By June 1937, Picasso had completed his monumental painting of this attack, *Guernica*, considered by many to be his greatest painting, for the Exposition Internationale des Arts et Techniques dans la Vie Moderne at the Paris International Exposition, part of the 1937 World's Fair in Paris. The painting was then sent on a brief world tour, displayed in London and New York. It helped to raise international awareness of the Spanish Civil War and in the process spread Picasso's fame.[5]

To talk about war, to prompt change, to get the viewer to engage fully, a more cerebral, less Romantic approach tends to be more effective. As Rene G. Cepeda wrote, Picasso in *Guernica* used "art as a weapon for social change."[6] In this way, Picasso was Brechtian. The playwright Bertoldt Brecht felt that walloping the audience with emotion resulted in a defensive reaction, a desire to say, "How horrible!" but to then turn away because it is too horrible to engage with. Both Picasso and Brecht used their "soft" weapons—pens and brushes—against Fascism. Cepeda cites Brecht's text, "In the Fight against Injustice Even Weak Weapons Are of Use." The paintbrush or pen can be mightier than the sword, provided said sword is not about to strike you and your pen down.

The chaotic nature of the scene depicted can make it difficult to pick out specific figures. The chaos is intentional, and wonderfully evokes the horror and disarray of the

Pablo Picasso, *Guernica* (1937). PHOTO COURTESY OF WIKICOMMONS FROM USER LAURA ESTEFANIA LOPEZ.

attack by disorienting the viewer into sympathy with the victims. The overall feeling of horror and chaos is more important than what the component parts symbolize.[7]

Picasso shifted through a number of stylistic periods, his work growing ever more abstract. His concept of Cubism, in which naturalistic images (such as still lifes or portraits) are broken up into constituent basic geometric forms that are then shuffled like a dropped deck of cards, later shifted into puttylike shapes and bodies, without weight, with elastic boundaries that could be altered and twisted at Picasso's will. The goal was to create a work more dynamic, absorbing, and inspiring of wonder than any realistic painting could achieve. For this work, a realistic image of the bombing of the town of Guernica, with corpses and screams in the night, would likely have felt melodramatic, saccharine, difficult to look at. It might have been Romanticized or it might have been so gritty that our reaction would be to shut down our ability to sympathize as a defense mechanism. The figures are almost cartoonish, but then, of course, when you look more closely, when you know the context, they are not. But the childlike abstraction pulls us in, whereas the same subject handled as a photorealist blood-fest would repel us.

Throughout its existence, this painting has been at the heart of drama and controversy. While living in Paris during the Nazi occupation, Picasso was harassed by the Gestapo. In a possibly apocryphal story, one officer is said to have seen a photograph of *Guernica* in Picasso's apartment and asked, with disgust, "Did you do that?" Picasso responded, "No, *you* did."

Like all great art, the power of *Guernica* transcends time and can symbolize something current and topical for individuals of any era. During the Vietnam War, the painting became the backdrop for antiwar vigils in the museum. These were quiet, poignant protests against the horrors of war. But in 1974 an Iranian political activist, who claimed to be protesting Richard Nixon's pardon of William Calley after his role in Vietnam's My Lai massacre, vandalized the painting, using red spray paint to write "KILL LIES ALL" across it. The paint was easily removed and the work undamaged. The vandal, who ironically later became an art dealer, waxed philosophical when interviewed six years after his attack. When asked why he did it, he said:

> I wanted to bring the art absolutely up to date, to retrieve it from art history and give it life. Maybe that's why the *Guernica* action remains so difficult to deal with. I tried to trespass beyond that invisible barrier that no one is allowed to cross; I wanted to dwell within the act of the painting's creation, get involved with the making of the work, put my hand within it and by that act encourage the individual viewer to challenge it, deal with it and thus see it in its dynamic raw state as it was being made, not as a piece of history.[8]

In this quote, he shows the slanted rationale of so many aggressive political protesters trying to gain attention by scandalizing. He does not possess the subtlety to recognize that *Guernica* has been alive and pertinent to every generation since its creation and has never been relegated to mere history. And while his action was damnable and, for all he knew, could have ruined the masterpiece forever, the fact that *Guernica* inspires such passions is a testament to its power and its enduring resonance in all eras.

This spray-paint vandalism was, in itself, a scandal, and interestingly the vandal in question, artist Tony Shafrazi, actually benefited from the publicity that his callous action generated. Shafrazi went on to become an art dealer, but he made his name by attacking *Guernica*.[9] Criminals involved in art seem to reap the same sort of minimal initial negative effects of the scandal around their crime as do artists involved in legal controversies. Such was the case for numerous art forgers, from Eric Hebborn to Wolfgang Beltracchi, to name but a few.[10] Criminals involved in trafficking cultural heritage seem to suffer from greater derision (Giacomo Medici and Robert Hecht, for example), but collectors who buy looted art (even if there is a probability that they were aware that what they acquired was looted) tend not to be damaged definitively (with some figures, like Marion True, a curator at the heart of some of the Getty scandals, ostracized by some, defended by others, but still working within the field).[11]

Picasso's Cubist abstraction was more powerful and scandalous, at the time, than a naturalistic depiction of the same moment would have been. No naturalistic scene could be as true to the real sensations and feelings of destruction, death, and war as the broken shards of life in Picasso's *Guernica*. A portrayal of the gratuitous bombing of the Basque historical town, Picasso's bent and shattered creatures are made of concentrated pain, which passes on to the viewer, trapped in blocks of line and color, for us always to remember the capability of man to hurt man. It revealed a scandal to many who were unfamiliar with it and created of it a lasting monument so that it would never be forgotten.

In *Guernica*, an artist made a monument out of a scandalous incident that the perpetrators hoped would be forgotten—forcing us to think deeply about it, to remember, and to forever blame the evil actors in it. There are also incidents in which the larger power attacks artists, a sort of reverse version A, instead of a work of art revealing a horrible travesty pulled off by a larger power (the Fascists who attacked the town of Guernica)—effectively art attacking the dark power. In the following case study, which fits out scandal version B, a well-known artist doing his own thing was attacked by a larger power (those problematic Fascists, once again) and was largely ruined because his art revealed the realities that the larger power wished to smother.

## Dix and the Legacy of a Victim of Scandal

The brilliant German printmaker and painter Otto Dix was an established artist and professor at the Art Academy in Dresden. He was not problematic to the Nazis from a racial purity standpoint, and his artistic skill was not in dispute, at least if one were being objective. It was his choice of subject matter and the message it conveyed that led to him being lumped in with Jews, abstract artists, and other modern avant-gardists by the Nazis in the 1930s when they launched a crusade against *entartete kunst* ("degenerate art"). This became a catchall term for art or artists that did not suit the aesthetic, ideals, or background supported by Nazism—Jews, Catholics, and Slavs were disfavored, but also pure-blooded Germans who worked in styles the Nazi leaders found overly modern. The Nazis preferred a sort of Neoclassical realism that could be used as propaganda: muscly,

heroic youths resembling Greek sculptures and showing the inherent superiority of Aryan Germans.

Dix had fought in World War I and was actually a war hero—he voluntarily enlisted, earned an Iron Cross, and was wounded in the neck. The experience, understandably enough, scarred him. He was interested in showing the dark, debilitating, futile side of war. His figures are grotesque, effete, damaged, sometimes overtly, including veterans mutilated by the war. The Nazi Party, however, thought that "all art should present the German values of *Kinder, Küche, Kirche*"[12] (literally, "children, cooking, and church" but meaning family, home, and faith), though it should be noted that religion would also be marginalized. Dix's works were among those selected for a Degenerate Art exhibit in Munich in 1937, in which art deemed inappropriate by the authorities of the German Weimar Republic were exhibited in the worst possible way, hung in awkward places and flanked by derogatory slogans and wall copy. The exhibit was meant as a hall of horrors showing what sort of immoral infestation the Nazis were saving their people from.

Take his *Metropolis* (1928), a triptych that shows the glamour of Berlin as a center of free thought and the arts in the 1920s in its central panel—we see a dreamy, slightly grotesque scene of jazz musicians in a nightclub.

But the wing panels show ugly prostitutes and an overweight invalid veteran walking on crutches. The choice of making a triptych, which is traditionally associated with Catholic altarpieces, also made the moralizing in Dix's painting feel more portentous, likening postwar Berlin to biblical ruinations like Sodom and Gomorrah.[13]

It was this attitude and the message in his work that led the Nazis to first get him fired from his teaching position in Dresden in 1933 before featuring him in the Degenerate Art exhibition. It would have been wise for Dix to leave Germany, but he did not, as he was "bound to Germany because of his family and his pictorial idiom."[14] He had an audience among sympathetic art lovers in Germany, but he found himself on the Nazi blacklist. When an attempt on Adolf Hitler's life was made in 1939 (Georg Elser was

**Otto Dix, *Metropolis* (1928).** PHOTO COURTESY OF WIKICOMMONS FROM USER MBENGISU.

the would-be assassin in what was known as the Bürgerbräukeller Bombing), Dix was arrested and imprisoned for two weeks, though he had no link of any sort to the scheme. During World War II he was forced to serve in the *Volkssturm*, a sort of local militia, and was captured by the French as a prisoner of war (ironically, an officer at the POW camp to which he was sent knew his work and commissioned an altarpiece and some portraits from him while he was interred). He returned to Germany after the war and lived until 1969, but his reputation, at least during his lifetime, had been smeared by the Nazis. He was one of hundreds of artists to have their career and quality of life suffer for being tarred as "degenerate."

The Degenerate Art exhibition caused a scandal within Germany and abroad. Most objective viewers outside of Germany saw it for what it was—a smear campaign based on ideology. The Nazis wanted their people to be scandalized by the sort of art the "degenerates" were creating, while the rest of the world was instead scandalized by the Nazis and their condemnation of what was considered among the greatest art of the day.

Otto Dix suffered, physically and professionally, during his career because of his tarring as a "degenerate," but his reputation as an artist among art lovers beyond the tentacles of Nazism remained strong, and even improved in sympathy for what he went through. He had admirers and sold to collectors throughout his career, even when he was in the thick of the "degenerate art" affair. And because of what he went through, his art is now, in retrospect, considered unusually powerful and true, so much so that it frightened the Nazi authorities into trying, and ultimately failing, to disqualify it. Had Dix been left alone to proceed with his art unmolested, he might not be considered, today, as the exemplar of the artist as fighter for truth, shiner of a spotlight in dark times. His suffering created a legacy as a sort of artistic martyr, punished for illustrating too accurately the realities of his place and time. Affixing a story of suffering to an ingenious artist helps secure his legacy, which might have been lesser had he not been involved in the "degenerate art" scandal.

# Greuze, the Académie, and the Hierarchy of Genres

Another example of eventually beneficial controversy is actually a layer cake of scandal, shock, and rivalry, one that led to a creative revolution against the academic, traditional, conservative power players who determined what sort of art was good or even acceptable.

Paris received its first academy, the Académies Royales de Peinture et Sculpture established by artist Charles Le Brun, in 1648, but it was not until a newer incarnation of this was set up after the fall of Napoleon that it began to draw the finest artists from throughout Europe. It was reestablished as the Académie des Beaux-Arts in 1816.

This national academy was heavily regulated, and there was only a certain, rather narrow concept taught about what great art should look like. Favored were the monumental, naturalistic paintings of Jean Auguste Dominque Ingres and Jacques-Louis David, the preferred painters of the Napoleonic era. Traditionalists could qualify for the annual salon showcase exhibition run by the Académie, but liberal avant-gardists were rarely considered.

Circa 1860, the understanding was that if you, as an artist, towed their line, then the Académie was the best place from which to graduate and embark on a career in art, which could be launched by showing your work at their salon. The Académie was both a school and a sort of club of established artists, so not only did they train the next generation, but they also expected active artists in Paris to join them, which meant following their preferences. A core group of older artists determined what was good, but they also condemned some art as having a corrosive influence on French culture. If you strayed from their expectations, then there was no place for you, and you were sidelined or branded as dangerous.

The most evident manifestation of this was the annual salon. This was held in the Salon Carré in the Louvre, and it displayed the winners of a competition to which artists could submit their works. From 1791 the competition was open to all, and it was established as the premier showcase for the best art created that year, launching careers, enhancing reputations, and, of course, leading to sales and commissions. But getting into the salon meant passing muster before that small group of judges from the Académie, which meant painting in a style of which they approved. There was ample reason to want in: From 1740 to 1890, the eight-week-long salon was the most prestigious and high-profile place for anyone to show their art, with fifty thousand visitors a day in some cases. This monopoly on what was considered proper art led to a monotony of style and rubbed many the wrong way.

Occasionally, controversial works slipped into salons, but this was sporadic. An early example came in 1769, with the painter Jean-Baptiste Greuze, whose work was exceptionally popular and whose style was, indeed, traditional and in keeping with the Académie's preferences. Stylistically, he was fine, but he did not paint "important" subjects, or so the judges of the salon thought. His regular work covered portraits and genre paintings. (Genre painting is a term for subjects from everyday life, considered unimportant historically and therefore of lesser value culturally: scenes of peasants, of ordinary people going about their quotidian routine, of domestic interiors, and the like.) Greuze was accepted as a member of the Académie, but at the lowest level, essentially with the caveat that the judges considered his work of no importance, with the dismissal that he was *just* a "painter of genres."

An informal hierarchy of genres was present, dating back to the seventeenth century, with biblical, mythological, and historical events involving kings and battles considered of greatest importance, and landscapes and still lifes of the least.[15] Genre painting was low on the list, below history paintings and portraits and only marginally higher than landscapes and still lifes. This condemnation of Greuze's subject matter caused something of a scandal of its own because Greuze was so popular with audiences. To dismiss his work was to dismiss the tastes of all those who loved it.

Greuze had enjoyed success at the Académie salon of 1755 with a genre painting, *A Father Reading the Bible to His Children*, which had been recommended to the Académie by one of its prominent members, the portraitist Louis de Silvestre.

This was a genre painting, to be sure, but it had advantages. Because the scene of ordinary life involved the Bible, it was considered more morally elevated. Both this work

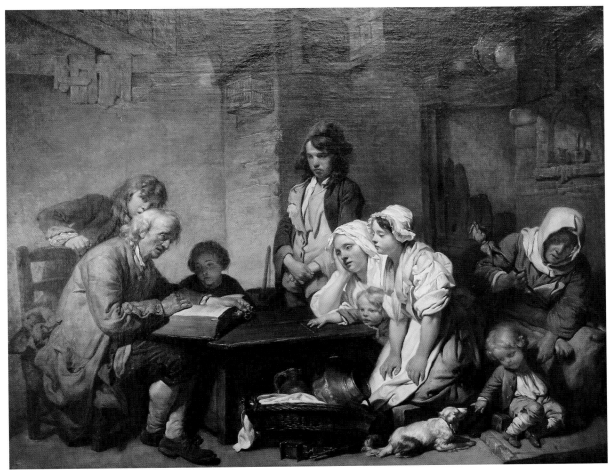

and *The Blind Man Cheated* were shown at the salon, and their success led to his acceptance as an associate member of the Académie. His timing was good and his themes well-chosen, as he was considered admirably Christian in his paintings, which were far more moral than the favorite painter of the French court at the time, François Boucher, whose Rococo style featured sexual escapades painted in a flowery manner, whimsical and associated with the frolicking aristocracy. Here, with Greuze, was a painter of subject matter more ethical and resonant with real people, not the frilly silliness of aristocrats at play. His style was influenced by seventeenth-century Dutch genre paintings (by the likes of Jan Steen) and British parallels of moralizing genre scenes (like those by William Hogarth). This success at the salon launched Greuze's career at the age of thirty, and gave him a boost of confidence that would later lead to a problem.

For Greuze was still an associate member and was classified as a genre painter. This meant that he was low on the hierarchy. He was popular with the public, certainly, but among his peers at the Académie, he was considered of minimal importance as a painter.[16]

Jean-Baptiste Greuze, *A Father Reading the Bible to His Children* (1755). PHOTO COURTESY OF WIKICOMMONS FROM USER TANGOPASO.

Greuze's genre paintings were successful but were pooh-poohed by critics and peers for not being "serious" enough. This bothered Greuze, but he was torn: He did not, perhaps could not, change his painting style, and he had already found success with it. On the other hand, he was aware of how influential the Académie was, and his own career had been launched through the 1755 salon. When he chose to apply for full membership, he had to submit a "reception piece," on the basis of which he would become a full member—or not. Greuze submitted his reception piece in 1769. Traditionally artists consulted with an adviser or sponsor, putting their heads together to determine what sort of a painting would have the best chance of success for full membership. Greuze chose not to consult with anyone, convinced that his popular success and experience as an associate member would suffice.[17]

He strategized, and so shifted toward the preferred subject matter of the Académie. He submitted a painting of two historical figures of importance, his *Septimius Severus and Caracalla*, hoping it would not only lead to his full membership but also elevate his status to that of a history painter, the highest rank.

**Jean-Baptiste Greuze,** *Septimius Severus and Caracalla* **(1769).** PHOTO COURTESY OF WIKICOMMONS FROM WEB GALLERY OF ART.

The work looks like something by Jacques-Louis David but precedes this most popular among academic painters by a generation: It is proto-Neoclassical, stylized and melodramatic, as the bedridden Roman emperor Septimius Severus chastises his son, Caracalla, for having attempted to kill him. But the painting was mocked and critiqued from the start. It was too small in scale, the historical moment too obscure, the figures weak, even the outstretched arms of Septimius Severus damned as too droopy for such an authority figure.[18] Greuze was accepted, but barely. The painting showed at the 1769 salon but was likewise dismissed by critics. Dismayed, Greuze would not show again until 1800, though popular interest led him to show works in his own studio in the Louvre while the salons were running—a sort of mini, private, alternative salon.

Here we see another incarnation of the multilayered scandal sandwich within the salon and its ultimate rival salons. With the case of Greuze, an established artist (already forty-four) was shamed by his peers, the academicians: punished, in a way, for being too popular.

Even some literati came to Greuze's aid. The leading intellectual of the day, Denis Diderot, editor of the first encyclopedia, said that Greuze's work was the "highest ideal" of French painting. The initial scandal was twofold: Greuze's low-level admission was one thing, and it was much discussed, but also, by dismissing what this popular artist created, the jury of the Académie was effectively shaming the taste of the general public.

The scandal of wrangling for status with the Académie helped solidify his popularity among collectors and led him to double down on what he knew he did best—moralizing, melodramatic genre scenes—rather than seek to please the jurors of the Académie while not being true to himself. Had he been accepted as a full member as a history painter, he would have felt obliged to shift to that genre, and he would not be associated, as he is today, with mastery of what was the most popular style of his era.

Other examples were likewise considered traditional in style but scandalous in subject matter, even if the finished product was of a higher objective quality than Greuze's ill-fated submission. Several such examples came from the brush of Gustave Courbet, whose career skipped along the boundary between scandal and intentional shock.

## Courbet and the Rival Salons

*A Burial at Ornans* (1849–1850) was a colossal painting (10.5 x 22 feet, or 3.1 x 6.6 meters), and a work of such a scale seemed befitting of important historical or religious motifs.

But Courbet produced a masterfully painted (in the Académie's preferred style) genre painting, showing not the funeral of some king or pope or saint, but of Courbet's great-uncle, a man of no particular importance to history. The funeral took place in September 1848, in a village, and Courbet painted exact likenesses of real people from the settlement, rather than models—the vastness of the painting meant that those portrayed were shown life-sized. The willful nature of Courbet's scandalizing paintings makes this fall into our category of shock, as opposed to the inadvertent scandal that surrounded Greuze,

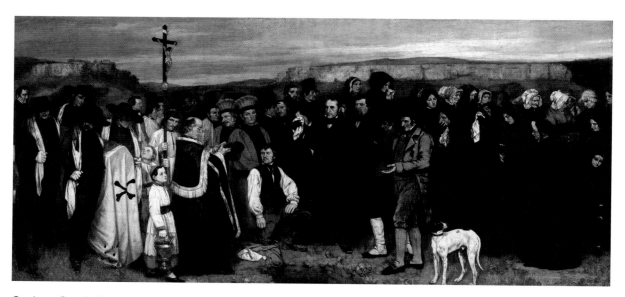

Gustave Courbet,
*A Burial at Ornans*
(1849–1850).
PHOTO COURTESY
OF WIKICOMMONS
FROM GOOGLE ART
PROJECT.

who did not intend to shake things up but wound up sparking debate when his work was accepted only begrudgingly by the salon.

Those viewers with traditional expectations were scandalized by the "overblown" importance Courbet gave to an event about a person of "no importance," or so they imagined. Courbet was playing with this notion, even naming the painting *A Burial* and not *The Burial*, as if to underscore that this was just one of many of equal importance (or lack of importance), depending on one's personal connection to the deceased. But this was not the done thing, and so while the quality of the work was without doubt, its subject matter led to it being the talk of the town, provoking a "how dare he" reaction while simultaneously stirring up the conversation of whether the strict expectations of art were appropriate and valid in the modern era.

The stories of Greuze and of Courbet's *A Burial at Ornans* fit scandal version B, in which the artists were doing their own thing, as it were, and were reacted to by the power structure in a way that many found inappropriate—hence the scandal. But Courbet was one of the great revolutionaries of art history, and he knew how to use scandal to his own end, adding shock to his arsenal. *A Burial at Ornans* was shown in the 1850 salon alongside two other works by Courbet, *Peasants of Flagey* and *The Stone Breakers*, which both show sympathy for the backbreaking plight of peasants.

This added fuel to the scandal, because it muscled sociopolitical commentary into art. State-run institutions were not welcoming of art that discomfited viewers as to the unfair imbalance of quality of life among its citizens, and Courbet, a self-proclaimed anarchist who enjoyed stirring things up, wanted to highlight just this.[19]

One might think that such a scandal, and the wrath of traditional critics pummeling the painting in newspapers, would ruin Courbet. Not so. In art especially, two parallel quotes ring consistently true. Oscar Wilde wrote, "The only thing worse than being talked about is not being talked about," while P. T. Barnum is credited as having

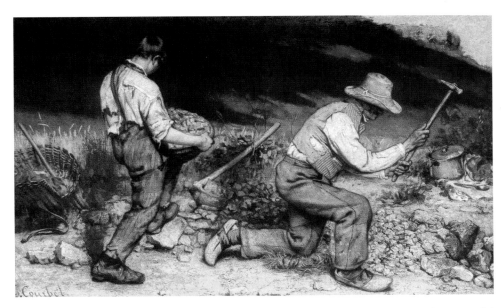

Gustave Courbet, *The Stone Breakers* (1849). PHOTO COURTESY OF WIKICOMMONS FROM ETSU.

said, "There is no such thing as bad publicity."[20] While many careers that scandal dashed against the rocks might be summoned as counterarguments, in the art world, at least, this has proven true. Courbet's was one among some two thousand pictures displayed, but the scandal he knowingly provoked led to his grabbing the headlines. This was quite literally the case, as Paris was a center for newspapers in the second half of the nineteenth century, and some that are still in print, like *Le Figaro* (founded in 1826) and *L'Indépendant* (established in 1846) were active opinionmakers in the 1850s. Media organs like these would prove crucial to the history of scandal and shock because they were the vehicles through which these incidents came to the attention of the wider public—and, although many newspapers have professed subjectivity, their authors in fact passed judgment for or against what they critiqued, and so not only did they announce incidents, but they also weighed in with their opinions on them, thus encouraging their readers to think likewise.

Courbet emerged from this premeditated scandal of his established as the leading painter of his era. While the naysayers tend to be louder and better archived in traditional news media, for every person who was dismayed by Courbet's paintings, others admired them and him for the same actions. No one doubted his technical superiority as a painter; it was just a question of whether a viewer was conservative and pro-state, preferring the official line and the status quo, or more liberal and inclined to tip their hat at Courbet's courage in lifting the veil and telling the truth about the difficult lives of a social caste that had no practical way of broadcasting their strife to the public, since the mainstream media did not offer them such a platform.

This incident was also important to the course of art history, as *A Burial at Ornans* and *The Stone Breakers* pioneered a movement of artist Realism. A work of art that is "realistic" (looks like a photograph or like real life) should not be confused with the artist

movement Realism. This truly began with *Adoration of the Mystic Lamb* by Jan van Eyck (1426–1432), which is considered the first work to bear a level of illusionary realistic detail: identifiable portrait faces of more than one hundred figures in the painting, botanically identifiable plants, an observation of the natural world down to the reflection of light in a horse's eye and the pores on someone's face. But Realism as a movement began here, at the salon of 1850, with Courbet's combination of scenes of everyday life shown unadulterated, as they were, with an unpainterly style as close to photorealism as the art world had seen. This was also a precursor to the movement of Social Realism, which we associate with art that promoted social consciousness and highlighted marginalized people, groups, and issues, which took hold in the 1930s in the United States. It was a strong shift away from the two prior preferred movements: Romanticism (embodied by Eugène Delacroix) and Orientalism (Jean-Léon Gérôme), both of which opted for exoticism and drama of historical moments in distant lands. Suddenly, Courbet was aggrandizing the everyday at home, and pointing out social issues on the front doorstep of those visiting the salon, issues that they preferred to overlook.

This incident of shock, intentionally induced scandal (of which much more in the next chapter), on the part of Gustave Courbet, is but one of many such stories woven into the history of the salon. Perhaps this is no surprise, when we must keep in mind that there were several thousand works selected each year for display, from a pool of as many as five thousand submissions. That amounts to a lot of case studies and many potential issues, dynamics, and brouhahas.

In 1863, there were 2,218 pictures selected from more than 5,000 submitted, the largest number of rejections to date, outraging those rejected and leading to claims (quite rightful) that the salon was heavily prejudiced in favor of one style and was not keeping up with the times. This led to a surprisingly liberal act on the part of Napoleon III, the emperor at the time, a man who was always conscious of the rumblings of the public and willing to act to calm . . . or crush them. For instance, he ordered the reconstruction of much of the center of Paris, which was on the one hand progressive—Baron Haussmann's new urban plan was more hygienic and modern, brighter and more livable—but it was also designed to make guerilla fighting in the streets impossible, widening avenues so that small gangs of peasant fighters stood no chance at barricading against the national army, as had been the case of the Paris Uprising of 1832 (made famous in *Les Misérables*).[21] From 1860 until his reign ended in 1870, Napoleon III made a series of liberal concessions to appease the public as his popularity waned. One such was his decree that a parallel salon should be set up to feature those artists of merit who were rejected. This became known as the Salon des Refuses (the Salon of the Rejected). This act would offer a sense of equality to the public and also allow the public to judge for themselves which styles they preferred, taking the power out of the hands of the selection committee of the main salon and giving it to the audience.

The first Salon des Refuses included 366 painters and 64 sculptors, with a total of 780 artworks displayed.[22] A who's who of important artists, from the perspective of historical hindsight but also in terms of contemporary popularity, appeared, including Courbet, Cézanne, Pissarro, Whistler, and Fantin-Latour.

This new rival salon drew around one thousand visitors a day. It was much discussed because of its novelty and the very fact that Napoleon III had shifted power away from the monolithic institution, the Académie, and allowed creative voices beyond its narrow definition of what was good and right to have a public venue. Many traditionalists were dismayed by this fact alone, and so the Salon des Refusés became a talking point. But when viewers and critics saw what was on display, new scandals launched and the "other salon" became that much more au courant.

Out of the 766 works that were displayed, two in particular ruffled conservative feathers but also became the darlings of the more liberal-minded, progressive viewers and artists.

## Whistler and the Weight of Rejection

James McNeill Whistler spent the winter of 1861–1862, when he was just twenty-seven, painting a portrait of his mistress, model Joanna Hiffernan. The American painter had moved to Europe to make a name for himself as an artist, for America would not become a center for fine art for nearly another century. Paris was the place to be, and Whistler lived there, but with this painting, he tried his luck in London. The annual Royal Academy of Arts exhibition in London was the British equivalent of the French salon. Inclusions were selected by a jury of traditional academic artists and professors, and variation from the artistic norm of the era was discouraged. But a good showing at this exhibit could make a career. In an attempt to establish his name in London, Whistler submitted this painting for the 1862 exhibition. The work, known initially as *The Woman in White* (now called by art historians *Symphony in White No. 1, The White Girl*), was sent to the jury, but Whistler never heard back about whether it had been accepted. So he traveled to London a week before the grand opening.

It was heartrending for him to meander from room to room in the expansive exhibition in search of his painting. He eventually stumbled upon it in a room at the rear, among a stack of rejections leaning against a wall. He reclaimed the painting and arranged for it to show at a commercial gallery, Morgan's. This was a bold move, for having once been rejected, he risked the same thing happening a second time. But he believed in his work, once saying, "She looks grandly in her frame and creates an excitement in the artistic world here. . . . In the catalogue of this exhibition, it is marked 'Rejected at the Academy.' What do you say to that? Isn't that the way to fight 'em!"[23] It was a clever and brash bit of marketing, choosing to wear the badge of rejection proudly. It was true that the style of the work, very loose and impressionistic (long before Impressionism had caught hold), appeared unfinished, at least to the stylistic eye of the time.

His second attempt made a splash and a scandal, but not the way he had hoped. The press used terms such as "incomplete" and "bizarre" to describe the work, and it did not go unnoted that this rash young American was throwing the rejection by the authorities back in their faces as a sign of honor. It just wasn't cricket, as the British like to say. It

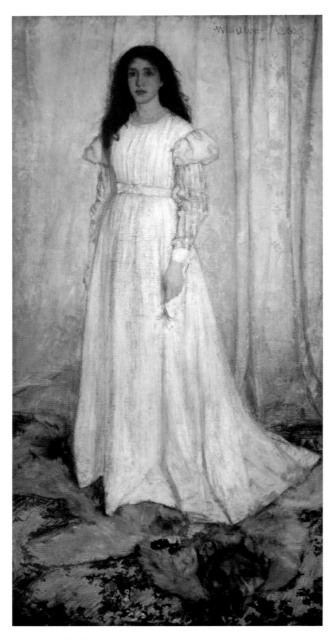

James McNeill Whistler, *Symphony in White No. 1, The White Girl* (1862).
PHOTO COURTESY OF WIKICOMMONS BY EASTTN.

was not sold, though Whistler might have taken some comfort in the fact that it did gain attention, albeit entirely negative at the time.

What constituted good art during this period in London and Paris was consistent—the Neoclassical likes of Ingres and David (which Greuze had foreshadowed with his failed 1769 submission) were still what was predominantly taught and appreciated. Saccharine, melodramatic works were in favor, the likes of John Everett Millais's *Trust Me*, which shows an aristocratic man in hunting uniform holding out his hand to retrieve a letter that a young woman, perhaps his daughter, hides behind her back.[24] A realistic, unpainterly painting that allows viewers to "read" a whole soap operatic story into it was à la mode. The most popular painting of the era in London was *Derby Day* by William Powell Frith, a work that took him fifteen months to finish and was called "the definitive example of Victorian modern-life genre."[25]

Whistler's *Woman in White* does not differ as much at second glance from these most popular works at the time, the ones showered with praise when shown at the academy exhibition. Frith and Millais offer genre paintings of everyday Victorian life, with many details to unpack and plots and character studies to "read." In this way, they mirror Dickens novels. Whistler's work is far more stark, minimalist, not only in terms of painting style (that impressionistic finish, the painterly brushstrokes visible), but also in terms of offering nothing but the model, standing atop a wolfskin rug, against a white curtain, not in a realistic room or space. Viewers are not peering at an unfolding drama but are clearly staring at a posed model. There is a literal resonance in the title—the mystery novel *The Woman in White* by Wilkie Collins had been a sensational hit when it was released three years before, in 1859. But it is not a scene illustrated from the novel, but rather a posed portrait resonant with it. The title of the painting would inevitably summon the novel in the minds of viewers, and it was up to them to interpret anything further. This was a step too abstract, stylistically and intellectually, for the preferences of the time.

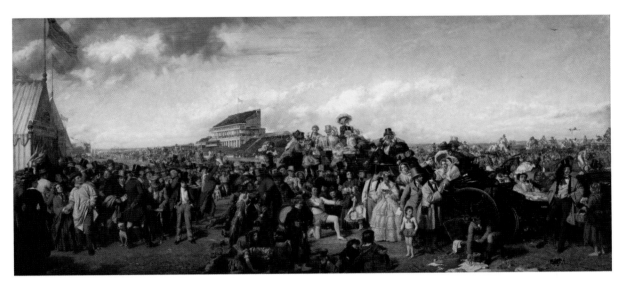

There were also details that seemed indecorous to prurient Victorians. This model was not dressed formally but was clearly someone being painted at home, in a casual dynamic with the painter. She is shown wearing a light summer dress (called a cambric), which was for spending time at home in warm weather—not acceptable for the public. Victorian women wore their hair in tightly done-up buns, not down and loose, as the model has here. Her face looks blank, not trying to win us over or indulge, and it is up to us to read expressions into her face, rather than her catering to us with obvious emotion. These may seem like subtle and unimportant distinctions now, but they were problematic for Victorian viewers.

Whistler did not seek scandal (that is why his story is not in our section on shock), but the work he fervently believed in made waves because his confidence pushed it forward. Had he slunk away after the initial rejection from the Royal Academy exhibition, that would have been one thing. But he turned around and showed the work at a commercial gallery, trumpeting its rejection in the catalogue, and that is what flustered many.

His American confidence encouraged him further, and he submitted the same work to the 1863 salon in Paris. It was rejected there as well. And so he tried again, now at the Salon des Refuses. Courbet and his fellow organizers accepted it, and it was displayed beside the most scandalous work shown there, the work that was the talk of Paris and beyond and makes for a stark contrast to *The Woman in White*, for the two are of similar artistic quality and style, but of a very different agenda. For on the same wall of the Salon des Refuses stood *Le Déjeuner sur l'herbe* by Edouard Manet.

William Powell Frith, *Derby Day* (1856–1858). PHOTO COURTESY OF WIKICOMMONS FROM ART UK.

## Manet and the Prostitutes

The informality of the model in *The Woman in White* is taken a large step further by Manet's *Luncheon on the Grass.*

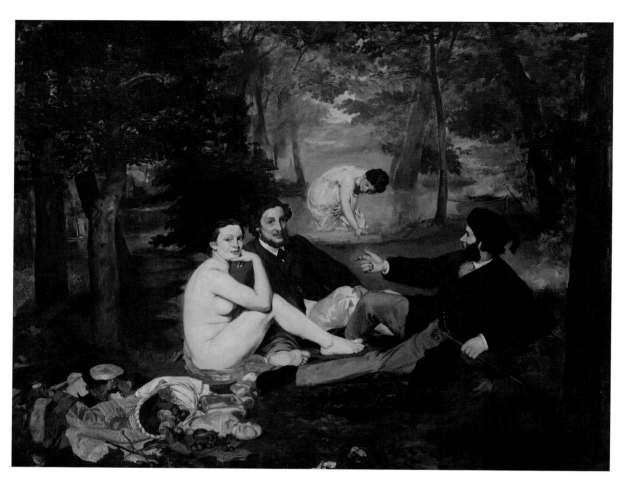

Edouard Manet,
*Le Déjeuner sur
l'herbe* (1863).
PHOTO COURTESY
OF WIKICOMMONS
FROM GOOGLE ART
PROJECT.

Originally called *Le Bain* ("The Bath"), this large-scale painting was designed to shock, and so it could fit into our next chapter. The obviously odd element is precisely what caused such a fuss. What is a naked woman doing sitting at a picnic in a park with two clothed men? One might think it would have been more scandalous had the men also been naked, but that would have projected a sense of equality of class, perhaps even a reference to the classical world or mythology, with idealized nude gods and goddesses frolicking. But here, in the context of Victorian-era Paris, it broadcast a single message to audiences: This painting pulled aside the veil and showed a prostitute—or perhaps two, if we include the scantily clad woman wading in a stream in the background—and a pair of johns.

The two men, well dressed in a dandyish manner, are engaged in lively conversation and seem to ignore the woman. But the woman makes eye contact directly with us, confronting the viewers and forcing them to stare back, though Victorian prudery instilled the idea that they should not let their gaze linger on nudity, at least not in the public context of an art exhibition. The canvas is substantial (81 x 109 inches), of a scale

normally reserved for "important" subjects like religious or mythological paintings. The brushstroke is present—the style is painterly, which was not preferred at the time. While it is not clear from historical documentation whether Manet sought to shock or simply to use this painting to comment and provoke debate (a milder intention), it certainly raised eyebrows and stoked outrage.

Prostitution was rife in this period throughout Europe, but it was not discussed. A skin of propriety was of the utmost importance, and what one did behind the scenes should never come to light. Thus, to essentially point out the prevalence of prostitution among the apparently high-class public was a step too far. The work is not realist, as the naked woman was not a prostitute. It was Victorine Meurent, a redheaded model nicknamed "the shrimp" for her petite size; she would also play the role of an empowered female prostitute in Manet's later work *Olympia* (begun shortly after *Déjeuner sur l'herbe* was finished, in 1863, and displayed at the 1865 salon, which by that time exhibited surprising liberalism in selection). Another aspect that dismayed Victorian viewers is the confidence, the strength, the empowerment of a prostitute. Sex workers were expected to be ashamed of their profession (acting out the shame that their johns perhaps should have been feeling) and were meant to be submissive. Not only are Manet's painted prostitutes present, highlighting this aspect of society that was meant to be hidden, but they were brash and powerful in their sexuality, the opposite of what was expected of them. That power is most evident in the eye contact that the nude seems to make with the viewer— this is the case in *Déjeuner sur l'herbe* and *Olympia.*

The great minds of Paris weighed in on Manet's work. Zola wrote of the painting as "the greatest work" of Manet.[26] The great novelist was so inspired by the work that he modeled his novel *L'Oeuvre* on the story of Manet showing at the Salon des Refusés. Proust recalled spending time with Manet by the Seine when they saw a young woman bathing in it. Manet said to Proust, "I copied Giorgione's women, the women with musicians. . . . It's black, that painting. The ground has come through. I want to redo it and do it with a transparent atmosphere with people like those we see over there."[27]

Prostitution has been an important part of life and culture throughout human history, but it was rarely something that was permissible to speak about in a public way. Art has occasionally transcended this unspoken boundary, and scandals have ensued. Caravaggio's *Madonna of Loreto* (1603–1605), mentioned in the introduction for the artist's very intentional use of a prostitute as the model for his Virgin Mary, is a case in point. Engagement with prostitutes was the norm in nineteenth-century Paris, but it was simply not something one talked about. Pictorial equivalents, paintings meant to titillate, were likewise acceptable if consumed in private: Ingres's *La Grande Odalisque* (1814) and Jean-Honoré Fragonard's *The Shirt Withdrawn* (1770) are other examples of works that are, simply put, sexy, and would have been fine for exclusively private consumption, but which crossed a line in public opinion. *La Grande Odalisque* was also scandalous because of the overtly, intentionally distorted nude body it featured—an almost grotesque departure from the academic style of Ingres's teacher, David. The most overt of all is Courbet's *L'Origine du monde* (1866), a naked woman with her legs spread, no part of her visible but her pudendum—this was just too realistic, and was meant to shock, as we will see in the next chapter.

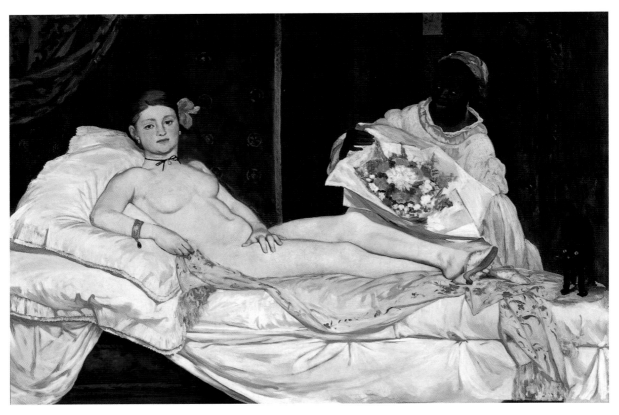

**Edouard Manet,**
*Olympia* **(1863).**
PHOTO COURTESY
OF WIKICOMMONS
FROM GOOGLE ART
PROJECT.

Manet's choice of subject matter was topical and of the moment, and he would stick with it in his next significant painting, *Olympia*.

It was exhibited in the 1865 salon (not the Salon des Refuses). *Le Déjeuner sur l'herbe* had been rejected by the salon, but in this case the technical brilliance of Manet and the direct reference to important works of art history (Titian's *Venus of Urbino* and Ingres's *La Grande Odalisque*), coupled with Manet's popular and critical interest (in no small part fueled by *Le Déjeuner sur l'herbe*) as well as his society connections (his father was a judge and chief of staff at the Ministry of Justice, and he had studied under an admired academician, Thomas Couture), led to its acceptance in the main salon.[28] *Le Déjeuner sur l'herbe* had broken the ice with a nude painting of a prostitute, and so this second one, very different but of a similar category, was less shocking. But it would make even choppier waves.

It shows Manet's frequent model Victorine Meurent as an empowered prostitute, Olympia, approximately life-sized, lying naked—aside from a bracelet, sandals, and a choker—on an elaborately unmade bed. A maid brings her a grandiose bouquet of flowers, doubtless from a male admirer. A green curtain is pulled aside behind her, a reference to backgrounds in many a Renaissance portrait of a noble or member of the clergy, which were frequently set again a lush velvet curtain pulled off to one side, as if standing in front of a theatrical set. (The most direct inspiration was Titian's 1534 *Venus of Urbino*, but

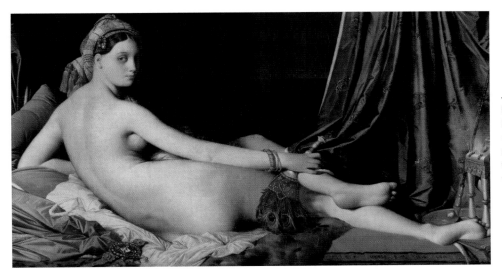

there is a long tradition of elegant reclining nudes throughout art history, with Ingres's 1814 *Grande Odalisque* the one likely to be freshest in the memory of the Parisian public.)

Olympia is shown full of power, seeming to make eye contact with the viewer, who, it may be inferred, is the male admirer who sent that bouquet—her latest john. She is clearly a very high-class prostitute, but she offers her naked body and stares at us with a mixture of emotions that can be read into her eyes. Her posture suggests power and comfort in nudity—she recognizes that her sexuality is her strongest attribute. But her eyes contain a softness and unhappiness somewhere deep inside them. She would not have chosen her profession, had she another viable choice, but she has decided to make the best of it, to own it rather than let it own her.

The scandals produced by this painting were manifold. As in Caravaggio's *Madonna of Loreto*, the model was a known figure. Victorine Meurent was a society woman, a model in many well-known paintings and also a fine painter herself (some of her works were likewise shown at the salon). To portray a known, respected figure as a prostitute was one issue. But more theoretically, it was considered indecorous that a recognizable contemporary woman should stand in for a mythological or historically significant figure. This is, after all, a sort of Venus picture, and as it was objectionable to have a known prostitute used for the Virgin Mary, so it was problematic and new to have a recognizable model as Venus.

The inclusion in the main salon further fueled the scandal. It was one thing for *Le Déjeuner sur l'herbe* to appear in the Salon des Refuses—that was the *other* salon, and the more conservative element dismissed what it included as of secondary importance, anyway. But now the main salon included a work that appeared even more overtly on point, and those who objected might well have seen a mirror held up to their own frequenting of prostitutes like Olympia. There were calls for the work to be burned, and one journalist wrote, "If the canvas of the *Olympia* was not destroyed, it is only because of the precautions that were taken by the administration."[29] Another wrote of its "inconceivable

vulgarity," while elsewhere it was written that "art sunk so low does not even deserve reproach."[30] Manet complained to his friend, poet Charles Baudelaire, that "insults rain down on me like hail."[31] But Émile Zola, champion of *Le Déjeuner sur l'herbe,* called *Olympia* Manet's masterpiece, and he recognized its scathing honesty: "It will endure as the characteristic expression of his talent, as the highest mark of his power. . . . When our artists give us Venuses, they correct nature, they lie. Edouard Manet asked himself why lie? Why not tell the truth; he introduced us to Olympia, this daughter of our time, whom you meet on the sidewalks."[32]

Both *Olympia* and *Le Déjeuner sur l'herbe* went on to be considered among the most important in the history of art and feature in any Art History 101 course. *Olympia* was, stylistically and in terms of content, indicative of its time, which is usually the key to a work's endurance. Such masterpieces offer time capsules. By examining them, we can travel back to a specific place and time long past, and understand it from all disciplines through the lens of a work of art. The "scandalous" nature of it, in this instance one of those more gossipy, sexually charged, "isn't it simply *scandalous*" reactions—rather than the deeper, darker issues surrounding, say, the degenerate art exhibition—helped its notoriety and extended its influence. It was a double scandal: To conservatives, the very fact that it appeared in the salon made it problematic. But among those who jostled to admire it, another scandal arose, borne of interpretation of an intentionally riddling work, but one the theme of which was clear enough, peeling away the skin-thin veil to show the taboo subject of the time and place: prostitution. One could argue that Manet was intentional in his scandalousness, making this fit our category of shock. But he was not as brash a figure as Courbet. This is more in line with a version B scandal, doing your own thing and telling it like it is, than an attempt to stir up publicity through a shock bomb.

The Salon des Refuses proved an important touchstone for the legacy of art from 1863 forward. Before that date, art was chained to the academy system. Academies in various cities and countries taught what they (usually the state) considered to be good and appropriate art, and anything that fell outside of its institutionalized definition had a much harder time finding audiences. The Salon des Refuses was no guerilla rebellion but was officially mandated by the emperor, and yet it announced that academies no longer held monopolies on what art could and should be. This lesson emanated from Paris throughout Europe. From that point forward, it was no longer the mark of sophistication to be an "academic painter" but, in many cases, it was considered old-fashioned and stodgy, and the artists of the avant-garde would not have even wanted to be associated with an academy. That it was an official, imperial mandate also helped legitimize the artistic styles shown there, giving wings to the new movements that were first shown in later Salons des Refuses (in 1874, 1875, and 1886), most notably Impressionism. Seeing the writing on the wall, the Académie relinquished their control over what could be featured in the salon in 1881, yielding the decision-making to the Société des Artistes Français (Society of French Artists), which was more democratic and functioned more like a union. Other alternative salons rose up in an unofficial capacity. Pointillist painter Georges Seurat established the Salon des Indépendants in 1884, and

the Salon d'Automne followed in 1903. These newer salons were less rebellious, since they followed the footsteps in the fresh snow of the Salon des Refuses, and so they were not considered scandalous.

## Koons, Leaks, and Misunderstandings

Version C involves something private "leaking" and resulting in public moral outrage. In the realm of news, this could be anything from a senator's wiener being photographed and sent to a "friend" to just about anything from Wikileaks. In art terms, this sort of scandal is more often associated with the trade—consider the various scandals involving Sotheby's (though Christie's was also implicated multiple times) in selling illicit antiquities, or indeed of major museums, most frequently the Getty but also the Met and scores of others, involved in buying them. These scandals initially broke when experts in looted art spotted objects in auction house catalogues that appeared to match objects listed as missing by police. In the case of the Getty's acquisition of looted antiquities, including famous pieces like the so-called Getty Aphrodite, it was not a question of whether the artifacts had been looted but of whether the Getty knew they were looted and acquired them anyway. This was proven by investigative journalists who found internal e-mails proving as much.[33]

An alternative version C scandal can be found in the outrage born of an inaccurate understanding of art world traditions, when "revelations" that major artists, like Damien Hirst and Jeff Koons (the two highest-earning artists in the world), are not actually involved in the physical assembly of most of the art they produce.[34]

News broke in 2017, via a leak from a fired worker, of a scandal involving Koons laying off much of his staff.[35] In a series of downsizing moves, Koons fired some thirty members of his painting staff, which at one time numbered one hundred. This was the third round of layoffs since 2015. Most of those painters were brought on to work the *Gazing Ball* series, in which they hand-copied thirty-five Old Master paintings, to which a shiny, metallic colored sphere was added. There were grumblings that they were vastly underpaid (*Artnet* reported that some were earning just $21 per hour, while Koons's works fetch millions at auction).

But what surprised (and scandalized) many was not that Koons would so underpay the people actually creating his works, nor that he would downsize his staff, but rather how an artist produces works that are labeled as his own when he may not actually have any hand in their making. Much was made of a series of Damien Hirst paintings because he had actually painted them all himself.[36] This may indeed sound like an odd statement: Don't all artists create their own works?

This is actually part of a long art historical tradition, and it is not in the least unusual or surprising. We have the Romantic era, with a dose of Giorgio Vasari's *Lives of the Most Eminent Painters, Sculptors, and Architects*, to thank for the general misconception that major professional artists create their works alone. The idea of the lone brooding artist, possibly depressed and drinking absinthe in a Parisian garret while wearing a black beret

and chain-smoking, is actually the oddity. Most professional artists through history ran studios, often called bottegas.

To understand how studios work (and worked), we might look at a Renaissance master—or we might look at one of the most popular painters in the world, though nary a critic would raise their eyes to give him the time of day: Thomas Kincade. The "Painter of Light," as he is sometimes called, employs an army of staff to paint his mildly cheesy, homey landscapes, the artistic equivalent of the Saturday afternoon made-for-TV Christmas films on Lifetime. Depending on how much you wish to pay, a sliding scale of options depend upon how directly the master himself would be involved in your commission. You could get a work entirely hand-painted by Kincade himself for a small fortune, or for very little money you can get a work designed by the main man but painted entirely by staff.[37] For even less money, you can buy a print of one of his paintings, touched up with hand-painted "highlights."

This is simply a continuation of the tradition of great Renaissance artists, like Domenico di Ghirlandaio (whose work opens chapter 3). Commissioning a work by Ghirlandaio did not mean that the master would paint the work entirely himself, but rather that it was the product of his studio. The more one paid (or the more prestigious the patron), the more the master would work on the painting hands-on.

Jeff Koons is best known for his monumental sculptures resembling balloon animals but made of glossy metal. But for most of his works, he might best be considered a conceptual artist in that he conceives of the works and designs them, but he rarely actually participates in their creation on a hands-on basis. For this, he employs a vast staff, making him perhaps more like an architect than our traditional image of an artist.

Vasari's 1550 *Lives*, considered the first work of art history, is originally responsible for our idea that an artwork is the complete creative expression of a single mind and hand. Most of how we think about art and museums today has its origins in Vasari's hugely popular and influential group biography of Renaissance artists, many of whom he knew and worked with. By featuring masters of studios and weaving a cult around them, he downplayed the collaborative aspect of their work—this may have been a sort of defense mechanism, as he was sometimes accused of being lazy and relying too much on his own assistants. Then the Romantic era promoted the idea of lonely, forlorn, brooding artists struggling to make ends meet but producing powerful art at great personal sacrifice. This idea has melodramatic appeal, and it stuck in the popular imagination. While it has been true for many artists, particularly those in the modern era, before they make it big, the truly big-name artists, from ancient times to the present, have been more like architects or film directors, designing and supervising but not always getting their hands dirty.

It requires knowing the history of art to realize that there really is no "scandal" in Koons, Hirst, or any other artists employing staff to create the works that they may only design and supervise the completion of. But for the underinformed public, assisted by engorging headlines run by clickbait-seeking media, it can become a scandal of our C variety.

Scandals in the art world can take many forms, and sometimes the line between inadvertent scandal and intentional shock is unclear. It also may be seen as an unimportant distinction, one that is purely academic. The distinction for the public may simply be that

what befell the artist was either out of their control, making them essentially innocent, or that they were "asking for it" by proactively seeking to scandalize through shock tactics. The main conclusion, however, is that, whether scandal or shock, these two traditional negatives were both positive for artists and their legacies. They provided promotion and did not bring about long-term ruination, so many would argue, based on this evidence, why not scandalize?

## Malevich and Attention Seeking

It is difficult to say whether there are some artists whose careers would have gone largely unnoticed, and certainly not included in the canon of artists to be studied, had they not been involved in a scandal. That game of "what-if" altered history is too speculative to reasonably play. But there are some artists who are known beyond art historical circles largely because of the "I can't believe they did that" effect. Their actions fall into the shock category. Consider Sebastian Horsely, an artist whose merit is arguable but who is known primarily because, as a work of performance art, he arranged to have himself crucified (but only for twenty minutes—after which he was efficiently uncrucified and attended to by doctors). This is actually very interesting in terms of the history of art, since entire books and courses can and have been taught and written about artwork of Christ crucified. But whether arranging to have oneself crucified qualifies as significant art or is merely attention grasping is another matter.[38]

In many examples it is too tricky to distinguish between scandal and shock. They might fall into the category of "they should have known," but the actions of the artist were designed to make a statement, not primarily to shock.

Kazimir Malevich's *Black Square* (1915) was hung in a high corner of a room at the Dobchina Art Bureau gallery space when it was first displayed.

This odd location made it more resonant, as this corner by the ceiling was where, in traditional Russian homes, gilded religious icons were hung. Malevich's concept was to replace the icon (formal, stylized paintings of saints against gilded backgrounds) with his anti-icons, stripped of any formal imagery. Placing his anti-icon painting in the space where a traditional religious icon would hang further hammered home his point. This was a form of iconoclasm (destroying or defacing icons), but a subtle one—although not subtle enough to avoid enraging the clergy and the masses. He surely knew that this would scandalize religious conservatives, but it cannot be said that he did this in order to shock. It was entirely in stride with his artistic concept, and that this was considered scandalous (more so than had he simply displayed *Black Square* in the middle of a gallery wall) was a side effect of his following his artistic vision.

Sometimes the public gets their knickers in a twist for reasons that are not logical. They are more about a general frustration at not getting a work of art, and resulting aggression, lashing out against it to compensate for a feeling of inferiority because others seem to get it, and if I don't then perhaps I'm not smart enough. This happened often with the married artists Christo and Jeanne-Claude.

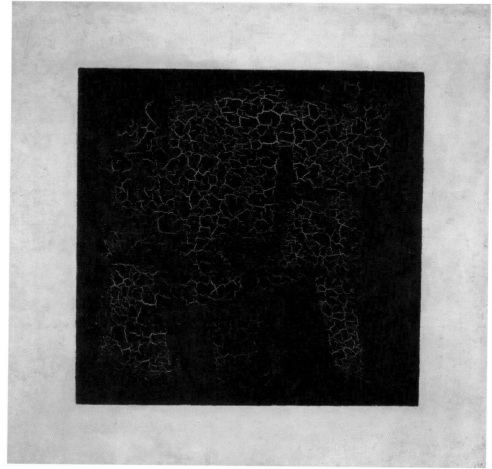

Kazimir Malevich, *Black Square* (1915). PHOTO COURTESY OF WIKICOMMONS FROM TRETYAKOV GALLERY, MOSCOW.

The couple are famous for large-scale public temporary installations involving huge swaths of fabric: wrapping the Reichstag in Berlin or the Pont-Neuf in Paris with cloth, for instance. They would plan these installations years, sometimes decades, in advance, because of the time it took to navigate the bureaucracy required to pull them off in famous public spaces. Christo has always paid out of pocket for his installations (the money he earns from selling his work is reinvested in future projects), and he has never accepted public funds, but that has not stopped conservatives and enraged taxpayers from trying to block his progress. Before he could wrap the Reichstag (1995), he was obliged to fully wrap two other buildings, so authorities could see what it looked like. His *Surrounded Islands* (1982) installation met angry protest from ecologists, concerned that the floating pink fabric around the Florida islands would disturb wildlife. The main objection was from people who didn't understand why anyone would want to create such installations—Christo liked to call them "gentle disturbances"—and the confusion was only multiplied when it was clear that the artist paid for everything, at the cost of millions,

and spent years in legal battles in order to bring artworks to a public that largely seemed in principle against them.[39]

On other occasions, an artist might expect a scandal and even court it, but it rears its head in a place the artist did not expect. Czech artist David Cerny's *Shark* (2005), a riff on Hirst's *The Physical Impossibility of Death in the Mind of Someone Living* (1991), swapped out a pickled shark floating in a tank of formaldehyde for a lifelike model of a nude Saddam Hussein. Critics objected to the work as overly humanizing Hussein, causing a scandal but of a different sort than the artist predicted. The same work was removed from an exhibit in Poland by Polish vice president Zbigniew Michniowski on the grounds that it insulted religion. This confused the artist, who said, "I don't get it. I know that in Poland it is illegal to insult anyone's religion. Okay. Now what about the character in *Shark*? I mean, is Saddam Hussein a religious figure? Does anybody worship him? Do the Poles put Saddam on the same pedestal as Christ or does this just reflect the ignorance of a couple of politicians?"[40] It was meant to shock, of course, but this work shocked in ways that the artist had never imagined.

## Bronzino and Shifts in Morality and Politics

Scandals can rise with the passing of time and new moral and aesthetic rules that accompany them. In Victorian London, Bronzino's *Allegory of Love and Lust* (1545) was considered too sexy for public consumption, and the extended tongue and bottom of Eros and erect nipple of Venus were painted over (they were only revealed in a conservation of the painting in 1980s).[41]

Prudishness was often to blame for such scandals in the name of censorship. Pope Paul IV was known for being an utter prude, and he did not approve of all this nudity found in the art of the papal collections. So, he ordered the "naughty bits" to be covered over—in the case of Michelangelo's *Last Judgment* (1534–1541), drapery was strategically added, very much against the will of Michelangelo, whereas fig leaves were affixed to key anatomical points of nude sculpture like the Apollo Belvedere, a process begun in 1541 under Cardinal Carafa and Monsignor Sernini, the Ambassador of Mantova.[42] Centuries later, this censorship of visible extremities was continued by Pope Pius IX (ruling 1846–1878), who had genitalia chiseled or smashed off of statuary.

Thus several popes were scandalized by seeing all of these penises in the Vatican, and art lovers—both contemporary (Michelangelo, for instance) and subsequent—were scandalized by the fact that popes had ordered great artworks adulterated by drapery and fig leaves and mutilation because of squeamishness. After Michelangelo died in 1564, his pupil Daniele da Volterra was ordered by Pope Pius IV to add those draperies (usually described as "breeches"), which led to him acquiring the nickname Il Braghettone, "the underwear maker." He further had to entirely remove the figure of Saint Blaise and part of Saint Catherine because viewers thought their relative positions suggested sexual intercourse, and Saint Blaise appeared to be staring at Saint Catherine's bottom.[43] In a parallel mini-scandal, a plaster cast of Michelangelo's *David* was sent as a gift to Queen Victoria

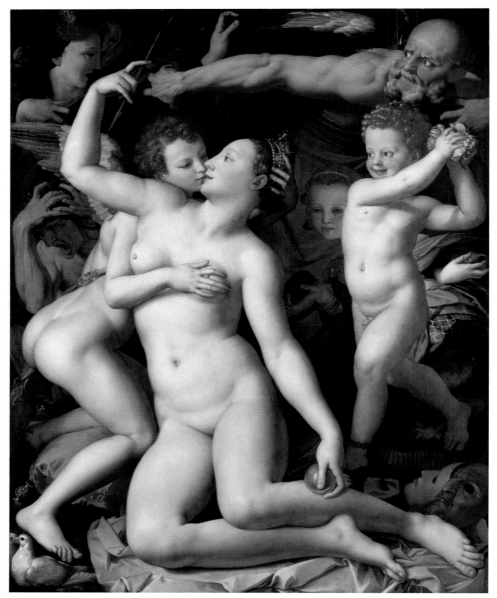

Bronzino, *Allegory of Love and Lust* (1545). PHOTO COURTESY OF WIKICOMMONS FROM NATIONAL GALLERY OF ART, LONDON.

in England from the Grand Duke of Tuscany in 1857. The queen found the statue's nudity to be unsuitable for the morality of the time, so a plaster fig leaf was made and kept in storage at the Victoria and Albert Museum, which housed the cast, to be fitted into place whenever she visited.

The issue remains present today, though these days it is the prudishness and catering to it that make headlines more than the nudity itself that is covered up. In 2016, the Capitoline Museum in Rome put "modesty boxes" around classical nude statuary in its collection ahead of a visit by the president of Iran.[44]

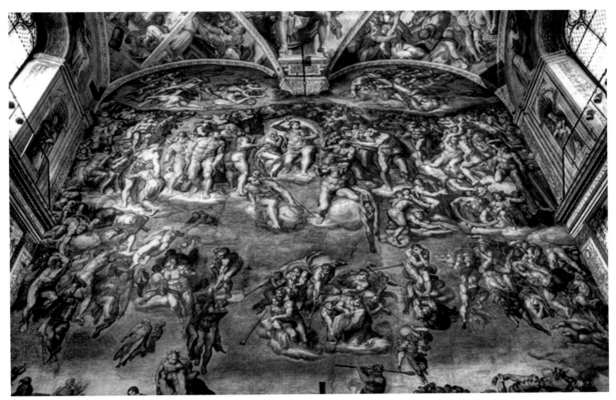

This history of Michelangelo scandals continued when the Sistine Chapel was subject to a hot debate born simply of what people were used to. In 1990, the chapel reopened after an extended cleaning of centuries of grime from the frescoes that decorate it. When visitors returned to the chapel, they were astonished to find paintings entirely different from the way they had been before, and had been studied, viewed, and understood for centuries. It was now so bright, the colors nearly neon—it looked far more like the proto-Mannerist masterpiece that it is, but to viewers who grew up admiring it covered in soot that made it dark, muted, and brooding, it looked all wrong, like it had been overcleaned or, even worse, touched up with new colors as a publicity stunt for Kodak, which sponsored the restoration.[45]

When politics slips into art, particularly in a subtle way, controversy can strike when those who feel accused by the commentary get it long after the fact. Théodore Géricault's *Raft of the Medusa* (1819) does not look like a painting rife with political commentary.

The scene of desperate sailors stranded on a raft after their ship sank is one of the greatest works of Romanticism. It shows the true story of survivors from the *Medusa*, wrecked off the African coast and stuck on a raft without any supplies for two weeks. One hundred fifty sailors began on the raft and only ten were rescued; they had survived thanks to cannibalism. But hidden within is a sharp political commentary that was ill met. The painting became the center of a debate between royalists (pro-monarchy) and

Michelangelo, *Last Judgment* (1536–1541).

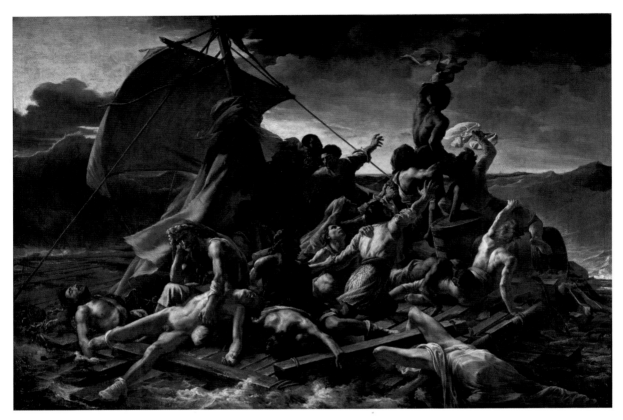

Théodore Géricault,
*Raft of the Medusa*
(1819). PHOTO
COURTESY OF
WIKICOMMONS,
PHOTOGRAPHER
UNKNOWN.

antiroyalists (Bonapartists, who favored the rule of a relative of Napoleon). This was because the ship that saved them, to which they desperately wave as it appears, hopelessly tiny, on the horizon, was a British ship, *Argosy.* When the painting was shown at the salon in 1819, it was almost universally denounced—not for its artistry, but because of the message they felt that it sent.[46] King Louis XVII had appointed the captain of the *Medusa*, Duroys de Chamareys, whom many contemporaries viewed as inept—a disaster waiting to happen. And the survivors of the wreck felt that he had run the ship aground through his incompetence. This accusation indirectly confronted the king, whose favoritism, it might be argued, resulted in the disaster. And because it seemed to speak against the king, it seemed to favor the Bonapartists. As Julian Barnes wrote, "The *Medusa* was a shipwreck, a news story and a painting; it was also a cause. Bonapartists attacked Monarchists. The behavior of the frigate's captain illuminated a) the incompetence and corruption of the Royalist Navy; b) the general callousness of the ruling class towards those beneath them. Parallel to the ship of state running aground would have been both obvious and heavy-handed."[47] This political commentary is not recorded as having been Géricault's main interest in painting the work, but it became, in the popular consciousness, the only thing the work was about.

Public grumblings may also be heard about things other than the art itself, especially its value. Many are dismayed by the prices for which art sells, particularly nontraditional,

nonformal works that do not exhibit classical skill on the part of the artist but are sold for mind-numbing figures. The wealthiest artist in the world, Damien Hirst, was criticized for his sculpture of a human skull studded with 8,601 diamonds, *For the Love of God* (2007).

It was seen as a tasteless attempt to profit without regard for artistic content, particularly since he actually was part of the conglomerate that bought the statue, effectively reinvesting in his own creation. It cost £14 million (around $18 million) to make and was sold for £50 million ($67 million).[48] Hirst's 2017 Venice Biennale show, *Treasures from the Wreck of the Unbelievable* (which we examine in chapter 3), was likewise seen as a sort of shopping mall of art for the nouveaux riches, without much in the way of artistry on display.[49] But these low-level scandals, more gossip and dismissive mutterings than anything more elaborate, did nothing to inhibit Hirst's sales, and the critics had already weighed in, either in praise or in condemnation of the statues, so the controversy did not affect Hirst in any way beyond churning up more attention for him and his work.

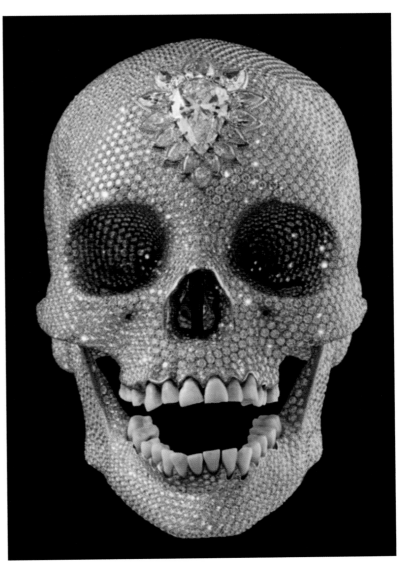

Damien Hirst, *For the Love of God* (2007). PHOTO COURTESY OF WIKICOMMONS BY USER AARON WEBER.

## "Bad" Artists and the Fame of Scandal

The extent of a scandal in the art world is directly linked to the amount of publicity it generates, which, in the modern era, is lashed to exposure in the media.

When scandal is negative for those involved, it is usually because the person scandalizing is already an established figure whom the public sees as trusted or morally upright, and that image is shattered because of the scandal. Whether it is a big company, like the chemical company in the water contamination case immortalized in *A Civil Action* or

Volkswagen in the emissions scandal, or a person, like a politician or member of clergy found to be lying or to be sexually aggressive, these are figures or institutions of authority who are supposedly setting strong moral standards to which we, the public, hold them.

Artists do not bear that burden. The clichés about artists include that they are liberal, edgy, and morally questionable and that they do things that are on the verge of good taste and sometimes even sanity. Every era has had its own moral boundaries, and yet artists were almost expected to confront and push beyond them. If there was ever a profession that was generally respected but that was considered liberal and off-the-wall enough to push moral boundaries, then it was that of the artist. So scandal did not have the same devastating effect on an artist's personal life or career as it might have in other, more traditionally upstanding professions. Rarely have artists been held up as beacons of moral virtue, the way clergy or politicians are. For this reason, the artists themselves rarely stand upon a moral cliff off which they can fall. If anything, they are already standing in the lowlands, sometimes with their feet a few inches down in the mire. Artists are almost always individuals (a few collectives aside), not associated with institutions. This means that from a moral standpoint, they really can only go up, and that they are not representing some larger power, company, or country that requires they behave "appropriately," whatever that might mean in a given era and situation.

Being a bad person, even a murderer, does not seem to negatively impact an artist's legacy. It only adds an asterisk to it, a whispered caveat. Caravaggio was a pugnacious murderer. Bernini ordered a servant to disfigure his lover's face with a razor and would have murdered his own brother in a jealous rage (regarding the lover) had his mother not intervened.[50] Hugo Boss may have been an enthusiastic Nazi, but he was a wonderful fashion designer (for their infinite faults, the Nazis were smart dressers), and we continue to buy clothing that bears his name because we like the way it looks, choosing to overlook the politics of the founder of the company. Charles Lutwidge Dodgson, aka Lewis Carroll, may have had interest in young Alice for very wrong reasons, but *Alice's Adventures in Wonderland* is still praised and beloved.[51] British sculptor Eric Gill was a pedophile who serially abused his own daughters, but his statues are admired and he is considered a brilliant typographer (you will certainly have read many a text printed in his Gill Sans, with variations, and Perpetua fonts, which are staples of Microsoft Word and ubiquitous in global printing).[52] Artists can do bad things, even be objectively bad people, and yet we still tend to look upon their art in a vacuum, gazing past the misdeeds, mentioning them only in passing, if at all.

Past eras considered the role of artists somewhat differently from the way we do today. In the Renaissance and Early Modern periods, some artists were members of court, or adjunct members (summoned to fulfill commissions), and were expected to behave with politesse in keeping with the standards of their environment. Artist guilds likewise kept behavior somewhat in check. These were periods of more rigid etiquette, but what went on behind the scenes, as long as it remained behind the scenes, was fine. Depraved behavior was rampant in the shadows and behind locked bedroom doors. The "age of morality" really came to the fore in the nineteenth century, with the Victorian era—the story of *David* being fig-leafed to "protect" Queen Victoria is a case in point. Morality

became both a sword and a shield, something that immoral people could hide behind while wielding accusations of immorality as a weapon.

This was also a time when mass media was establishing itself through newspapers. This allowed a scandal that might otherwise have been limited to a specific locality, or even to the small group of individuals affected, to reach the widest possible audience, even spreading out internationally. This infinitely expanded not only the promotional possibility of scandal but also its potential devastation, exponentially increasing exposure to news, and therefore scandals, which have always been popular reads. The only farther leaps, in terms of the spread of information after the age of newspapers, was television in the 1960s and the internet in the 1990s. The internet era democratized breaking news and commenting on it. It was no longer the realm of editors and professional journalists and critics; now anyone with an internet connection could weigh in. This has resulted in far more scandals (not all of them real) coming to light, but it has also diffused the impact of any one scandal. There is now such a tidal wave of information available that scandals are often forgotten within a matter of days as newer news takes its place. This is the case in the art world as well as the general news cycle.

On August 29, 2019, news broke of a "scandalous" statue erected in a village in Slovenia. It was called *Kip Svobode* (*Statue of Freedom*), but it bore a suspicious resemblance to President Donald Trump portrayed as a colossal wooden nutcracker. The artist, Tomaž Schlegl (full disclosure: he is a friend of mine), was surprised with the avalanche of media interest. After the story broke in a *Washington Post* article it was picked up by hundreds of media outlets, large and small—in print, online, and televised—around the world.[53] But in a matter of weeks, it was already old news. When it was threatened with destruction by upset local conservatives, it no longer qualified as newsworthy, and none of the journalists contacted who initially reported on the statue's existence decided to follow up on the story and report on its new twist.[54] The statue was designed to shock (we will examine it in the next chapter), but the waves did not echo beyond announcing its existence. At least, that is, until it was destroyed—and once again was newsworthy. This is indicative of news in the internet era, in art and beyond.

Particularly during the age of international media, which coincides with the morality of the Victorian age, a scandal could make someone instantly a household name around the country and, in fact, in much of the world. The upset about a scandal involving art tends to recede quickly, but the name of the artist involved resounds and endures, not only during their career, but well beyond it. In this way, a scandal helps extend an artist's long-term name recognition and reputation. Some artists were damaged in the short term but found scandals beneficial to them in the long run. It is difficult to think of any artist who was involved in a scandal that proved their absolute ruin both in the short and long term.

# CHAPTER 2

# Shock

In 1917, the Cubist painter Marcel Duchamp took a factory-made urinal, turned it on its side, signed it with the name of an invented artist, "R. Mutt" (a joke, as Mott was the name of the company that mass-produced the urinals), and claimed that this "sculpture" was a great work of modern art.[1]

It was part of a new type of art that he called a "readymade," the first of which was his 1914 *Bottle Rack*, which, as the name suggests, consisted of a rack for bottles. Duchamp, who had moved from Paris to New York in 1915, arranged to have a young woman submit *Fountain* to the Society of Independent Artists, a group he had cofounded as a New York–based answer to the Salon des Indépendants in Paris. It was claimed that R. Mutt was the sculptor, and Duchamp did not, at the time, reveal that he was behind it. The young woman was likely Baroness Else von Freytag-Loringhoven, who may have been the actual originator or cooriginator of the urinal-as-sculpture concept.

The initial response of the society board of directors was that this urinal was not a work of art. They also deemed it indecent for display, as it brought the image of urination and excretion to mind, which was best left a private matter not dragged into the light. The sculpture was proposed for a society exhibition at the Grand Central Palace in New York, scheduled to open on April 10, 1917. By a narrow margin, the board decided not to include *Fountain* in the show. Outraged, Duchamp and another board member, collector Walter Arensberg, resigned on the spot.

This had been, in part, a test of just how democratic this new society would be. Back in 1912, one of Duchamp's greatest works, a Cubist painting entitled *Nude Descending a Staircase, No. 2*, was accepted at the Salon des Indépendants in Paris and was featured in the catalogue. But the salon organizers grew concerned that the subject matter was too risqué. They did not have the cojones to confront Duchamp directly about this change of heart and instead asked his brothers, also artists, to ask him to voluntarily withdraw the painting prior to the opening of the show. He did this and did not make a public fuss, but it infuriated and disappointed him, and he would go on to describe this as a turning point in his life. That Cubist painting was not made to shock. It did not cause a scandal at the time because it was not shown at the salon, in the end, and Duchamp did not make

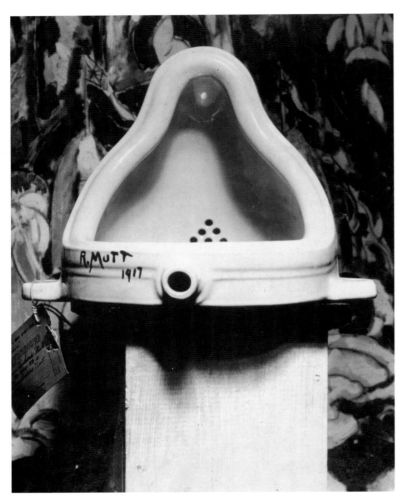

Marcel Duchamp, *Fountain* (1917). PHOTOGRAPH BY ALFRED STIEGLITZ, COURTESY OF WIKICOMMONS FROM NPR.

a ruckus about having to withdraw it. He just burned on the inside, and determined to crash this world of art. He was no longer interested in the medium of which he was undoubtedly a master, Cubist painting, but instead shifted his interest to themes and media that were iconoclastic. He would blow down the barriers of what art could be. Shock would be his weapon of choice.

The society was enthusiastic about democratizing art exhibitions. Artists would hang or situate their own works in the gallery. The works would be displayed in alphabetic order of the artist's surnames, so there could be no favoritism on the part of curators. Art submitted by members of the society would be shown without passing by a jury—all that was required was a $6 membership and entry fee. This meant that the decision by the board not to show *Fountain* went against the founding principles of the society. The board claimed they blocked its inclusion for reasons of moral decency rather than artistic merit, but it was blocked all the same. By offering up an intentionally shocking, provocative readymade, Duchamp had put the liberalism and open-mindedness of his fellow board members to the test. In his mind, they failed, though the vote to exclude the work was a narrow one.

A few days after the Grand Central Palace exhibition opened, on April 13, 1917, Duchamp retrieved *Fountain* from storage and brought it to be photographed by Alfred Stieglitz, the star photographer of New York at the time. A photograph was taken on April 19 (and the original *Fountain* was subsequently lost), and that photograph managed to shift opinions on the work. Stieglitz wrote in a letter on April 23, "The 'Urinal' photograph is really quite a wonder. Everyone who has seen it thinks it beautiful. And it's true, it is. It has an oriental look about it. A cross between a Buddha and a Veiled Woman."[2]

Was Duchamp laughing to himself about making a mockery of the art world? The answer is complicated. He was not trying to show that the emperor wears no clothes but instead to detonate what the public considers clothing fit for an emperor. The Dadaist

magazine Duchamp cofounded, *Blind Man*, published an anonymous article (likely penned by Duchamp) arguing the merits of *Fountain* as an artwork, along with Stieglitz's photograph. In it, we can hear Duchamp's rationalization:

> Mr. Mutt's fountain is not immoral, that is absurd, no more than a bathtub is immoral. It is a fixture that you see every day in plumbers' shop windows. Whether Mr. Mutt, with his own hands, made the fountain has no importance. He CHOSE it. He took an ordinary article of life, placed it so that its useful significance disappeared under the new title and point of view—created a new thought for that object.[3]

This article helped to sway some skeptics in favor of the work, as did Stieglitz's photograph of it. An artwork (a photograph) of a found object perhaps provided a filter that made it easier to see the readymade object as art in itself. The photographic print transformed the cold, practical porcelain into something simultaneously more sculptural (because it is more abstract) and more painterly (because of the grayscale of the black-and-white photo). Duchamp's iconoclasm was not shock just for the sake of it or just to garner publicity. It was shock designed to shake things up—shock with a positive purpose.

Duchamp was trying to make a revolutionary statement, and he succeeded. His claim was that anything an artist deems a work of art is, in fact, a work of art. The artist does not need to have created it himself. The traditional art historical criteria—that "good" art should exhibit artistic skill, that it should be interesting, and that it should be beautiful—was no longer relevant to the twentieth century, Duchamp claimed. Now an artwork only had to be interesting and provocative. Art was whatever an artist said it was.

Many people thought this ridiculous, but many others found this iconoclastic concept exhilarating. Duchamp's action can be considered a point in history when art split in two distinct directions, never to meet again.

Much ink has been spilled in debate over the relative merits of traditional art versus conceptual art, art in which the idea is of interest but the art itself may not be anything more than a conduit for the idea. The result was that twentieth-century art split into two distinct factions, each progressing in its own direction, one no longer comparable to the other. On the one hand there was the traditional, academic avenue, in which art is linked to the history of art and follows the traditional criteria. On the other hand, there was the Duchampian avenue, from store-bought urinals up to sharks in formaldehyde tanks. Anything could be art: It need not exhibit artistic skill and it need not be beautiful.

It must, however, be interesting and provocative. Many subsequent artists, one might argue *too* many, interpreted provocative to mean shocking, when the two are not necessarily the same.

## Aristotle and the Art Split

Before Duchamp's *Fountain*, great art was meant to fulfill three criteria, as described by Aristotle in his book *On Poetics*: (1) Art should be good, as in well-made and skillfully

executed, accomplishing what the artist set out to create; (2) art should be beautiful, a subjective conceit but implying either aesthetic or moral beauty that will inspire the viewer; and (3) art should be interesting, thought-provoking, mysterious, new, emotionally provocative.

From *Fountain* on, art split into two avenues. One avenue followed the traditional art historical road, in which all three characteristics were important. In this vein, newly created art was heavily influenced by past artists. There are still artists today who follow Aristotle's ideals, of course. We might consider John Currin or Kehinde Wiley as prominent examples. Most people see these works as "real" art and are dismissive of the conceptual work of artists like Duchamp, often with the tone of "if I feel that I could make a similar work myself, then it must not be good."

We are left with the two most important paths forward: the route that embraces the classical conception of art and the Duchampian route. This second avenue emanated out of Duchamp's new ideas, and said that art only had to be interesting, rejecting art historical influences. Most contemporary art walks the path that Duchamp began.

Works of a conceptual nature should be considered independent of the continuum of art history, not compared with, say, a Michelangelo sculpture, but rather taken in and of themselves. In the contest of "which is a better work of art" between a Michelangelo sculpture and Duchamp's *Fountain*, Michelangelo would win by a landslide. However, the two categories should not be placed in competition with each other—they require separate sets of criteria to evaluate. The key is not to compare the two styles of art directly but to consider each as its own field, each one brilliant and flawed. It is also key to understand that there is a difference between provocative and shocking.

First, the dictionary definitions: "provocative" excites appetite or passion, is a stimulant, is apt to incense or enrage, to provoke or excite;[4] "shock is the emotional or physical reaction to a sudden, unexpected, and usually unpleasant event or experience . . . a feeling of being offended or upset by something you consider wrong or unacceptable" or, making a metaphor out of the verb definition, "the effect of one object violently hitting another, causing damage or a slight movement" which, in art terms, swaps out "object" for "idea."[5] Artists always relate to their present times, whether they do so consciously or not. Great art has always provoked, avoided the mundane, and created something edgy that would summon up a reaction. Provocation is striving for a reaction. It is less violent than shock and tends toward the positive: exciting passion, even if the passion is rage. Shock is about feeling upset or offended because something is wrong, going against your morals or what you understand as right. It is easier to shock than to provoke. Shock is more of a blunt instrument. And in the art world, shock comes when one idea about what art is, can be, or should be hits against another, causing damage or slight movement. The only thing that no artist wants is no reaction at all.

## Cattelan, Ai Weiwei, and Art as Prison Break

The most talked-about conceptual artwork as I was writing this book was Maurizio Cattelan's *Comedian*.

Derivative work inspired by Maurizio Cattelan, *Comedian* (2019). PHOTO COURTESY OF WIKICOMMONS BY USER JANE023.

On his way to his own exhibit at the prestigious Art Basel Miami in 2019, Cattelan stopped at a Whole Foods supermarket and bought a banana. When he got to the fair, he used duct tape to attach the banana to the wall. That was the entirety of the work. The mundane silliness of this creation story is part of Cattelan's shtick. He loves to show that the emperor has no clothes, mocking the art world that has made him wealthy and famous. His titles bristle with irony, but they are also ingenious. He is not showing the middle finger just for the sake of it. He shows us the middle finger in brilliant ways. Consider *America*, his solid gold toilet displayed at the Guggenheim Museum in New York—in the bathroom. It is a functional toilet (the queues to use it—not just to admire

it, but to *use* it—are long). It comments elegantly and wittily on the commodification and rampant capitalism of America which, as Cattelan knows perfectly well, are what support his lifestyle.

*Comedian* is an example of shock art. Cattelan is a veteran. Perhaps his best-known work before this one was 1999's *The Ninth Hour*, a hyper-lifelike sculpture of Pope John Paul II having been struck by a meteorite—an "act of God" that made waves among upset Catholics and made Cattelan a household name.[6] It should be noted that, while *The Ninth Hour* is an example of shock art, it is also Aristotelian in that it is a skillfully executed sculpture. *Comedian* is neither beautiful nor does it exhibit skill, so it represents the Duchampian path. The artist was so hugely confident in his place in the establishment, that he could do no wrong, that he tested the theory. Cattelan claims he spent a year considering *Comedian*, first thinking he would make a banana made of resin, before it occurred to him that "the banana is supposed to be a banana."[7] It echoes his 1999 work *A Perfect Day*, in which he duct-taped a gallerist to the wall of his gallery.[8] It comments at once on the crazy prices for which art sells (there are three versions of *Comedian*, and each has sold to a collector for around $120,000—one wonders what happens as the banana rots), as well as the overblown prices of food, like a banana at Whole Foods (there is an *Arrested Development* episode that riffs off the joke that rich people don't know how much a banana should cost, guessing about thirty cents). It pays homage to Andy Warhol's painting of a banana, which was used for a Velvet Underground album cover. But then this work of shock art became the victim of another work of shock art, when Georgian artist David Datuna ate one of the bananas as a performance he titled *The Hungry Artist*.[9]

Cattelan's attitude, and his status in the art world, give him complete freedom. Anything he makes will be considered art of the highest caliber and will sell accordingly. He loves to flex this muscle, as he did in a literal escape act. In *A Sunday in Rivara* (1991), he gave strict instructions to be left alone; no one could come into the castle art gallery until the hour of the opening, including the gallery staff.[10] Not knowing what sort of installation or performance to expect, staff and visitors entered the gallery and walked from room to room. There was nothing there; it was totally empty. In the last room, they found only an open window, with a rope made of knotted bed sheets leading out of it. That was the work: the artist's escaping from having to make a work and being celebrated for it.

But Cattelan's "escape" is from a first-world position of privilege, wealth, and success. There are stresses accompanying it, to be sure, but it is very much relative. He might not feel like yet another big opening, but for much of the world, this is playing the world's smallest violin. There are significant artists who made their names by being thrown into actual prisons, not the gilded cage Cattelan slipped out of, because of their artistic attempts to break free from repression.

Shocking acts involving art can be about the art or the notoriety, but they can also be attempts to shock a system, to make a political statement—what is sometimes labeled as "protest art." Some are simple symbols of the subversion of a system. Consider Chinese artist Ai Weiwei's *An Animal That Looks Like a Llama but Is Really an Alpaca* (2017). Understanding it requires an exegesis to the point where one appears among the FAQs of an exhibit of his work that was held at the Hirschhorn Museum in Washington, DC.[11]

Fair enough that what requires a roadmap for viewers outside of China is subtle, sophisticated, and clear enough to the Chinese—the wallpaper is, upon closer examination, comprised of a graphic pattern that conceals references to Ai Weiwei's imprisonment and challenges to Chinese authority, including Twitter logos, handcuffs, and surveillance cameras. The work that propelled him to international stardom was *According the What* (1995), which involves brightly painted pots set before a triptych of black-and-white photographs in which Ai appears to knowingly drop and smash an antique Chinese urn. He was commenting on Mao's movement to wipe out traditional Chinese cultural heritage (during the period of 1966–1976) and was hugely influenced by Duchamp. He would buy objects at markets in China that he considered like Duchamp's readymades. Ai tells that he bought a pair of two-thousand-year-old Han dynasty urns that he smashed for these photos (the first one he dropped did not come out well in the photograph, so he had to smash the other). But it is not clear whether we are to believe him or whether the urns were modern replicas (he runs an architecture and design company called Fake, so he clearly enjoys the "is it or isn't it" game). The goal was shock: that he would "sacrifice" a precious antiquity in order to make a point and that this shock would lead simultaneously to his renown as an artist and a dialogue about Mao's cultural heritage genocide attempts.

If these examples of fighting the system through art-as-shock-as-commentary are too subtle, consider the polar opposite, sledgehammer approach of punk band Pussy Riot "performing" at Christ the Savior Cathedral in Moscow.[12]

On February 21, 2012, members of the collective, wearing homemade balaclavas, staged a guerilla performance inside the cathedral. Three members of the group were arrested and charged with "hooliganism motivated by religious hatred." They argued that their action was a protest against the Orthodox Church's support of Vladimir Putin. The action was filmed and went viral online. The subsequent trial was heavily covered in the media. The shock tactic of the performers, motivated by political protest, was counter-punched by the Russian authorities, arresting and imprisoning members of the collective, though the members could hardly have been surprised. If their goal was notoriety of the collective, then it certainly worked (though at a great sacrifice). However, the specific political issue was lost to most in the cacophony of press coverage. The general public understood that they were anti-Putin, but the subtleties beyond that, the objection to Orthodox leaders supporting Putin's reelection, are recognized only by true students of their activities.

Shock leads to publicity that leads to awareness of both artist and (sometimes, and to a far lesser extent) a cause. The problem, if it is indeed a problem, is that the public tends to remember the shocking action, and probably the actor, but the rationale or cause tends to recede into oblivion, recalled only by scholars and those closest to the cause.

## Schlegl and Burning for Attention

In the idyllic alpine village of Sela pri Kamniku, local artist and architect Tomaž Schlegl and the village cultural society built a hollow twenty-five-foot-tall statue, dubbed "Slovenia's

Tomaž Schlegl, *Statue of Freedom* (2019). PHOTO COURTESY OF THE AUTHOR.

Statue of Liberty," that looks like a sort of colossal nutcracker Donald Trump. On August 28 and 29, 2019, world media enthusiastically ran stories about the statue. Cleverly mocking Trump with an intriguing piece of conceptual art is, of course, delightful clickbait. The statue was seen to mock Trump, and as such was delightedly broadcast on the landing page of all imaginable news sites, from the BBC to the *Washington Post*, from Finland to Japan.

But not everyone was amused. A certain group of more conservative villagers were dismayed by the notoriety of the statue, which they feared would put their tiny village on the map for the wrong reason, making it a laughingstock or incurring the wrath of the president portrayed (whatever that might entail). There was even a call to burn the statue, or at least force it to be moved from the land on which it was temporarily displayed. Not wishing to upset the locals, the cultural society was at first resigned to losing the statue, perhaps symbolically burning it (to keep one step ahead of the grumpy group of locals, who considered doing so one moonless night). But it is a wily installation, a work of folk artistry and a wry commentary. It had already made international headlines and had already made Sela a point of pilgrimage for curious tourists. It was temporarily moved away from the village center, to the private property of a farmer farther up the mountain, giving it a far better view.[13]

Schlegl is careful to say that this is a *kip svobode*, Slovenian for a "Statue of Freedom" (or "Statue of Liberty") and any likeness to politicians—Trump, for instance—he leaves to the interpretation of the public. Call it the Roland Barthes defense: Proper artists do not interpret their work on behalf of others, but create, present, and allow the public to interpret it as they see fit. His goal is to provoke thought and comment on contemporary politics.

With the statue a proven tourist attraction, it was just a matter of time before a bold mayor invited it to move to their hometown. It was offered domicile, as Slovenian newspapers joked, by the nearby town of Moravče. It arrived there in early January 2020. A

few days later, on January 8, the statue made international headlines again when arsonists burned it to the ground in an act of vandalism.

The funny thing about it is that Schlegl was completely delighted.

The tone of the headlines that reported the burning of what has been referred to as the "Slovenian Trump statue" seems to give a sense that the arson was an act of pro-Trump protestation over a statue that clearly makes fun of its subject. The implication was that the artist should feel bad about this destruction and that he got what was coming to him for taking the piss out of a person who at least a portion of the population thinks is great (or at least not catastrophically problematic, which is saying something). But Schlegl always planned that this should be a temporary statue. The idea was to burn it ritually in a bonfire on Halloween 2019—Burning Man meets a witch trial. But the locals got nervous about burning Trump in effigy and got cold feet. Schlegl felt that the concept was not complete, the work unfinished without its flaming end.

And so, reluctantly for the artist, a new plan was hatched, to move the statue elsewhere and let it remain "alive." The mayor of Moravče saw this as an opportunity to raise the visibility of his town and draw some tourists. So the statue was brought from Sela to Moravče, about thirteen kilometers away. There was a grand ceremony to install it. Within days, it was dramatically burned to the ground.

Was this an act of vandalism (random destruction without ideological motivations) or iconoclasm (destruction for symbolic reasons)? It's a better media story to report that it was either pro-Trump iconoclasts who destroyed something that mocked their hero or anti-Trump iconoclasts who destroyed the statue in order to burn Trump in effigy. Schlegl is firmly in the second category—he wanted the statue to be burned to symbolize the destruction of populist, neofascist-type leaders in general.

The actual rationale for the act appears to be far more prosaic and lame. At the unveiling ceremony, several people overheard some local teenagers talking about getting gasoline in order to burn the statue. It was likely an idiotic prank undertaken by bored teens to get some attention. But they inadvertently managed to spark more than just their gasoline—they've sparked a debate and world headlines. And whatever the impetus of the arsonists, the artist is thrilled that his conceptual work has finally been completed.

Whether related or not, a second famously grotesque statue in Slovenia, meant to look like Trump's wife, Slovenian model Melania Trump, which stood above her native Sevnica, was burned down on July 5, 2020. If only this were the act of an artist, it would have more resonance than the more probable culprit: more bored teenagers.[14]

## ISIS and the Shock of the Act against the Art

If the act of arson that incinerated the "Trumpcracker" were also an act by an artist, there would be a good deal more poetic resonance to it. One should not condone attacking art as an act of art unto itself (although this has been claimed by some vandals and iconoclasts, including Tony Shafrazi, whose spray-painting of Picasso's *Guernica* we discussed in the previous chapter), but it is important to understand that art has been targeted

because targeting it produces shock. Sometimes it's not about the art; the art is mere collateral damage to trigger a desired effect: shock, outrage, publicity.

Such was the case when ISIS posted videos of their smashing ancient statuary (many of which were actually modern replicas, it turned out) and the more heinous extremes of blowing up ancient monuments at Palmyra.[15] They sought publicity for their cause, radical fundamentalism, and wished to provoke outrage. Their choice of target was based more on what would dismay "the West" than objection to the art itself (which predated Muhammad and therefore could not logically have adhered to Islamic principles). The intentionality is what separates two similar acts of destruction: vandalism and iconoclasm. Iconoclasm, which comes from the Greek word *ikon*, meaning "symbol," is damaging or destroying something because of the target's symbolic value. Vandalism is damaging or destroying without regard for what the target symbolizes or represents, where the act of destruction, not the object itself, is the point. If ISIS targeted ancient statuary because it was not in keeping with Islamic restrictions on what art can be (no formal images permitted, as in Judaism; therefore no visual representations of God, Muhammad, or other prophets; hence the prevalence of abstract, geometric, or floral motifs), then their actions qualify as iconoclasm. If the goal was purely destruction and the subsequent outcry and attention from the West, then it was an act of vandalism. Either way, it was a concerted effort to shock. It might not be qualified as such had the destruction taken place and been

**Diego Velázquez, *Rokeby Venus* (1647–1651).** PHOTO COURTESY OF WIKICOMMONS FROM NATIONAL GALLERY OF ART, LONDON.

discovered after the fact and reported by outsiders. But that ISIS filmed it themselves and posted the videos online is the clearest demonstration that it was a proactive attempt to shock, a scream for attention.

While the actions of ISIS represent institutional destruction encouraged by a regime, individuals have often attacked art, and not always simply because they were mentally unsound, as was the case on March 18, 2017, when a man "with no fixed abode" slashed Thomas Gainsborough's *The Morning Walk* (1785) with a screwdriver at London's National Gallery.[16] The vandal did not appear to have a rationale for attacking the art, or this rather unobtrusive and unobjectionable work in particular. It seems that he was simply unstable.

Other times art is targeted because it will shock and make headlines, and this is strategic, a smaller-scale version of ISIS's tactic. Velázquez's *Rokeby Venus* was knifed in 1914 by a suffragette who was outraged at the arrest of Emmeline Pankhurst for demonstrating in favor of women's right to vote.

The attacker smashed the glass that covered the painting and slashed it seven times before she was grabbed by security personnel. The slash marks were carefully healed and only three pale, barely visible scars can be seen on Venus's back. The choice of object attacked was one the attacker felt objectified women: a nude female was commissioned by a man, painted by a man, and meant to be an object of beauty and perhaps sexual

Diego Velázquez, *Rokeby Venus* (1647–1651) after 1914 knife attack. PHOTO COURTESY OF WIKICOMMONS, PHOTOGRAPHER UNKNOWN.

inspiration for a male audience.[17] It therefore might seem objectionable to a fighter for women's rights. But the primary goal was not the destruction of the artwork but the notoriety that came from the attack and arrest, allowing a media platform to speak out about the suffragette movement and in condemnation of the treatment of fellow suffragettes.

A similarly impressive repair can (barely) be spotted on Rubens's *Adoration of the Magi* at King's College Chapel, Cambridge. In 1974, an Irish Republican Army activist carved the letters "IRA" into the canvas. The patching was so good that today, the ghosts of those letters can be seen only when you examine the work at a sharp angle and against slanting light. The choice of artwork appears to have been random, though the location in an English institution like Cambridge University is perhaps meaningful. The goal of the action was to shock and, in doing so, draw attention to the IRA's cause.

People strike out at objects that symbolize an idea that they wish to damage, with the artworks acting as a stand-in. These fork into two subcategories: acts intended to shock and acts that happened to shock. American soldiers tearing down statues of Saddam Hussein were not after shock value but rather the symbolism of removing likenesses of the deposed despot. Protestant destruction of Catholic statuary was about disapproval of a religion and the desire to destroy its representations and institutions in lieu of destroying the ideology. Shock was a by-product, and there was no doubt delight on the part of Protestant rioters thinking of the dismay they would cause Catholics who worshipped at the churches they targeted, but this, too, does not fall into the focus of this chapter. The acts of the Taliban and ISIS do, however, because while there was a faith-based rationalization for their actions (a Buddha statue "should not" be present in a fundamentalist Islamic country, or pre-Islamic statuary is not Islamic and therefore should not be present and admired), the acts of iconoclasm were proactively promoted, filmed, and distributed in order to produce shock. That proactivity is what includes them in the focus of this chapter.

You may have noticed that I have been careful not to include the names of any vandals in this text. That is on purpose and is something I would recommend as a policy for all media. We cannot prevent art from moving people, very occasionally even moving them to violence against it. But we can eliminate a frequent rationale for attacking art: achieving one's fifteen minutes of fame. Would John Hinckley Jr. have attempted to murder Ronald Reagan if he knew that his name and picture would never be "promoted" by the media (and therefore Jodie Foster would never have known of him)?[18] Would the suffragette have attacked the *Rokeby Venus* had she known that she would not be given a platform to speak about her noble cause to the media? If the media removed the incentive of simply getting attention, by refusing to publish names or photographs of vandals or their subsequent statements, it would eliminate one of the motivations for such incidents. The shock would remain, but the notoriety and platform would not.

This might weed out such actions as the one taken by celebrity musician Brian Eno, who urinated on Duchamp's *Fountain* when it was on display at MOMA in New York.[19] His rationalization for this act was a feeling of outrage that the work should be considered art—shock—but in what appears to have been a blatant attempt at getting media attention, he decided to shock back and take a whiz on the artwork.

This is a reaction fairly common among people who feel they don't "get" conceptual art, those who think art should only be what follows the Aristotelian tripartite classical definition. So Eno rigged "a couple of feet of clear plastic tubing, along with a similar length of galvanized wire," filled the tube with urine, then slipped "the whole apparatus down my trouser-leg." He put one end of the tube into the display case and let it rip. He dubbed this "re-commode-ification" and used it as the focus of a public talk he was giving that night.

Eno is an artist and musician, so his articulated lack of understanding of Duchamp's concept behind *Fountain* is a surprise—or an act of cunning. Because Eno wound up turning his protest at what he calls the silliness of the art world into an act of performance, an artwork of his own. He shocked shock, and he did it for the shock value, sang the praises of his own action in a public talk that very night, and enthusiastically described his action in interviews, documentaries, and memoirs. Perhaps Brian Eno is more insightful than his words make him appear. But he is also just one of many artists who thought it was a fine idea to urinate in *Fountain*.[20]

The funny thing is that Duchamp might well have approved of these acts.

## Ofili and the Shock of the Weird

Would you fork over a million bucks to own someone's unmade, suspicious-liquid-stained bed? Have you ever stood in your living room thinking, "You know what this needs? A bust made of frozen blood plugged in next to the TV?" How much would you invest in a pile of elephant shit shaped into the boob of the Virgin Mary? How about a pickled goat rammed through a spare tire?

Welcome to the shock tactics of contemporary art. The Duchampian path, in which "interesting" is the only important component to a successful work of (conceptual) art, has given birth to an array of works that are readily mocked, result in head-scratching and confusion, and yet have rich markets, have books written about them, and are, indeed, proper works of art worthy of attention—though of course with the aforementioned caveat that they inhabit a parallel but distinct world of what should be considered art from the classical, Aristotelian lineage of works good, beautiful, *and* interesting.

On July 1, 2017, *My Bed* by Tracey Emin was sold at auction for £2.5 million ($3.3 million). Part found art, part sculpture, part conceptual work, part readymade, the entire installation consists of Emin's actual unkempt bed. She looked at it after a self-destructive multiweek bender of booze, drugs, and promiscuous sex, and decided to leave it just as it was. For her, it was a snapshot of her behavior, memento of a raucous period in her life. Featuring used condoms and pregnancy tests, bottles of liquor, drug paraphernalia, and assorted nefarious stains, it has been a centerpiece of London's Saatchi Gallery for years. Charles Saatchi bought it in 2001 for £150,000 ($250,000), so he turned quite a profit in the sale, certainly a world record for an unmade bed covered in suspect stains.

Many art historians, myself included, like (but perhaps do not admire) such works. "I'm particularly interested in works that make a point of that 'weirdness,'" says renowned

art critic Blake Gopnik. "'Beauty' must be the worst red herring in the entire history of art—art's never been that much about good looks. . . . What mattered, and matters, was that the object in front of you conveyed the maker's concepts and ideals—so all art has really been 'weird' and conceptual, all along."[21] Some works certainly are. But Emin and Michelangelo were after very different things. Michelangelo sought to make art that exhibited skill, was beautiful, and was interesting. Tracey Emin, Marcel Duchamp, Damien Hirst, and assorted other avant-garde conceptual artists have chosen to discard the first two requisites. All that they expect their art to be is interesting (and by interesting, this often means provocative, which is often mistaken for shocking). So in 1959 when Robert Rauschenberg bought a taxidermic goat, shoved it through a spare tire, and slapped a title on it, it became an early exemplar of this movement of art that exhibits no skill on the part of the artist (and in many cases is only designed and not actually *made* by the artist), is no one's idea of beautiful, but certainly does provoke, whether thought or outrage.[22] Shock was the goal, or perhaps what Duchamp would have preferred to call "provocation."

A problem with shock art is that over time, the public is decreasingly shocked—or rather, it takes ever more weird and taboo things to shock us. "In olden days, a glimpse of stocking was looked on as something shocking," goes the line in the Cole Porter song "Anything Goes," and we have come a long way. Manet's *Déjeuner sur l'herbe* was enough to cause a scandal in the nineteenth century, but particularly in the second half of the twentieth century and beyond, audiences have grown immune to what used to scandalize and make our jaws drop. Blood, death, murder? It's on the evening news and on our TV screens, so much so that we associate real footage of, say, a firefight between armies with films of fighting.[23] Nudity no longer shocks, as internet access to pornography means that the naked body alone is of little interest. The public wants hardcore acts and fetishes if they are to even bother offering up their attention.

In a world in which we have access to stories, videos, and images of anything we want, anytime we want it, and against a backdrop of people inured to extreme violence and sexuality, what's left to shock with? The answer that artists have come up with is to veer into the weird, to proactively seek boundaries to cross and trample upon. What we wind up with is some art that is more weird than good, more noteworthy than brilliant, more talking point than revolution. Sometimes it feels that artists are just trying *so* hard to find something that will shock that they forget they are supposed to be making interesting art.

But I can argue both for and against the merits of some of the most famous works of shock art. Take Chris Ofili's *Holy Virgin Mary*, for instance.

It is a painting of a black Virgin Mary that, at first glance, appears to be a work of African religious folk art. But further inspection reveals that what look like butterflies fluttering around the Madonna are actually cutouts of lady parts from pornographic magazines. And Mary's breast is made from lacquered elephant dung. (At least it's lacquered.)

This work made Ofili a household name. His shock tactic worked brilliantly, choosing to stomp around the line between holy and mundane, sexual, excremental. The icing on Ofili's dung cake was when Rudy Giuliani, then the mayor of New York, sued to stop

Chris Ofili, *Holy Virgin Mary* (1996).
PHOTO COURTESY OF WIKICOMMONS FROM SAATCHI COLLECTION.

the Brooklyn Museum of Art from exhibiting the painting because it was, in his opinion, "disgusting." Giuliani lost and Ofili got more publicity than an army of publicists could muster, though it must be concluded that very few who were aware of the "elephant dung Virgin Mary" could later remember Ofili's name, the actual title of the piece, or details of it beyond the Google search keywords.[24] This raises the legitimate question of whether the notoriety that comes from shock art benefits the artist directly, since the people who become aware of the work through the headlines conveying dismay are likely not art

lovers or art collectors or regular museumgoers. So how, exactly, does this fifteen minutes of fame in a fragmented summary of the story of the artwork actually help the artist—or, as goes the thesis of this book, the course of art in general?

It likely does not do so directly, but it can be argued that, indirectly, all publicity—fragmented or whole, even wholly incorrect, fake, or slanderous—can be beneficial in the long run when it comes to art. The artist gets a big boost in name recognition, which is valuable in making their name stand out in bold when listed in catalogues and exhibitions among other artists. This trickles down to more casual art lovers and less serious collectors, who are often more interested in something or someone they've heard of than in a work that is actually great, perhaps even one that they love, but which is unknown. So much of the pleasure in art collecting, currently and historically, has been about conspicuous consumption and showing off what one has collected among peers, and this is made far easier if the artist collected is well known. Hence the wild popularity of an artist like Banksy, whose creations are fine and fun, but who is not really doing anything special in art historical terms—yet he is a household name due to this mystery surrounding his identity, a mystery he has reveled in.

Art in general also benefits because such shocks make people talk about and engage with art. At whatever level, a passing comment by the watercooler at work or people deciding to go see an exhibit because they've heard of the scandalous story behind an object shown there, it is good for art when people are interested in it. Whether the interest comes from more traditional studies and aesthetics or a delicious scandal, interest is still piqued. Art shifts into the light, for otherwise it remains as it always has been—the realm of a relative few elite and wealthy collectors and patrons as well as art lovers who are generally from privileged, highly educated backgrounds and living in cities. These are generalities, but (unfortunately) they are true. Art can remain within this web of influencers. It has survived for millennia without the support of the masses. But it is a shame, because art can and should be for everyone. When art makes headlines, for whatever reason—even if it is because of scandal or shock or the "outrageous" prices for which it sells to those elite collectors and institutions—then the general public engages with art, to whatever extent that engagement may be. Art is—for that metaphorical fifteen minutes when the moment leans into fame, before inevitably and swiftly receding—a center of attention. And each time art gets mass-media attention, a small percentage of those otherwise unengaged and "uninterested" in art will become interested. And a percentage of that percentage may start to engage with art and join the fold of art lovers.

Ofili's painting, as with much of the art that shocks at first, actually has a good deal of merit to it, and is cleverer than the headlines about the shock value alone would lead you to believe. It references Jean Fouquet's *Virgin and Child,* painted in 1452, which features a far sexier Virgin Mary with a floating, gravity-defying boob that has broken free of its garment, à la Janet Jackson.

Those flying butterfly cutout lady parts in Ofili's painting are actually an art historical inside joke. They are a pun on *putti,* the Italian term for little flying cherub angels that often accompany the Virgin Mary—a term that also refers to the naughty bits of ladies. As mentioned earlier, it can sometimes feel that the desire to shock overpowers

Jean Fouquet,
*Virgin and Child*
(1452–1458).
PHOTO COURTESY OF
WIKICOMMONS BY
USER 8WEEKLY.

and overshadows the quality of the art, but we must take care not to dismiss the art as not good just because it shocks.

Semen, urine, excrement, vomit—these are not materials we have come to expect in high art, or any art, for that matter. Art is an elevated practice, sophisticated and, at least until industry allowed prices to come down, expensive. Historically, the raw materials that were used to create art, the most traditional of which were bronze and marble and imported pigments like lapis lazuli for cobalt blue (a stone that was, during the Middle Ages, the single most expensive item by weight that one could buy, as the only source of lapis lazuli were mines in what is today Afghanistan, and which therefore had to be painstakingly carried to Europe over the Silk Road) were hugely expensive.[25] Even paper was an extravagance until after the Industrial Revolution. It was made with old rags, not

wood pulp, and so essentially consisted of recycled clothing; its cost was therefore akin to that of secondhand clothing rather than the disposable, mass-produced paper of today that costs far less than a penny a sheet.

This means that the choice of "base" materials, associated with the hidden-away, perhaps even shameful expulsions of the human body at its most basic, stands in stark contrast to our idea of what art is and what it is made of. It is a clever subversion to make "high" art out of "low" materials. This can come in the form of found objects, which differ from readymades in that they are not bought and displayed, as Duchamp did with *Bottle Rack* and *Fountain*, but are manipulated and/or integrated into art in a more traditional sense. Consider Gabriel Orozco's *Black Kites* (1997), which started with a found object (a human skull) upon which Orozco masterfully drew diamonds, or kite shapes, with graphite. Perhaps the earliest example came, as so many revolutions did, with Picasso, who experimented with adding pieces of found objects into traditional oil paintings, as in *Still Life with Chair Caning* (1912). There he toys with the idea of a still life and blurs the line between painting and sculpture. A still life is normally a painting of inanimate objects, but here it also features a part of an inanimate object glued on, sculpturally.

These concepts were taken to an extreme by the other great twentieth-century revolutionary, Duchamp. There is a story, perhaps apocryphal, that he made an abstract painting of a white circle on a black ground as a gift for his lover. It eventually turned out that the white circle was painted in his own semen.[26] This story is unconfirmed (and the work, if it existed, is lost), but it sounds feasibly Duchampian. He was quoted as saying, aged seventy-two and reflecting back on his work, "Eroticism is a subject very dear to me. . . . It's an animal thing that has many facets and is pleasing to use, as you would use a tube of paint."[27] This work—if indeed it happened at all—does not qualify for our shock category, since it was not meant for public display; it was a private tease or inside joke with his lover. But the idea of using one's own bodily excretions as a medium made a splash (or a plop, if you like) with Piero Manzoni's *La Merda di Artista* (1961).

These sculptures consisted of (as you may have guessed) the excrement of the artist, canned and sealed in what appear to be containers for shoe polish. Part of what makes shock art spread virally is the shorthand summary of the art. The ability to summarize a work in an off-the-cuff shorthand helps word of it to spread, from headlines to casual watercooler chats at the office. "Did you hear that an artist did X?" it might go, as your coworker pours himself a cup of coffee in the office kitchen; or, in this case, a headline might read, "Artist cans his own poop and sells it for a fortune." The general public and the more tabloid-y media tend not to differentiate shock art that is clever, and sometimes even great, from that which shocks and does little more. Manzoni's work is both clever and great in its subversiveness. It takes a raw material that no one wants, and of which there is limitless quantity, and commodifies it. He produced ninety cans, each with thirty grams of his "freshly preserved" poo (as it says on the cans) in May 1961. Each one is signed on the top of the can. He wondered what might be the least desirable thing for a collector to desire and to pay good money for. A can of shit, he thought. And so, by virtue of his position as an artist and the presentation (the limited edition, the signature)

Andres Serrano, *Immersion (Piss Christ)* (1987).
PHOTO COURTESY OF THE ARTIST AND NATHALIE OBADIA GALLERY.

he transformed what many would pay *not* to own into something of high value, a collect-ible.[28] There is also a bit of a game of timing with Andy Warhol's *Campbell's Soup Cans,* which was begun in 1961, the year Manzoni created his *Merda di Artista,* but was finished in 1962. Making high art out of simple canned goods was clearly in the air.

Building on this idea of bodily fluids as media, one of the works that sparked the greatest outrage was Andres Serrano's *Immersion (Piss Christ)* (1987), a photograph of a small plastic crucifix (a purchased found object) immersed in a jar containing the artist's urine. This was seen by the Catholic community as the ultimate insult to their beliefs.[29]

It manages to be a flashpoint for controversy and protests each time it is shown. The photograph is actually quite beautiful, and the fact that the "filter" tinting the crucifix orange is actual urine is not obvious aesthetically. But the title hammers this home, for the artist does not want his concept to go overlooked.

The work was particularly controversial because it sparked a 1989 debate in the US Congress about funding the arts and was pointed to as evidence of the wastefulness of arts funding, because works of this sort were the fruit of taxpayer investment. On Palm Sunday in 2011, when it was displayed in France, a group of fundamentalist Christians attacked the photograph. The outrage that some art can trigger is a testimony to its power, even when those who categorize themselves as "against the arts" or as uninter-ested in them would claim otherwise. If art can provoke, then it has succeeded. When asked about the work, Serrano prefers to resort to the Roland Barthes defense: "At the time I made *Piss Christ,* I wasn't trying to get anything across."[30] In other words, "It is not for me to interpret." But Serrano considers himself a Christian, and he does go on to interpret the work (and in doing so, makes no headway into endearing himself to Christians): "The thing about the crucifix itself is that we treat it almost like a fashion accessory. When you see it, you're not horrified by it at all, but what it represents is the crucifixion of a man. And for Christ to have been crucified and laid on the cross for three days, where he not only bled to death, he shat himself and peed himself to death."[31] This is likely not strictly accurate historically (death by crucifixion usually came through suffocation, when the victim's ribs collapsed), but the point is a real one. A cross was an ancient instrument of torture. It is odd indeed that it has become a fashion accessory. Bill Donohue, president of the Catholic League for Religious and Civil Rights in the United States, said, "I would argue that ethics should dictate that you don't go around gratuitously and intentionally insulting people of faith." In 2010, he successfully cam-paigned to have the National Portrait Gallery in Washington, DC, remove from display a work of video art about AIDS by David Wojnarowicz, which contains an image of Jesus on the cross being eaten by ants.[32]

These sorts of incidents provoke debate, particularly when conservatives, the group most likely to be offended, see them as a rationale for cutting arts funding. But there is an art historical tradition of gruesome crucifixion scenes. The crucifixion is surely the most frequently depicted scene in the history of art. There is no record of controversy when Matthias Grünewald painted the *Isenheim Altarpiece* (1516), which features the most grotesque of all crucifixions, including Christ's body covered in thornlike black lesions.

Matthias Grünewald,
*Isenheim Altarpiece*
**(1516).** PHOTO
COURTESY OF
WIKICOMMONS,
PHOTOGRAPHER
UNKNOWN.

This was meant to provide a sort of cold comfort to patients treated at the monastery where the altarpiece was displayed, most of whom were suffering from Saint Anthony's Fire, a disease that came from eating infected rye and resulted in painful lesions. The illness caused hallucinations and a chemical in the rye would later feature in LSD. *Piss Christ* has a point and echoes the history of art. There is some degree of choice in finding a work like this offensive. One could choose to ignore it, but its existence, particularly its success and the fame and wealth of the artist, gets on one's nerves and feels morally "wrong." But the genius of shock art is that acts of protest result in more media coverage, which heightens the fame of the work and, through it, the wealth of the artist. It's an ingenious trap.

From placing a bodily expulsion into a container, as Manzoni and Serrano did, the next logical step to push the extreme is to create an artwork wholly of a bodily fluid. *Self* (1997) by Marc Quinn creates a cast of the artist's head using frozen silicone and ten pints of the artist's own blood, which he had drawn over an extended period of time and stored until he could use it to create this series of busts. Quinn's very realistic busts have the appearance of a death mask, which also has a rich tradition, dating back at least to the bronze Mask of Agamemnon from ancient Mycenae, which is said to have been molded from the face of Agamemnon, the Greek leader of Trojan War fame. From the Middle Ages through the nineteenth century (until photography took over the role of visual

memorial), death masks were taken of famous individuals or beloved family members, literally laying down plaster over the face of the subject shortly after death and preserving the mask as a final "snapshot."[33]

Since Quinn is alive and well, *Self* technically functions as a life mask, but both the expression and the use of blood as a sculptural medium recall death masks. Quinn likewise is subversive in his use of a material we associate with liquidity as the replacement for the materials normally associated with busts: marble and bronze. We also think of busts as everlasting, and Quinn could have prepared a cocktail with his own blood that would coagulate and remain solid, such as mixing it with epoxy. Instead, he chose to freeze the blood, meaning that the work must be plugged into electricity to maintain a low enough temperature through mechanical cooling, otherwise it would melt. Quinn volunteers that he made the work at a time when he was an active alcoholic, and liked the notion of his *Self* requiring a constant supply of external stimuli (in the case of the work, electricity) to mirror his dependence on alcohol.[34] Because the blood sculpture is in such a precarious state, fighting to remain frozen while the ambient temperature of a gallery space threatens to melt it, it normally has the appearance of "sweating," with beads of moisture building up on its surface, making it that much more lifelike.

The work is completely ingenious, and yet its shock value is high since it can be snap-summarized at the watercooler with, "Did you see that an artist made a self-portrait out of his own blood?"

## Orozco and the Memento Mori

You walk through the darkness of the crypt, with choral music playing from hidden speakers. All around you, human bones are arranged in patterns, tiling the walls, divided by bone—a flood of hip bones that look, from a distance, like a cluster of oversized mushrooms, a phalanx of femurs, and a cobble of skulls. Skeletal arms are crossed and nailed into the wall, making the symbol of the Franciscans, normally painted, out of the real thing. Even a child's skeleton has been strapped to the ceiling like a fleshless cherub, decked out as the angel of death, scales in one clawlike hand, a scythe in the other. The holiest members of the order were reburied in the floors, in earth imported from Jerusalem, while others were partially mummified, their leathered skin clinging to their skulls and hands, still dressed in the cassocks, five-knotted rope belts around their waists, and harnessed into niches in the walls of bones, but leaning forward over the years. If you blink, you might swear that they've stepped away from the skull wall toward you, off to grab a cappuccino (most were Capuchins, after all).

The scariest place I have ever been that was not intended to be scary is the crypt that perches beside the church of Santa Maria della Concezione dei Capuccini in Rome. At the foot of Via Veneto, the church contains a Caravaggio, but you could be forgiven for overlooking it in favor of the cavalcade of beautiful horror that awaits in the adjacent vaults. There lie the bones of some thirty-seven hundred former Capuchin and Franciscan monks, a haul that began with three hundred cartloads of deceased brethren who

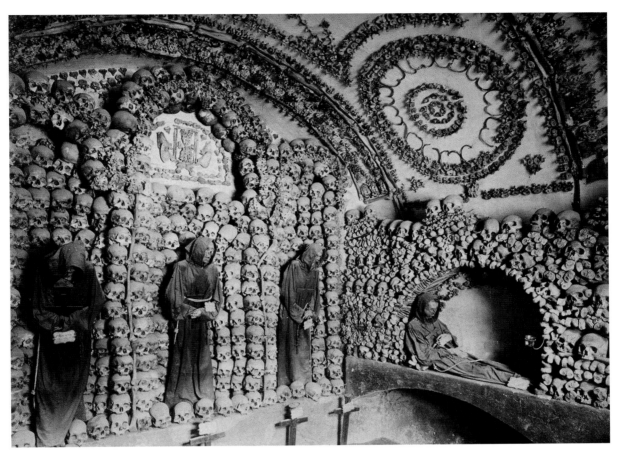

accompanied the friars who founded this church in 1631. This initial haul was added to all the way to 1870—the dead would be buried in the earthen floor for around thirty years, without a coffin, and then exhumed to make room for the freshly deceased. What to do with this avalanche of human remains when lacking even space to rebury them? Friar Michael of Bergamo led the initial arrangement of the crypts and their occupants, "burying" the brethren in a way that at once suited the available space—the walls, ceiling, and floor of six vacant crypts alongside their church—venerating the remains and happening to also create what we retrospectively label as one of the most beautiful, moving, and haunting art installations ever made.

If the message of this reburial-as-artwork were not clear, it is written into the floor of the final crypt, beneath the child's skeleton: "What You Are, We Once Were, What We Are You Will Be." All are equal in death; gather your rosebuds while you may, for death comes to all, king and peasant, sinner and saint. Memento mori. Remembrance of death. Be a good Christian, before it's too late.

This is an example of historical shock art, but one that was unlikely to have been considered an artwork when it was created. It was a repurposing of materials that modern

Detail of the ossuary crypt of the church of Santa Maria della Concezione dei Capuccini in Rome.
PHOTO COURTESY OF WIKICOMMONS FROM WELLCOME COLLECTION.

art historians considered a proto-installation, conceptual in the sense that it had a single concept that was meant to be absorbed by those who saw it. Modern minds looked back upon it as artwork, as an installation through which viewers were meant to walk and absorb the idea that it hammers home. The shock was not one in search of attention, but was meant to provoke fear of inevitable death and therefore a snap out of the mundane realities of human sin and obliviousness to impending doom.

If a skull appears in a work of Western Christian art, it is as a memento mori, and there are plenty of them to be found—from grotesquely realistic ones, like the one perched above a caged skeletal torso at the back of Rome's church of Santa Maria del Popolo, to contorted ones visible only at a sharp angle, like the hidden anamorphic skull at the bottom of Hans Holbein's *The Ambassadors*.

Gabriel Orozco, *Black Kites* (1997). COURTESY OF MARIAN GOODMAN GALLERY.

The skull is a universal symbol in every human culture, far beyond the borders of Christianity. When humans are long dead and gone, skulls remain. They are warnings of the possibility of death, flapping white on black on the Jolly Roger pirate flag, a skull and crossbones (meant to shock with fear captains of nearby vessels who would spy it through their telescopes), decorating the lapels of the SS (the SS-Totenkopf Panzer division had a smiling skull with crossed bones behind it as their logo), and on labels of poisonous materials (designed to repulse those who were not sure what a vessel contained). Even the illiterate can read a skull as a warning. But they needn't be fearsome. Hamlet communes with the skull of Yorick, and as horror filmic as the Capuchin ossuary chapels in Rome may sound, the creepiness of moving through them is cut by a cocktail of beauty (in the careful aesthetic arrangement of this walkthrough sculpture, for which bones happen to be the medium instead of wood or marble), tenderness (the hands of the friars who placed and fastened each component), and the sublime (the

sweeping knowledge that death conquers all, and that you will become one of these soulless tusks, when all is said and done, and there is nothing you can do about it). It was meant to shock you into better behavior, into seizing the day.

It would be wrong to think that skull imagery in art is a matter of the past. While we have been largely secularized in Western culture, skulls remain (after all, we all have them), death remains, and all the symbolism that skulls carried in the past reverberates even today. Take the two most recent famous skulls in art, two very different approaches: Gabriel Orozco's *Black Kites* (1997) and Damien Hirst's *For the Love of God* (2007).

One might assume that Orozco, who is Mexican, is referencing the Day of the Dead in this work—a real human skull he spent months holding and drawing upon in pencil, in the shapes of squares, so the skull appears covered in a graphite and bone-white chess board (though the theoretically even and consistent checkerboard pattern is contorted as the squares bend around the contours of the skull). But Orozco disagrees. This is not about Day of the Dead or a memento mori (though art historians are entitled to argue otherwise). As he says, this is "an experiment with graphite on bone. . . . The thing is a contradiction, really: a 2D grid superimposed on a 3D object. One element is precise and geometric, the other is uneven and organic. The two are not resolved."[35] It is certainly beautiful, echoing the Capuchin ossuary chapels in the communion of the artist holding the skull of someone who once was, and drawing upon it—a thoroughly intimate act.

Symbolism and the history of art are laced into any skull that is repurposed. Humans are human, art repeats, and the historical continuum is inescapable whether the artist objects or not. Our psychological defense mechanisms insulate us from thinking too much or too often about the fact that we all will die. The skull shocks us as a reminder of just that cold fact.

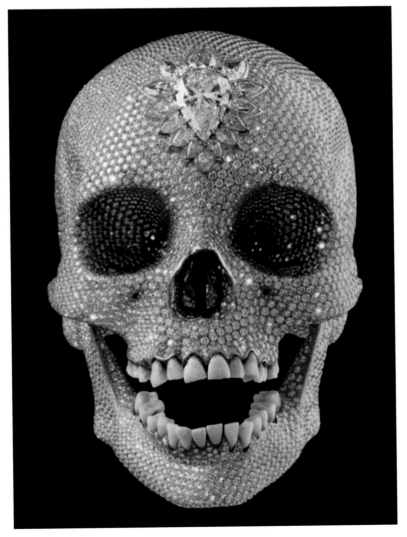

Damien Hirst, *For the Love of God* (2007). PHOTO COURTESY OF WIKICOMMONS BY USER AARON WEBER.

# Abramović and Shock through Pain

While using one's bodily fluids as a medium of sculpture, painting, or photography takes shock art in one direction, it is in the past tense: The artist *did* this, and now, long after, we see the result. This gives it a step remove that helps the viewer feel safe. Performance art is another matter. The immediacy of it is confrontational. The adrenaline of performance art, the reason some artists love it, are almost addicted to it, is their direct contact with the audience, the moment-to-moment feedback of their provocations. This is also why many art lovers do not enjoy attending performances (or situations or actions, whatever the artist likes to call them). It's like that moment in a theater performance or magic show that a large percentage of the audience dreads: when the performers turn to the audience and interact with them, put them on the spot, ask for (or call up without asking) a volunteer. But for those audience members who enjoy the adrenaline of the spectator, this is what makes performance special. It is unpredictable. And the voyeurism of being a spectator at an artistic performance is heightened when the performer does the unexpected, the unimaginable: torture themselves.

In body art, artistic acts (usually performances) involve the artist manipulating (usually in a gruesome way) their own body, their body acting as artistic medium. Artists asked themselves how they could counter the traditional pose of someone consuming art. You know what it looks like, because you've done it yourself, even if you were not aware of it: The standing pose, square before a painting or sculpture, one arm folded across your stomach, the other vertical, balanced between your crossed arm and propping up your chin. That's how art has been studied, admired, analyzed since time immemorial. How can this be changed? There are answers to this that are more immersive, like performance. Body art is as far from traditional as possible, as it often involves something that audiences feel like they don't want to be looking at. Watching an artist injure themself live in a gallery is as far as is possible from the quiet, civilized admiration of inanimate objects, with the artist long dead or nowhere near the museum. Of the edgiest of movements in the 1970s, perhaps the most visually dramatic was *Suspension* by Stelarc (the artist name for Stelios Arcadiou), a series of twenty-six different performances (the last of which he did in 2012, when he was sixty-six), in which metal hooks were inserted into various parts of his body; these were attached to cables by which he was lifted, suspended in the air. This practice, called "flesh hook suspension," is meant to test the participant's pain threshold but not cause any lasting damage. It was inspired by an 1832 painting by American explorer George Catlin, called *The Cutting Scene,* which was an anthropological painting of a horrific tribal ritual the artist witnessed as the first European American to behold and depict the traditions of Plains Indians, as they were called at the time, in the American West.

The painting is one of a series of four that shows the O-kee-pa ceremony, the key religious event for the Mandan tribe.[36] Young men volunteered for this rite of passage, in which wooden splints were inserted into their chest and back muscles (which did not cause long-term injury but was designed to be extremely painful) and then, as icing on the cake, were suspended from ropes that were attached to the splints. The overwhelming

pain caused the participants to faint, entering a trance as their minds tried to blot out the pain, and the men believed they would receive supernatural visions or messages. Those who completed the ritual were the most respected in the tribe. Catlin was one of the few nonnatives to witness the ritual, which was banned in 1890.

George Catlin, *The Cutting Scene* (1832). PHOTO COURTESY OF WIKICOMMONS FROM GOOGLE ART PROJECT.

By turning this ritual into an artistic performance, Stelarc referenced cultural history and art history (since the Catlin painting is an anthropological relic in the form of an artwork), but it remains more stunt than masterpiece. It was not an invented action, but rather an echo of a past tradition. One might interpret it as commenting on the popularity of piercings and tattoos, historical rituals that have gone mainstream, but it lacks the resonance of other shock art actions. It was hugely popular among those who did not consider themselves art lovers, and particularly in the extreme sport world, as evidenced from the fact that Stelarc has been asked to repeat the performance twenty-six times to date. His own comment that his work deals with the idea that "the human body is

obsolete" feels more relevant to his other works that have more intellectual meat on their bones and feel more resonant with contemporary cultural issues. For example, in *Parasite: Event for Invaded and Involuntary Body* (1997) he attached electrodes to his naked body and allowed himself to be remote-controlled via the internet, a brilliant commentary on how the internet (relatively young at that point) controls our minds, desires, and even our bodies (through, say, the stimulation of pornography or encouragement to diet)—in this case quite literally, with the human body moved as if in a video game by a remote individual. His 2007 *Extra Ear Surgery* involved him having doctors surgically attach an ear that had been grown through cell cultivation to his left arm. This cleverly comments on how we surgically manipulate our bodies in terms of superfluous plastic surgery, while also tackling issues surrounding laboratory-grown organs. These two works shock but also comment brilliantly, whereas, at least in my opinion, *Suspension* feels more like a sideshow.

The French artist ORLAN uses plastic surgery as body art. She has redesigned her face numerous times, sometimes asking surgeons to make her look like *Mona Lisa*, another time like Venus from the famous Botticelli painting. This is extreme and semipermanent body art—the artist cannot go back from it, but it is only permanent until the next plastic surgery appointment. The willing self-sacrifice for a concept is powerful, as is the commentary on our dissatisfaction with our own appearance and willingness to invite the knife to alter it. It is particularly chilling because ORLAN seems to suffer from this compulsion and yet comment on it at the same time.[37]

Serbian artist Marina Abramović first joined the self-harming movement with a 1972 performance in which she cut herself between the fingers on her left hand, one at a time, changing knives after each stab. With *Rhythm 5* (1974), in the center of Belgrade, she drew a star in gasoline, lay down in its midst, and ignited it.[38] She passed out when the fire sucked the oxygen out of the star's center, but since she was lying down already, spectators did not respond. When the flames brushed against her legs and she still did not move, some of the audience rushed through the flames and carried her out. In 1975, she carved a star into her own stomach, calling the action *Lips of Thomas.* These two works reference the red star, the symbol of the Socialist Federal Republic of Yugoslavia, particularly her hometown of Belgrade (the local football team is called Red Star Belgrade). Branding herself with the red star, the symbol of her socialist homeland, was a powerful iconoclastic statement.[39]

Her most famous work is *Rhythm O* (1974), in which she stood naked in a gallery beside a table laid with seventy-two objects ranging from the innocuous (a rose) to the deadly (a loaded pistol). She permitted the audience to do anything they wanted to her over a six-hour period. She was interested in the response of the audience, which did indeed vary: Some harmed her, others protected her. This was a variation on *Cut Piece* by Yoko Ono (1964), in which the artist sat in a gallery, clothed and with a pair of scissors, which she invited the audience to use to cut off any piece of her clothing they liked.[40]

In *Art Must Be Beautiful* (1975), Abramović took injury back into her own hands and used a hard metal hairbrush and comb to brush her hair for so long and with such force that her head bled and hair started to come out. All the while, she repeated the phrase,

like an incantation: "Art must be beautiful, artists must be beautiful."[41] This is a direct reference to Aristotle's concept, which she saw her work as pushing against.

Abramović met the German artist Ulay in 1975 and the two began working together and became a couple. Ulay had done some early performances that involved slicing away squares of his own skin, so the two were on the same page artistically. Early works as a duo included a performance in which they took turns slapping each other, interested in the sound it made. In *Expanding in Space* (1977), they ran naked in a parking garage, repeatedly smashing into columns with their shoulders. The columns were unattached and had been rigged on sleds, so they would slide ever so slightly backward with each strike. But they were heavy and caused bruising nonetheless.[42]

Volunteering oneself for what amounts to torture, or inflicting it upon oneself, can feel meaningful, referential—or not. In the last chapter we discussed Sebastian Horseley's voluntary crucifixion. Chris Burden is another artist who went in this direction, but instead of signing up for a formal ritual, as Horseley did, he opted to have himself nailed to a Volkswagen Beetle (*Trans-Fixed*, 1974). The work that made his name and was perhaps the earliest of the self-harm body art movement, was *Shoot* (1971) in which he arranged for a colleague to shoot him in the shoulder with a rifle. Burden's interest in pain likely had its origins in a Motorino accident he suffered at the age of twelve while on vacation on the island of Elba. His left foot was crushed and had to be amputated, without anesthesia. Artist origin stories, when interest first shifted in one direction or another, are interesting from a voyeuristic perspective but do not always help us understand the art. When we see a Magritte painting, like *The Lovers* (1928), in which a man and woman kiss while wearing wet white cloths over their faces, and learn that when Magritte was fourteen, his mother ran away from home and drowned herself, and Magritte saw her body dragged from the water with her white nightgown covering her face, things click for us.[43] The painting was a working-through process for that formative trauma, as any psychiatrist would say. But that does not necessarily help us with the art. It excuses but doesn't explain. And so, when critics point to Burden's physical formative trauma as the reason his art dealt with his own pain, that may indeed be why, psychologically, but we're still left with the art itself, which needs more of an exegesis than a simple Psych 101 explanation.

Much has been written on the problems of art that require explanations. But, as Slovenian conceptual artist JAŠA explains, "Explanations are part of the work. When the method applied is so complex and conceptual, and it's about the thought behind the work, usually the visual element is only the pretext for an explanation of the concept. So, the explanation is necessary to the work. But you'll have mediocre work that over-relies on explanation, and genius work that still requires explanation and is the better for it."[44] Explanations are not inherently bad. There is a visual vocabulary of iconography that art history students must learn in order to interpret and fully enjoy Old Master works. To recognize, for example, an Annunciation scene, one must know the New Testament story, the figures in it (Mary, the Angel Gabriel), and a slew of weighted details, like the occasional presence of a parrot and a beam of light passing through a pane of glass without breaking it (both used to explain away Mary's virgin birth). We viewers tend to complain when a contemporary work is obscure and requires explanation from an artist,

curator, or critic in order for us to get it, as if the work must be self-explanatory, but in fact there are very few periods in art history that produced work that does not require any a priori knowledge, at the very least setting the historical scene, so that modern viewers do not apply today's mentality to works of the past.

A work like *Shoot*, on its own, is not particularly interesting. It became so because it was the first of the self-harm body art performances. It certainly shocked (as dramatic firsts will do). It is interesting for its shifting of the body into the fore, as the canvas. Burden repeatedly sought to harm himself in his works: He tried to breathe underwater for five minutes in *Velvet Water* (1974). He kayaked to a deserted island in Mexico and lived there for eleven days with no food and only a supply of drinking water in *B.C. Mexico* (1973). He lay on the ground, covered in a sheet and with ignited road flares set up across his body, in *Deadman* (1972)—this continued until viewers thought he was dead and called the police, who arrested him when they realized he was still alive.

A number of Burden's performances were in isolation, or near isolation. Sometimes he had a photographer with him, and that was it. This raises the question of whether these dramatic acts, performed without an audience, have the same shock value when they are experienced exclusively secondhand. If you only hear about an artwork, or see photographs or a video of it, doesn't it lose most of its power?

**Ulay/Abramović, *Expanding in Space* (1977).** SCREENSHOT FROM VIDEO COURTESY OF YOUTUBE.

Most performances have small audiences. Some of Ulay and Marina Abramović's performances, including *Expanding in Space*, were actually witnessed by just a few dozen people.[45]

Performance art is not meant for stadium crowds, nor is it broadcast online. There are exceptions, but they tend to be dismissed by artists as selling out, providing entertainment rather than serious art. An example is the celebrity magician Criss Angel, who borrowed a note from Stelarc and did a suspension, hanging from hooks embedded in his back and flown dangling beneath a helicopter, as part of his television series *Mindfreak*.[46] In our contemporary social media–frenzied era, in which we feel that what we do in life doesn't count if we don't post it online, dramatic performances that are almost unwitnessed seem a waste.

JAŠA notes that artists inevitably ask themselves the question, "How can I get the maximum amount of the public's attention in the shortest possible time?"[47] It is a fair question to ask who shock art is trying to shock. It is rarely fellow artists, critics, curators, gallerists, and collectors who are honestly shocked by an artist's actions. They are the converted—they know all about shock tactics and they relish a good scandal, but they have seen up close what artists do, they know artists personally in many cases, and they know to expect artists to push boundaries, to push metaphorical buttons, to attempt to provoke. The ones who are shocked are the general public or the informed public—two distinct groups, for the general public is unlikely to notice anything that is not wholly mainstream, whereas the informed public, the generally more educated readers of newspapers and magazines that cover culture and have Arts and Culture pages, are far more likely to become aware of happenings in the art world. The general public's attention is unlikely to result in any benefit to the artist. This group, the vast majority of the world's population, might smirk or shake their heads to learn of some artist who put hooks in his flesh and hung from the ceiling or another guy who—get this!—*shot* himself and called it art. That audience is not likely to be converted into art lovers, nor will they be buying high-end, noteworthy art. The benefit to artists comes when the informed public takes notice of a new name for the first time. And this, in turn, tends to happen only when an artist who is not yet a household name does something so noteworthy that the Arts and Culture sections decide to cover it. Thus, even if it is at a subconscious level, artists understand this and recognize that they cannot "only" create good art; to become known, to feel relevant (which leads to better income and status within the art world), they must make themselves newsworthy.

Selling art for more money and with greater consistency follows this exposure, and with it a higher art world status. That is the single best currency for artists: wealth and appreciation within the art community. While artworks rarely shock art world stalwarts, the media coverage is admired as a currency, and the art world will certainly talk about a shocking work, even if they themselves do not feel shocked by it. Cattelan's *Comedian* made international headlines but was also the talk of artists, curators, gallerists, and collectors. It hit both publics simultaneously.

JAŠA explains shock from an artist's perspective:

> Artists ask: How can we still be unpredictable? What do we mean by that and what can we achieve through that? Shock as a reality can be content already.

From the unexpected, you get a slap in your face. This slap can be extremely positive. A smell can be extremely shocking, because we're not used to the sense of smell engaged in an artwork. Imagine walking into a show with a strong stench of rotting meat. But the show is full of happy, bright, positive colors. By shocking you with the smell, I'll elevate you to a different platform of perception. Picasso once said: "You don't have to draw a pistol to be revolutionary. You can draw an apple in a revolutionary way." Artists don't just want the response to be, "Oh, I like this." They want a reaction. Especially when the art is performative, like a concert—you want the immediate feedback of the audience, the instant flow of energy.[48]

JAŠA was giving a talk on art theory in Milan in 2011 to an audience of art lovers. The talk was going well, and then he began throwing empty beer bottles out into the audience. He had calculated where to throw them and how hard so he could be sure not to hit anyone, but the audience felt they were in danger and were shocked by the sudden shift in the dynamic of the situation. They had expected to attend a theoretical lecture in which they would sit, safely and quietly and in the position of power, listening to and judging the artist's words and considering whether they agreed or not. Suddenly he was hostile, forcing the audience to participate and be active, the spotlight shone upon them. As he predicted, half the audience hated him for it and half were blown away by it.[49] Sometimes an artist can even shock members of the art world, if they can be caught unawares.

## Bernini and the Shock of the Body

Harming the body or using parts of (or expulsions from) the human body, which might be generally categorized as forms of violence, found a parallel in shock art with works that dealt with sex, gender shifts, and the capability of the body to endure pain. Some of Ulay's earliest works are from a series of photographs called *Renais Sense* and another called *S'he* (both series were explored during the 1970s). In the latter, he cross-dressed, whereas in the former, he made up one half of his face, split vertically, as if he were a woman, and the other half as if he were a man.

(The Austrian performer and Eurovision winner Conchita Wurst plays a similar game by wearing a thick beard while otherwise appearing to be an attractive woman.) This messes with one's head, quite literally, in that our definitions of human beauty, newly researched in this period, are based on symmetry—we tend to find faces more attractive if they are more symmetrical.[50] It also argues that the lines of gender should be more fluid, foreshadowing the LGBTQ+ movement by many decades. This multilayered performance even references Marcel Duchamp, who invented a female alter ego named Rrose Sélavy (a pun based on "eros" and the French phrase "C'est la vie," together meaning "erotica is life"). Renais Sense was Ulay's hybrid-gendered alter ego in these early performances. And the name is even more relevant, since there was distinct interest in gender-bending during the late Renaissance.

Ulay, *S'he* (circa 1973). PHOTO COURTESY OF ULAY FOUNDATION.

Historical artworks have dealt with gender uncertainty, including Jusepe Ribera's Baroque painting *The Bearded Woman Breastfeeding* (1631), which is a portrait commissioned by a proud husband of himself, his breastfeeding infant, and his wife, Magdalena Ventura, who had a rare condition that caused hair to grow all over her body.

*Sleeping Hermaphrodite* (1620) is a sculpture attributed in part to Bernini (the mattress is his; the figure is ancient Roman) of a beautiful individual lying naked on their stomach on a divan. From one side, it appears to be a young woman with a voluptuous

Jusepe Ribera, *The Bearded Woman Breastfeeding* (1631). PHOTO COURTESY OF WIKICOMMONS FROM WEB GALLERY OF ART.

rear end, but circling around the sculpture, viewers are surprised to see that it is a man, inevitably doing a doubletake at the sight of its penis. (If you know the name of the sculpture then it gives away the surprise, but artists did not name works regularly until centuries later and viewers of this sculpture would not necessarily know ahead of time what to expect.) This was a very early work of shock art, the reaction of the viewers, it can be inferred from the work itself, a point of delight for the artist. Bernini was already the toast of Rome and a favorite of the popes, and he loved a good joke. Among his many talents he was a playwright and set designer, and his plays were built around special effects of his own invention. *The Flood of the Tiber* (1638) featured real water bursting out from backstage and coursing toward the audience, with a trap door snapping up just in time to prevent the front rows from being inundated. The actual Tiber River had flooded the year before, so this was designed to tap into the genuine fresh memory and fear of what had recently occurred.[51] *The Fire* involved—you guessed it—the illusion that the theater was on fire. The fire was actually controlled, but this did not go over well with audiences.[52]

Bernini was the first great shock artist. This is nowhere more evident than in a pair of his famous works, which were the subject of my MA thesis: *The Ecstasy of Saint Teresa* (1647–1652) and the *Tomb of the Blessed Ludovica Albertoni* (1671–1674).

Both are multifaceted sculptures (involving his design of architectural space in the churches where they are installed, paintings and mosaics built around the main sculptures, and additional complementary sculptures, stucco work, control of light via hidden windows, and more). Both purport to show spiritual ecstasies of female holy figures. Both look like sculptures of women having orgasms.

Sexuality is another taboo barrier upon which artists can trample. It is perhaps the most obvious one to deal with, and examples of art depicting not only covert and subtle and implied sexuality, but the vivid sex act itself, can be found in ancient Greece and Rome. It was really the rise of Christianity, and its accompanying prudishness (so as not to lead those abstinent monks, nuns, and priests astray), that sexuality was obliged

Gian Lorenzo Bernini and ancient Roman, *Sleeping Hermaphrodite* (1620). PHOTO COURTESY OF WIKICOMMONS BY USER JASTROW.

Gian Lorenzo Bernini, *Tomb of the Blessed Ludovica Albertoni* (detail, 1671–1674). PHOTO COURTESY OF WIKICOMMONS FROM THAIS.

to recede into the shadows, into implications and artistic whispers. There were suggestive nudes in art, of course, but they often had to be disguised. Bronzino got away with painting an adolescent boy, his rump tilted out for maximum visibility and supposition, French kissing his mother while toying with her nipples because his *Allegory of Love and Lust* (1545) was ostensibly a painting of pagan gods, the boy being Eros and the girl Venus. The nudes were polished, more like marble statues of nudes than actual people. There was never any pubic hair painted; that was considered too much, which makes its appearance in Jan van Eyck's *Adoration of the Mystic Lamb* (1432), a work that was not designed to shock, that much more surprising. The Carracci family pulled a similar trick in their *Loves of the Gods* fresco cycle in the Farnese Gallery in Rome (1597–1608), which showed various gods trying to get it on with mortals—the sexiness was acceptable because these were pagan gods and stories that were invented (as any Christian would say) and told by respected classical writers like Ovid, painted at a time when interest in ancient Greece and Rome was at its peak and anything from that era was looked upon with respect and admiration.

"I know it when I see it," said US Supreme Court justice Potter Stewart, referring to pornography in the landmark 1964 case of *Jacobellis v. Ohio*. The film in question,

*The Lovers* by Louis Malle (1958), did not qualify as hard-core porn in the judge's eyes, and the obscenity conviction of the Ohio theater manager who screened the art film was reversed. But this case, with its famous statement, raises a good question: Where is the line drawn between erotic art and pornography?

The Cambridge Dictionary definition is not particularly helpful: "books, magazines, movies, etc. with no artistic value that describe or show sexual acts or naked people in a way that is intended to be sexually exciting."[53] There must be explicit display with *intent*

Gian Lorenzo Bernini, *The Ecstasy of Saint Teresa* (detail, 1647–1652). PHOTO COURTESY OF WIKICOMMONS FBY USER DNALOR 01.

to stimulate sexual excitement. Nudity, even explicit, without intent to stimulate is ko-sher. That means that Courbet's 1866 *Origin of the World* is art, not porn (though it was certainly accused of obscenity by its contemporaries). A close-up of a woman's lady parts was too realistic for Victorian society, even though it is decidedly unsexy. It was intended to stimulate, of course—but discussion rather than sexual excitement.

Nudity has always been acceptable in the art world, but this was largely with the unwritten requirement that the nudes be statue-like, idealized, scrubbed clean of overly realistic and close-to-home details like pubic hair. These nudes were often intended to be stimulating, however. Excusing the art because it depicted Venus rather than a real woman, gentlemen patrons sometimes kept these reclining nude paintings behind cur-tains for private enjoyment or to show off to male friends. Though such paintings seem lovely and tame from a sexual standpoint today, they must be considered in context. We live in a society hypersaturated with sexual images of the most graphic nature, which are available in abundance, everywhere, just by searching Google (while careful to erase one's browsing history afterward). Back in the sixteenth century, a fellow might never have seen a naked lady before his wedding night, so sneaking a peak at Lucas Cranach's rendition of *Reclining Venus* was pretty hot stuff. It was art, but it was also sexually stimulating.[54]

Each of these works was a one-off. But part of the distinction between art and por-nography is that art is almost always unique (and its uniqueness helps drive its value), whereas pornography is almost always mass-produced, meant for wide distribution. So what of the origin of mass-produced porn? Its story further blurs the line, because the first example was created by Marcantonio Raimondi, one of the great Renaissance artists.

Raimondi was among the most famous and skillful printmakers of the sixteenth century. He was a major artist in his own right, but he was best known for having been Raphael's official printmaker.

Raimondi created the images for the first work of printed pornography, a book called *I Modi* ("The Positions" or "The Ways"), also known as *The Sixteen Pleasures* (or, if you're into Latin, *De omnibus Veneris Schematibus*).[55]

As indicated by its title, the book was built around engravings of sixteen sexual posi-tions, based on a lost series of paintings by Raphael's pupil Giulio Romano, which he had painted for Federico II Gonzaga to decorate and provide inspiration at his Palazzo Te in Mantua (destroyed in 1630 during the War of Mantuan Succession). Raimondi first published the engravings in 1524. Pope Clement VII was unimpressed and threw him into prison, ordering all copies of the engravings burned. Like Justice Stewart, Pope Clement knew porn when he saw it, and he had seen it. But here's the catch: Giulio Ro-mano was not punished for his original paintings, because they were never intended for public viewing—only the private enjoyment of Duke Federico Gonzaga. Raimondi was quick to "borrow" the art of others, not only of the most famous European printmaker of the Renaissance, Albrecht Dürer (Raimondi had been the subject of a 1506 lawsuit for forging Dürer prints)—it turned out that Romano had no idea about the engravings and was only informed when visited by one of the great personalities of the Renaissance, and a man with a wonderfully naughty streak himself: Pietro Aretino.

Marcantonio Raimondi, "The Paris Position" from *The Sixteen Pleasures* (circa 1524). PHOTO COURTESY OF WIKICOMMONS, PHOTOGRAPHER UNKNOWN.

Aretino was perhaps the first person who was famous just for being famous, more so than for any of his actual creations: his letters, plays, or sonnets. The best friend of Titian, Aretino owned a palazzo in Venice where he hosted raucous parties. He was known as a great wit, referred to as the "scourge of princes" for his scathing repartee—something of a premodern Oscar Wilde. To get a sense of him, you need only learn how he died: The story goes that he had a stroke induced by laughing too hard at a dirty joke made at the expense of his sister. This was a man with whom you wanted to do ice luge shots.

Aretino liked the cut of Raimondi's jib and decided to compose sixteen sexually explicit sonnets to accompany Raimondi's engravings. He negotiated Raimondi's release from prison, and a second edition, now with Aretino's text, was published in 1527. This was the first time that erotic text and images were combined in print, and the first time that pornographic images (which happened to be very beautiful and by a great artist) were mass-produced for the general public. Pope Clement was still unimpressed and tried to destroy all copies of this edition too. (As far as scholars can tell, only a few fragments survive.)

*I Modi* is no historical footnote or oddity of artful perversion. It influenced the history of art. Agostino Carracci's interest in it (whether artistic or corporeal or both) resulted in an adaptation of its poses to deck out the Farnese Gallery, the second most important fresco in art history after the Sistine Chapel. The great room at Palazzo Farnese in Rome was painted by the Carracci family and their students, who were the leading academic painters of the seventeenth century (they ran an academy in Bologna that trained

the top painters of the post-Caravaggio era). The ceiling of that room (which was not so well known outside of art history circles, since Palazzo Farnese is the French Embassy in Rome and the room can only be seen on guided tours) is decked in paintings with a theme of gods gettin' jiggy with mortals, making plastic the popular ancient Latin poetry of Ovid's *Metamorphosis*.

## Burden and Shocks That Bit Back

Chris Burden's self-harm performances were one thing, but he pushed it even farther and endangered others who were not volunteers. In *747* (1973), he repeatedly shot with a pistol directly at a Boeing 747 passenger plane that was taking off from Los Angeles International Airport. At least, this is what we are told—the only witness was his photographer.[56] If, in fact, he actually shot at a moving passenger plane, what gave him the right to endanger other lives in the name of an artistic action?

The thesis of this book has been that shock has been beneficial to artists and the course of art history, but there are, of course, counterpoints to this argument. Shock without a platform, without a thoughtful concept, can be entirely overlooked and might make no lasting impact. If taken too far and without a counterbalance of rationale and sensitivity, it can also poison the well and turn out badly for the artist.

Costa Rican artist Guillermo Habacuc Vargas tied up a stray dog at the Codice Gallery in Managua, Nicaragua, in 2008. He spelled out the Spanish words for "You Are What You Read" in dog biscuits, set 175 pieces of crack cocaine in an oversized incense burner, and played the Sandanista anthem backward as a soundtrack. The dog, it is thought, starved to death. This, the artist said, was his point. He was testing the public, putting the initiative to "save" the dog on the shoulders of the audience, predicting that they would do nothing. The director of the art gallery insisted that the dog was tied up only for a few hours at a time and that the artist fed the dog regularly and then released it.[57] Whatever the case, the concept utterly failed and the artist was not just panned but became the object of overt hatred, receiving death threats. It was a total disaster in every sense, the press garnered entirely negative and of the sort more likely to promote death threats than to seal an artist's notoriety. It is one thing to injure yourself, but to injure another, particularly a helpless animal, is a shock too far.

That same year, German artist Gregor Schneider planned to exhibit a dying man as a performance. He found a volunteer with a terminal illness who was prepared to die naturally in an art gallery. He said that he hoped to show "the beauty of death."[58] The performance was never enacted, as no gallery wanted to host it. Schneider received death threats and vast quantities of hate mail. And his artistic reputation was not enhanced. He published an article in the *Guardian* to explain himself, stating, "To those who call me a coward for not putting myself up for the project, I would just like to say: when my time is up, I myself would like to die in one of my rooms in the private part of a museum."[59] He remains an artist respected for his other work, but this unfulfilled performance remains a blot on his otherwise strong résumé. It was a shock that shocked back.

Shock and even death can also have a deadening effect on the public. These days we are so used to things being shocking—wars, viruses, poverty, immigration crises, terrorism, lying politicians—that we sometimes slake them off with a shrug. Shock has become the new norm.

In 2016, the Russian ambassador to Turkey, Andrei Karlov, was assassinated at an art gallery opening in Ankara. The murderer shouted, "Don't forget Aleppo. Don't forget Syria. Unless our towns are secure, you won't enjoy security. Only death can take me from here. Everyone who is involved in this suffering will pay a price."[60] The event was captured on video. Because this took place at an art opening, many thought it was a cutting-edge performance, not an actual political murder. The gunman, who turned out to be an officer in the Ankaran riot police squad, was soon shot to death by Turkish police. JAŠA recalls the event and its video as "a cold shower for the art scene, because people thought it was a performance. And it wasn't. When you play with reality and then reality happens, not your playtime version of it, it makes you become responsible and get introspective."[61] What would have been an ingenious performance laced with political commentary was actually a real-life horror. JAŠA continues: "Where does provocation and shock end? Do we need this anymore? Maybe embracing beauty will be the new thing to provoke. Maybe today peace is provocative? The world has gone so mad that you see an actual shooting in a gallery you think that it was a staged performance. So maybe the responsibility of the artist is to make a step backwards."[62]

Jeff Koons has occasionally missed with his attempts at shock art. His *Made in Heaven* (1989) series of photographs explicitly show him having sex with his then-wife, Hungarian pornographic actress Cicciolina. The photographs had art historical relevance, modernizing some of the sexually implicit works by artists like Bernini and Rococo painters Fragonard and Boucher. These historical works were far more subtle, and Koons wanted to test the line between art and pornography. The series was a commercial success, with photographs selling for between $300,000 and $800,000 each, despite the fact that they look little different from the cheap photographs found in mass-produced hard-core magazines.[63] But it was critically panned. A review in the *Guardian* called them "cheap, tone-deaf, misogynistic images," a reaction indicative of most critics. "They don't even revile, they merely recede."[64] Their high selling price came in the 2000s, long after they were first produced and when Koons was already one of the highest-selling artists in the world (along with Damien Hirst). Had Koons not made his name in other spheres, these photographs would likely have gone entirely unnoticed. It is actually Koons's earliest work, his "equilibrium tanks" (circa 1985), in which he suspended basketballs in aquariums, that garnered him the greatest acclaim.[65]

There are other shock art attempts that draw a reaction more along the lines of "*Really*, is this all you could come up with?" In 2013, Russian artist Pyotr Pavlensky got naked, sat in Moscow's Red Square, and nailed his own scrotum to the ground. The idea was to use this action to speak out against Putin's police state, but . . . *really?*[66] He was apparently on the same page with Japanese artist Mao Sugiyama. To highlight issues in asexual rights, in 2012 he underwent surgery to remove his genitals. They stayed in his fridge at home for some time, but eventually (perhaps because he couldn't be bothered

to go to the store), he cooked them and served them to his friends. As *Guardian* art critic Jonathan Jones wittily noted, "But was it art? Hard to say without actually tasting them."[67] That sums up the danger of such extremes that do not feel, at first or even second glance, of artistic merit. The actions become the punchline of jokes and rolls of the eyes, even from art world experts who are supposed to "get it." You've gone and nailed your nuts to the pavement, and the sum result is a collective squirm and giggle.

Even acclaimed artists have hits and misses. Vito Acconci is among the pioneers of performance art, but his 1972 *Seedbed* featured an audience walking over a false gallery floor under which he was lying, masturbating, his sounds amplified through speakers. But how was this different from prerecorded sounds of an enthusiastic masturbator, and how does it comment, as the artist is said to have wished, on Nixon-era paranoia? Austrian artist Rudolf Schwarzkogler made plans to cut off his own penis as a body art performance, but he did not have the, uh, balls to follow through, so he cut off a fake member instead. He never lived it down, and some believe he killed himself as a result of the shame and sense of failure. He fell from a window in 1969, and it is unclear whether it was suicide or an accident.[68]

## Shock as a Means to an End, Not an End unto Itself

Chris Burden's later work, when he stopped focusing on bodily harm and stopped shooting himself and nailing himself to cars, is far less shocking and far more beautiful—and, dare I say, more interesting. *Urban Light* (2008), installed at LACMA, consists of tight rows of antique-style lampposts, clustered so closely together that their function as streetlamps is negated. Instead they turn into a forest of metal and light, a surrealist architectural installation that does not shock but has become beloved and iconic.

It is hard to fathom that this is the same artist who had himself shot and called it a performance.

Now we come to a trend that was first brought to my attention by JAŠA—that the big-name artists, the A-listers, the household names exhibit a trend. They shock their way to the top and once they are established—once they feel locked in place in the highest echelon, when anything they make will sell—they stop. The shocks wind down and their work becomes safer, more traditional, less edgy, and often the better for it. He notes, "What is questionable is why so many artists seem to be rebellious, seem to be against the system. But the moment they're welcomed into the system, they become good puppies, traditional and safe, shifting to paintings and sculptures, which are the easiest to sell and collect."[69]

There are countless examples. Jeff Koons has settled into his bread and butter, which are oversized metallic sculptures of things like balloon animals or his gargantuan *Play-Doh* (1994–2014) in which Play-Doh is piled in clumps far taller than a grown man. The material and scale feel like surreal matchups between the subject matter and what we associate as the "appropriate" material for them. Koons and Hirst had a lighthearted

Chris Burden,
*Urban Light* (2008).
PHOTO COURTESY
OF WIKICOMMONS
FROM FLICKR USER
SKINNYLAWYER.

competition to have their armies of assistants (not themselves—they have reinstated the Renaissance bottega tradition of master artists overseeing a vast studio, designing works, and supervising their completion, but assigning the lion's share of work to staff, which in Hirst's case at one point included 150 people, while Koons had 120 create rather straight-forward paintings). Hirst opted for "spot paintings," a supersized nod to the French Pointillism movement of the nineteenth century,[70] and then "spin paintings," where paint was applied as the canvas was in motion, the opposite to Jackson Pollock's "splatter paint-ings," in which paint was applied while the artist was in motion. It first made headlines as a pseudo scandal when it came out that Hirst employed so many people to make his artistic ideas reality. Then it made headlines when he announced that he was actually making his own paintings. Koons went in for Pop Art–style photorealistic paintings of things like lips, chocolate, hair, and corn kernels in series like *Easyfun-Ethereal* (2000).[71] The two are well aware of their shared status as the top-grossing artists in history, and they are mutual admirers. In 2016, Hirst curated a show of Koons works from Hirst's personal collection. This felt like a power play, the two big dogs of the art world inflating one another's value, and the two have been called "artist-as-CEO."[72] In an article entitled "The Art of Selling Out," Hirst was quoted as giving credit to Andy Warhol for making the monetization of an artist's career acceptable: "Warhol really brought money into the equation. He made it acceptable for artists to think about money. In the world we live in today, money is a big issue. It's as big as love, maybe even bigger."[73]

The onetime bad-boy rebels have turned into corporate giants. Koons is careful to call his 120-strong studio a "hub" and "not a factory," but this is splitting hairs.[74] Both artist giants are open about how success in today's art world is as much about PR as it is

about the art itself. There are wonderful, ingenious artists who never garner attention or acclaim beyond the narrowest of audiences, because they do not know how to sell themselves, refuse to, or have lacked luck in doing so.

The most influential artist of the late 2010s has been Ai Weiwei. The moment he fled to the West from China, he exploded. The Western world relishes the story of rebel artists in the parts of the world that are "not free." Gallerists and managers look to sign on artists from repressive countries and bring them to the "free" West to commodify them, because they sold so well. They were voices that the West wanted to hear.

But who is to say that the West is as free as we like to believe? We feel that such artists are more authentic because they have genuinely suffered. But the Western idea that suffering and repression is an elsewhere phenomenon shifted in 2016, with the Trump presidency. America suddenly had a repressive leadership, one that was openly against culture. The "Resist" movement was accompanied by an artistic movement that started after the election. This included a coalition called "Hands Off Our Revolution" begun by Berlin-based artist Adam Broomberg and featured in *Frieze* magazine in November 2016, just after the election disaster, as the resisters (and really the art world and art-conscious world as a whole) considered it.[75] Hundreds of artists signed on to the movement, which was committed to mounting contemporary art exhibits that would confront right-wing politics and populism.[76] The manifesto was signed by big-name artists, including Anish Kapoor, Ed Ruscha, Wolfgang Tillmans, Steve McQueen, and JAŠA.[77] But some artists who eventually became involved saw this movement as just another way to be seen. What started as a fine way to protest, to rebel against the new populism that was uninterested in culture, became an echo chamber. As is so often the case, well-meaning movements, publications, talking heads, media hubs, and the like wind up preaching to the converted, only heard by like-minded people, changing no minds through their efforts and ending up with much talk, some action, and no discernible effect.

It can be difficult to distinguish rebellious energy from PR stunts, just as it can be hard to separate shock art for shock's sake from shock art for art's sake.

Art lovers have a good radar system. There are those who interact with art for the bling, the prestige, the bragging rights, the investment alone—they are not necessarily art lovers in the pure sense. Walter Benjamin famously wrote that great art has an "aura" about it that we cannot explain scientifically, there is a mysticism to it, and that is what makes it great.[78] That "aura" is something that can be sensed, a sort of inarticulate vibe, and Benjamin thought it had to do with authenticity.[79] He was writing about this in the sense of a work not being a reproduction, but it also resonates in terms of authenticity as honesty: art from the heart, not just the mind. The true revolutionary artist is creating work for a better cause, not for ladder climbing.

We art critics and historians tend to be good bullshit spotters. If our radars are set off by a work here and there by an otherwise great artist, this does not mean the artist's entire oeuvre should be dismissed. We all, in any creative profession, have ups and downs. But we tend to judge artists by whatever we first learn of them. If our first and only introduction to poor Pyotr Pavlensky was of his nailed scrotum, then our opinion of him as an artist would be about as positive as a hammer to the testicles. Acts such as his recall the

antics of the MTV series *Jackass*, not artistry. We will have to muster great drive to delve further, because our instinct is to dismiss. So that shocking artwork designed to summon attention must be carefully chosen by the artist, or else their big chance to make a first impression will have been squandered and will result in our thinking poorly of them. But if the first big shock is ingenious, like Damien Hirst's shark in a tank, *The Physical Impossibility of Death in the Mind of a Living Person*, or Tracey Emin's *My Bed*, then the shock will result in positive aftershocks and a new star pulleyed up into the constellation of artists we admire.

Once an artist is up there, a star in our night sky, then they no longer need to resort to shock to command our attention. They already have it, and we will give due consideration to everything new they offer up. This is where we can spot the trend: It feels like artists who once shocked feel a sense of relief to no longer have to play the exhausting PR game and are content with making art that would not necessarily make headlines but is often better than art that does.

When Chris Ofili established himself as a household name, made for life, he literally moved to an island, shifting from hectic London to relaxing Trinidad. Once he had made it, he no longer needed to do the rebel thing. He admits that he felt "suffocated by his images as the elephant dung YBA [Young British Artist]."[80] Now he makes perfectly good, but uncontroversial, works, like his tapestry *The Caged Bird's Song* (2017) and paintings like *Forgive Them* (2015). Artists play the provocateur until they are in the club, and then they play the good boy and shift to more straightforward works that are, dare we say it, Aristotelian.

Tracey Emin's latest work is as a classical painter in the vein of Egon Schiele. It's fine, well-executed, a bit edgy in that her subject is nudes with explicit naughty bits—but it is also a bit boring. It looks like an admirer of Schiele trying to do a Schiele-like original work. During my research for this book, I was browsing paintings by Emin and stopped at one I thought was truly excellent, which she stood before proudly in a photo. I clicked on it. Turns out it was by Schiele. In an exhibit of her work at the Leopold Museum in Vienna in 2015, Emin included some Schiele works from their permanent collection among her own. The juxtaposition does not flatter her, but the main point is that she is no longer trying to woo the tabloids with her art.[81] After a career of progressive works, she now does paintings of the sort associated with the male Expressionist tradition. If they were exhibited without Emin's name, they wouldn't have anywhere near the same value and would go largely unnoticed. Still, some artists so enjoy being newsworthy that they see no reason to stop: In 2016, Emin claimed that she married a stone in a special ceremony in the south of France. Some are incorrigible.[82]

# CHAPTER 3

# Rivalry

Step inside the Florentine church of Ognissanti (All Saints) and the heat of the summer air riveting itself to the khaki stone of the city will quickly dissipate as the dark coolness of the interior welcomes you in. You'll be struck by the scents: votive candle wax, leftover incense, a hint of moisture trapped in ancient stone. And then you see the fraternal twin treasures held within.

In 1480, Sandro Botticelli, one of many great painters living in Florence, was commissioned to paint Saint Augustine of Hippo for this, his neighborhood church. Botticelli was born on this very street and spent his entire life within a short walk of it. He's there to this day, buried inside. It was a street populated with figures of note, including the Vespucci family (North and South America were named after a member of that family, explorer Amerigo).[1] The Vespucci were wealthy merchants and were friendly with Botticelli, and it was Amerigo's father, Nastaglio, who commissioned *Saint Augustine in His Study*. But the family also commissioned another painting for the same church, *Saint Jerome in His Study* by Domenico di Ghirlandaio.

Two famous saints and early church doctors, historical figures who were idols for Renaissance humanists, commissioned of the two leading painters, not only of Florence but of this very neighborhood in Florence. It was clear to all that this was a friendly competition, an artist's duel. Which painter would depict his assigned saint in a more interesting way? This was not a question of quality—the artists involved were already considered to be the very best. It was about subtle variation and interpretation, what they would have called *invenzione*—the concept behind an artwork, before it is executed. The ability to implement your concept and manifest it in paint (or ink, or stone, in the case of sculptors) was called *disegno*. So this was more a conceptual duel, about the way an artist entirely capable of *disegno* of the highest level would interpret the subject at hand. Intellectuals like the Vespucci family would have taken great pleasure in showing their wealth and erudition in commissioning such elite artists and giving them a scholarly subject. And one can imagine the Vespucci delighting in visits to the church with friends, to stand before the paired paintings and discuss their relative merits and which was any given viewer's subjective favorite.

Sandro Botticelli,
*Saint Augustine in
His Study* (1480).
PHOTO COURTESY OF
WIKICOMMONS FROM
THE YORCK PROJECT.

Domenico di Ghirlandaio, *Saint Jerome in His Study* (1480). PHOTO COURTESY OF WIKICOMMONS FROM ART UNFRAMED.

Such competitions were great fun for the public and for patrons. While they were probably not fun for the artists (too much pressure), they did encourage artists to up their game. As Ronald Lightbown wrote, artistic duels were "always an inducement to Botticelli to put out all his powers," and the same might be said for any artist.[2]

## Vasari and Competition for the Greater Good

Capitalist economic theory tells us that competition is good. It encourages better and less expensive products, as competing producers seek to outduel each other for thicker slices of the market. This is also better for consumers, who have options to choose from, with products always improving and prices kept reasonable and often lowered as producers try to attract consumers to their offering over their rivals'.

But does this transfer to the world of art? Unlike a smartphone or a pair of socks or a jar of mayonnaise, artworks tend to be unique, high-end, important creations. Even art made in serial, like prints, is numbered and finite, increasing its value. We are not talking about art in the sense of just something to stick on a white wall. Our interest is in art that is prized for its rarity, authenticity, and demand. Did the likes of Bernini and Borromini really compete over who could design a better church, the advances made by each improving the overall final product for the client? Did competition over pricing of works between Roman and Dutch painters in seventeenth-century Rome really result in better executed, less expensive paintings, to the benefit of commissioners? And was a less expensive option inherently better for anyone but the patron's accountant? When commissioning a magnificent altarpiece or portrait of a king, do you really want one of the key adjectives describing it to be "cheap"? And was it good for art, as a whole, to have Caravaggio threatening to beat up any rival who imitated his distinctive artistic style?

As we shall see, rivalry has indeed stimulated the art world, but not in a way that mirrors economic theory. Art defies and overarches economics—that is one of its charms. Rivalry tends to drive prices up rather than down, because higher prices are seen as assurance of better art. And since authentic, important art does not lose value, it is a strong investment.[3]

Rivalry does stimulate innovation. A patron in, say, fifteenth-century Florence had an embarrassment of riches to choose from when on the lookout for an artist to paint, for example, an Annunciation for their family chapel. Ghirlandaio or Botticelli? Castagno or Pollaiolo? Filippo Lippi or Verrocchio, or even a young Leonardo? Among top-tier artists, competition sought to win high-profile commissions, not drive down prices. Paying top dollar (or, back in fifteenth-century Florence, top florin) was a point of pride for patrons, and the art was expected to be elevated in line with the price. It was not uncommon to commission intentional artistic duels, with rival artists each asked to create a work for the same space, works that would be displayed in proximity so visitors could see them both, side by side, and discuss their various merits and which they prefer. The Botticelli versus Ghirlandaio example is only a short stroll from another, in the Palazzo Vecchio in Florence, in which Leonardo and Michelangelo were each commissioned

to paint an enormous fresco of a battle scene on opposite walls of the vaulting Sala dei Cinquecento.

Leonardo began his wall painting, a work in oil (very unusual for a wall painting, where tempera was the tried-and-true medium) showing a scene from a 1440 battle later referred to as *Battle of Anghiari*, but was called away and left it unfinished.[4] Michelangelo made a fully worked-up cartoon for the central portion of his subject, *Battle of Cascina*, but he never began the mural. There is some thought that Michelangelo may have felt he'd been given the lesser side of the wall, with worse lighting, and was therefore at a disadvantage.[5] In fact, he was called to Rome by Pope Julius II in 1508 to paint the Sistine Chapel ceiling, while during this time (1501–1505), he was still in the design and preparatory drawing phase of this project, so the *Battle* painting in Florence had to take a back seat, and when Leonardo likewise abandoned the commission neither returned to it.

Leonardo abandoned his unfinished painting. He was notoriously impatient and rarely completed anything—he was known to have lingered over paintings. *Mona Lisa*, for instance, was touched up so often and so slowly that it was never actually given to its patron. There are around fifteen extant Leonardo paintings, ten of which might be described as "finished." This is a small number but is just as indicative of Leonardo's many professions (painting being but one of them) as of his habits of rarely considering a work

Peter Paul Rubens, *Copy After Battle of Anghiari by Leonardo* (1603). PHOTO COURTESY OF WIKICOMMONS FROM WEB GALLERY OF ART.

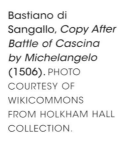

Bastiano di Sangallo, *Copy After Battle of Cascina by Michelangelo* (1506). PHOTO COURTESY OF WIKICOMMONS FROM HOLKHAM HALL COLLECTION.

complete and skipping from one project to the next. Leonardo's efforts disappeared when Giorgio Vasari was asked to renovate the room, completely rebuilding parts of it and expanding its scope as well as frescoing the walls and painting the ceiling compartments, all at the behest of Duke Cosimo I de'Medici; its fate—likely preserved beneath a false wall erected by Vasari—remains one of art history's great unsolved mysteries.[6]

Another short stroll further through Florence takes you to the Brancacci Chapel, home of a fresco cycle by Masaccio (circa 1425) that was a point of pilgrimage for all artists in Florence. It was one of the earliest works to shift toward realism, showing figures from behind, not just face on and profile, giving them distinctive emotions, and painting them so that they appeared to have weight and mass, standing on solid ground, as opposed to the earlier tradition of figures sort of semi-floating above the painted ground. Students would spend hours sketching these frescoes, and naturally, rivalries would manifest. A young Michelangelo was so superior in his sketches (and so full of himself, mocking his fellow students) that he managed to provoke one of them, Torrigiano, to the point where Torrigiano punched Michelangelo in the nose—and broke it. This would lead Torrigiano to leave Florence—he spent his career in London and is responsible for the wonderful sculptures in Westminster Abbey—and left Michelangelo with a distinctive boxer-like visage.[7]

There were also stylistic rivalries. Siena, Florence's neighbor and competitor until it was conquered and subsumed within the Duchy of Tuscany, favored what is now called a Sienese Gothic style of painting, continuing the medieval tradition of intentionally more two-dimensional altarpieces on a gilded ground, with Duccio being the leading light. Meanwhile, in a Jets-versus-Sharks sort of situation, Giotto was the contemporary star of Florence, painting in a more realistic style, with more depth, shadow, three-dimensionality, and sense of mass in his figures, who obeyed the laws of physics while Duccio's did not. Both were star pupils of the same master, Cimabue. Each was the champion of his city-state.

Duccio, *Maesta*
(circa 1285).
PHOTO COURTESY OF
WIKICOMMONS FROM
GOOGLE CULTURAL
INSTITUTE.

Cimabue, *Maesta*
(circa 1280).
PHOTO COURTESY OF
WIKICOMMONS BY
USER GHISLAINN.

Giotto, *Maesta*
(circa 1310).
PHOTO COURTESY OF
WIKICOMMONS FROM
GOOGLE CULTURAL
INSTITUTE.

When each painted the same subject, *Maesta*, Madonna enthroned (a subject also painted by master Cimabue), the works were injected with a sense of competition, with Sienese and Florentines inevitably favoring their local hero. This comparison of rivals makes great sport for modern art history students, who can admire and contrast all three *Maesta* paintings in the same room in the Uffizi Gallery.

One should not think that Florence was the only hot spot for pugnacious, combative rivalry among artists. High-end commissions were always scarce and to be competed for, and rivalries between cities could lead to throwdowns among artists. There was consternation that Jan van Eyck, a painter from Bruges, should have been responsible for the greatest artwork of the rival neighboring city of Ghent, *Adoration of the Mystic Lamb* (1432). It had originally been commissioned of his brother, Hubert van Eyck, who lived in Ghent, but when Hubert died in 1426, his first year working on the triptych, Jan took it over, and this was not met with universal approval.[8]

## Pliny and the Artistic Duel

The history of artistic duels has a specific origin story, likely apocryphal. It is told in Pliny the Elder's *Natural History*, a magnum opus of the ancient Latin world, published starting in 77 CE and totaling ten volumes divided into thirty-seven books. It is Pliny's last work (probably of many) and the only one that survives. It was the forerunner of all encyclopedias, and among its many sections, it covered painting and sculpture. It was hugely influential to the Renaissance, the very name in French meaning "rebirth" and referring to a rebirth of interest in the classical world. Printed book versions were published in Venice in 1469 and 1472, based on some two hundred extant manuscripts. It was de rigueur reading for anyone of scholarly sympathies and with a knowledge of Latin, and it would have been fresh in the minds and conversations of people like the Vespucci when it came to commissioning art circa 1480.

In *Natural History*, Pliny tells the tale of Parrhasius and Zeuxis, rival painters in ancient Athens. The story is brief, but is resonant for the history of art.

> Parrhasius is reported to have entered a competition with Zeuxis, and when [Zeuxis] painted grapes so successfully that birds flew down to the panel, [Parrhasius] painted a linen drape, portrayed so truthfully that Zeuxis, puffed up with pride about the birds' judgment, demanded imperiously that [Parrhasius] lift the drape and reveal his picture. But when [Zeuxis] understood his mistake, he conceded the victory to Parrhasius with sincere deference, because he may have fooled the birds himself, but Parrhasius had fooled a fellow artist. It is said that later Zeuxis painted a boy carrying grapes, and when the birds flew to that, too, with the same sincerity he angrily addressed his work and said "I painted the grapes better than I painted the boy, because if I had painted him right, the birds should have been afraid."[9]

Pliny's tale of two ancient painters who duel one another to see who is superior is a classic that may have never happened, but it set a standard moving forward. Zeuxis painted

grapes that were so realistic that it fooled birds—a pretty good trick. Parrhasius, however, was able to fool a human, Zeuxis, into thinking that a curtain covered his painting when, in fact, the curtain *was* the painting. Fooling a human trumped fooling an animal. Fooling the human eye into thinking that a painting was a real view, a mirror of the world, was the goal of painters throughout history, until the invention of photography made hyperrealistic painting no longer important, as photographs took over the role of accurately reproducing images, freeing painting to do other things, like abstraction.

This memorable anecdote set two important standards. First, it encouraged the course of art, and the goal of the most prominent artistic movements, over the next two millennia, to be realistic illusionism. And second, it encouraged us to pit artists and styles against one another, judg-

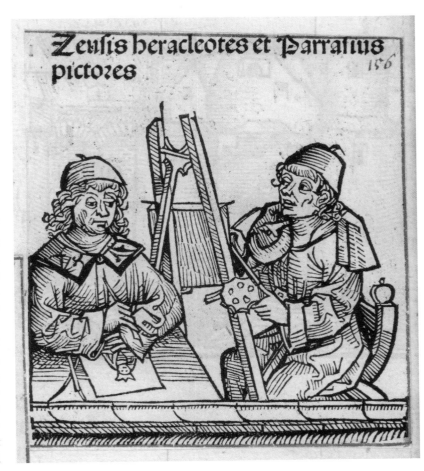

Michel Wolgemnut, *Zeuxis and Parrhasius* (1493), woodcut engraving from a printed book illustrating the story from Pliny.
PHOTO COURTESY OF WIKICOMMONS FROM RIJKSMUSEUM.

ing which is superior, when in fact this is usually a subjective judgment, a personal opinion rather than an absolute fact. This duel among artists makes for a good storyline, and we humans are programmed to think in terms of opposites, antagonists and protagonists, good and evil. Real life and true history rarely fit such a bipolar worldview, but narrative can.

One of the reasons the story and its two standards influence our thoughts on art is that it was retold by Giorgio Vasari in his influential and popular book *Lives of the Most Eminent Painters, Sculptors, and Architects* and paralleled in many of the chapters that focused on rivalries, including the aforementioned Duccio versus Giotto. And Vasari turned true history into a narrative.

Vasari was court portraitist to the Medici family in the sixteenth century, architect of the Uffizi (now a famous museum but, as the name implies, built as the offices for the Duchy of Tuscany) and the leading artist of Florence during his time.

But he is best known as the godfather of art history, his *Lives* considered the first proper book on art history, an encyclopedic group biography of famous artists, with editions published in 1550 and 1568. Vasari's agenda was to show that Tuscan art was best,

Plate of Giorgio Vasari from *Le Vite* (1568 edition).
PHOTO COURTESY OF WIKICOMMONS FROM HOUGHTON LIBRARY, HARVARD UNIVERSITY.

GIORGIO VASARI PIT. ET
ARCHITET: ARETINO

and that the course of art moved from less realistic to more so, culminating in the work of his friend Michelangelo. Vasari's narrative often set one artist or style against another, particularly highlighting his chosen good guys (Michelangelo, Giotto, Brunelleschi) and bad guys (Andrea Castagno, Baccio Bandinelli) and twisting the historical record to suit his tale. But Vasari told a good story, and his book was so popular that it cemented the way we think about art, even today. It also was written in the vernacular, Italian, and translated widely, so it was read by a public that might not have encountered Pliny directly in Latin, the language of the highly educated and the clergy.

The second standard set by the anecdote was the direct comparison between two artists and their work in competition, formal or informal, to determine which was better. In

practice, especially when it comes to artists of the highest level, "better" is subjective. But it is also great fun. What is the best novel ever written? The best song? Such questions do not actually seek to define an objective truth. This is not about the fastest runner or the strongest lifter; it is about opinion and the pleasure of debate leading to subjective conclusions.

The best and most oft-referenced rivalry stories of Renaissance artists come from Vasari. It was knowingly, and knowing that his readers would catch the reference, that Vasari included several updates on the Parrhasius versus Zeuxis battle royale. Vasari's first artist duel tale, the one we mentioned earlier, is of how Giotto trumped his mentor, Cimabue, in a manner that is meant to recall Pliny's story of Parrhasius versus Zeuxis.

> It is said that when Giotto was still a boy working with Cimabue, he once painted a fly on the nose of one of Cimabue's figures, so lifelike that when the master returned to resume his work, he tried more than once to swat it away with his hand, thinking that it was real, before he realized his mistake.[10]

This is one of many stories in *Lives* that we cannot be expected to believe as fact. It is, rather, a trope—a standard tale used by many authors to demonstrate the illusionistic powers of great artists. It also illustrates how Vasari pitted one style against another to find out which was "better." Dante wrote a similar text in the 1320s in his *Purgatorio* (Canto XI):

> Cimabue thought that he held the field in painting
> But now Giotto enjoys the acclaim
> The shadow of one eclipsed the other.[11]

The apprentice surpassing the master is a regular literary trope. The sequence of rivalry stories told by Vasari goes on and on, hammering home the point that artists lived in direct competition with one another.

The most important point to take from *Lives* is that its influence was so broad and long-lived that what Vasari thought about the artists he immortalized is what the general public has come to think about them. Aside from specialists, like art historians, if the world at large knows something about Renaissance artists, Vasari is the font of that knowledge. This means that Vasari's personal opinion and theoretical agenda have colored the way we approach all Renaissance Italian artists. This is why, if you stop a random person on the street and ask them to name a famous Renaissance artist, nine out of ten will name Leonardo, Michelangelo, or Raphael. If they grew up as fans of the Teenage Mutant Ninja Turtles franchise, they might add in Donatello, but he lived a generation earlier than the others, so he should not really be among the namesakes of the ninja turtles. The fourth should actually be Titian, for he was a strong and proactive rival of the aforementioned three.

## Titian and Renaissance Rivalries

*Renaissance Rivals* by Rona Goffen (2002) is a classic art history book, standard reading for Renaissance studies. It is a group biography of Raphael, Leonardo, Michelangelo,

and Titian. These were the big four in the first decade of the sixteenth century. The first three were from central Italy (Raphael was from Urbino but worked mostly in Rome; Leonardo and Michelangelo were Tuscan). Titian was Venetian, and Venice was its own superpower city-state with little to do with the rest of the Italian peninsula. (Recall that Italy did not exist as a unified country until the nineteenth century, so in the Renaissance it was an assemblage of duchies and city-states, each run by a noble family independent from and often antagonistic to their neighbors.) Venetian art, as Vasari tells us, focused on *colore*, color, whereas central Italian art developed around *disegno*, which in this case does not refer to the skill of artistic execution but drawing, draftsmanship. In the simplest terms, the distinction was thus: Central Italian painters would draw first and then color in their underdrawings with paint, while Venetian painters tended to apply paint directly to canvas or panel. This is an oversimplification, but it is one that Vasari described and has been passed down to us, with Venetians considered the masters of color and Tuscans the masters of drawing.

In 1510, at the heart of the High Renaissance, there was a great four-pointed rivalry among Italian painters. The leaders in the field, Raphael, Michelangelo, and Leonardo, hailed from the belt across central Italy. But marvelous things were happening in Venice as well, most notably the buildings of a transplanted Tuscan architect named Jacopo Sansovino, and the career of a painter named Titian.

Vasari throws in backhanded compliments to the great Titian (though the two were friendly), who he claims would have been so much greater if only he had employed the Tuscan style of focusing on drawing. But Titian could not be ignored, since his success throughout Europe was indisputable; he was a favorite of the Habsburgs, and there are more of his paintings in Madrid, the Habsburg capital, than in Venice.[12] It is difficult to tell whether Vasari's opposition to the Venetian style was heartfelt or more about siding with his fellow Tuscans. He described Titian as "the most excellent of all the others": the best of what Venice had to offer, with the implication that all of that Venetian business was well and good but would have been much improved had they all studied in Rome and practiced drawing. What results is Vasari's presentation of a rivalry of places (Tuscany versus Venice) and their styles (*disegno* versus *colore*).

The question of how artists did, or should, go about their craft is a question that Vasari deals with in many of the stories in his book, as debates raged through the fifteenth and sixteenth centuries on technique, both theoretical and practical. This loaded opening section to the life of Titian manages simultaneously to praise and undermine Venetian painting, incorrectly considering that the city's distance from Rome meant that artists of the Veneto were not "able to study ancient works" (there were of course ancient works throughout the territory that once was the Roman Empire) and also setting up a delineation from Venetian-style painting. The Tuscan focus on the drawing (*disegno*) itself was both to play around with the composition until it was just right and then map out the final before adding paint. This involved preparatory sketches on paper as well as full-sized cartoons (from the Italian word, *cartone*, meaning "large paper") that could be literally used to transfer the drawing onto a wall or panel (either by punching pinholes along the lines of the drawing and blowing ash through them or by under-drawing directly on

canvas or panel and then painting over it). Never mind that Venetian painters did draw and that Giorgione did not invent the mode that Vasari attributes to him; because of Vasari's predominance, his dichotomous description of Tuscan versus Venetian painting styles was believed, internalized, and taught for centuries.

According to one story, we have scheming Bramante to thank for the fact that Michelangelo received the commission to paint the Sistine Chapel. This is an apocryphal anecdote that comes from a 1553 biography, *La Vita di Michelangelo* by Ascanio Condivi. It has since been discredited, but its resonance is such that I was taught it as fact in my college art history classes.[13] The gist is that Bramante was nervous about his contemporary but thought Michelangelo would never be able to pull off a massive fresco, as he'd never worked in the medium. He arranged for Michelangelo to receive the commission for the ceiling, very much against Michelangelo's wishes. With *Pieta* in Rome and *David* in Florence, Michelangelo was at the top of his game as a sculptor and could afford to pick and choose his projects, choosing only the grandest. It was then, in 1504, that he was invited to participate in the "artist's duel" of battle scenes for the Sala dei Cinquecento. He would have seen it not just as a friendly competition, but also as the passing of the mantle of Florence's leading artist from the older Leonardo to him.

Then Pope Julius II called and honored Michelangelo, by then considered the leading sculptor in Italy, with the request to carve forty statues for his tomb. Michelangelo was likewise to be entrusted with architectural work on St. Peter's, but when estimates came in, the pope backed off. Michelangelo's ideas were apparently too rich for the papal coffers, though Michelangelo suspected that Bramante, the current architect of St. Peter's and a papal favorite, had whispered words against him. Instead, he was asked to prepare an enormous bronze of the pope for display in his native Bologna (which, alas, was destroyed when the citizens drove the papal army out of the city). As a possibly apocryphal story goes, in order to scuttle the aspirations of a rival, Bramante convinced the pope to assign Michelangelo a project he would surely fail to pull off—the frescoes in the Sistine Chapel.

The Sistine Chapel was already painted when Michelangelo arrived. The cream of the late fifteenth century, including Botticelli and Perugino, had decorated the upper registers of the high walls of the room, and the ceiling was covered in blue and gilded stars. If his treasury could not support a tomb studded with forty life-size statues, Pope Julius determined to make his mark with the relatively inexpensive repainting of the ceiling, and he assigned Michelangelo the task, which would take him four years beginning in 1508.

The original theme was to be the twelve apostles, and the seven prophets and five sibyls integrated into the ceiling today are a trace of this. The ceiling was meant to be a secondary attraction to the finished works on the walls, but Michelangelo had other ideas. Ceiling frescoes rarely showed scenes from history and the Bible, usually showing instead individuals or clusters of angels or (in later periods) trompe l'oeil views of the sky. Michelangelo's scheme was radical in that he would include painted architectural features and massive statuesque individual figures as well as entire scenes from the Old Testament. He started with the story of Noah's Ark and painted it to completion before determining that he had made the figures too small to view comfortably from the floor. But rather than repaint the scene, he left it, and viewers today can see clearly that the painter decided

Michelangelo,
Sistine Chapel
(ignudi detail)
(circa 1508–1512).
PHOTO COURTESY OF
WIKICOMMONS BY
USER ENWIKI.

to "zoom in" for the other scenes to make them more legible from nearly one hundred feet below. The intentionally contorted bodies, the visual preference to make paintings that looked like painted sculpture, the DayGlo bright colors, cemented Michelangelo's unique style, which would become the mannerist movement in the hands of his followers.

If Bramante had indeed schemed, then his plan certainly backfired. Michelangelo created what would become the world's greatest fresco—and then continued in the medium, painting his *Last Judgment* on the wall of the same room. Raphael, a close friend of Bramante, later created a rival fresco, *Fire in the Borgo*, in the papal apartment next door, in which he mocked Michelangelo's style while at the same time demonstrating that he could do it just as well. In doing so he demonstrated his admiration for Michelangelo, even if his preferred aesthetic differed. He and Michelangelo were the twin peaks of painting in Rome, and it shows a certain subconscious lack of confidence that Raphael felt the need to demonstrate, in a work of art, that he could "do" Michelangelo's style but just chose not to. Michelangelo, more self-confident and comfortable with his position, never felt the need to show himself capable of painting like Raphael.

If this early history of artistic rivalry feels very Vasari-focused, it is with good reason. His book has so colored the way we think about art and artists that the biggest stories of competition and rivalry prior to the publication of his *Lives* were codified by him. In many cases, his is the only surviving textual source to attest to them.

Perhaps the most famous of his competition tales focuses on a public call in 1402 for designs for the *Gates of Paradise*, bronze-cast reliefs to decorate the portal to the Baptistry of Florence's cathedral. This contest pitted the greatest sculptors of the era head-to-head, including Donatello (only twenty years old at the time), Lorenzo Ghiberti, and Filippo Brunelleschi, a goldsmith.

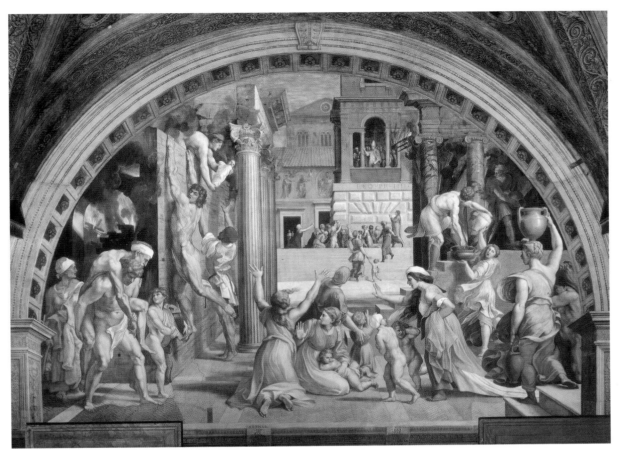

Each competitor was asked to prepare a single relief sculpture in bronze depicting the sacrifice of Isaac theme. In the end it came down to Ghiberti versus Brunelleschi, and Ghiberti's design won the day. But the long-term winner was Brunelleschi, who, in 1418, well into middle age, managed to best other architects in a related competition to build the dome above the cathedral.

Like Giotto, at least in Vasari's telling of the story, Brunelleschi obtained the commission by a display of unconventional cleverness:

> The [other architects] wanted Filippo to describe his intentions in detail and show his own model, as they had shown theirs. He had no desire to do so. Instead he put this challenge to the masters, both Florentines and outsiders: whoever could balance an egg upright on a marble slab should make the cupola, because in this way their ingenuity would be seen by all. An egg was provided, and all these masters tried to make it stand up straight, but none could find the way. When they finally told Filippo to make it stand still, he graciously took the egg, smashed its bottom onto the surface of the marble—and up it stood. When they all protested loudly that they could have done the same thing, he

Raphael, *Fire in the Borgo* (1514–1517).
PHOTO COURTESY OF WIKICOMMONS BY USER ARTWORKSFOREVER.

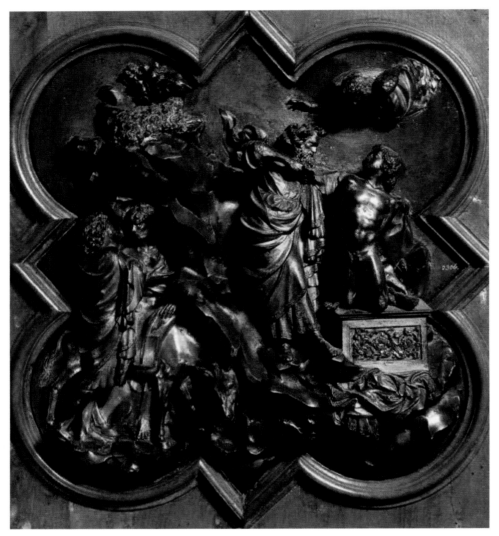

Lorenzo Ghiberti, *Sacrifice of Isaac* (1401). PHOTO COURTESY OF WIKICOMMONS FROM WEB GALLERY OF ART.

replied, laughing, that then they should also have known how to vault the cupola, with its model and blueprint in front of them. And so it was decided that he should have charge of this project.[14]

Brunelleschi declares that this test will reveal what he calls the architects' *ingegno*, a word that means wit and intelligence and ingenuity and creative power and genius all rolled together, and in this anecdote, Filippo demonstrates every one of these qualities. His *ingegno* is what wins him the commission in the first place, but it is also what enables him to complete it, by taking a trip to Rome and studying the dome of the Pantheon; its double-shelled concrete structure provides him with a model for how to put a roof over the yawning center of the unfinished cathedral.

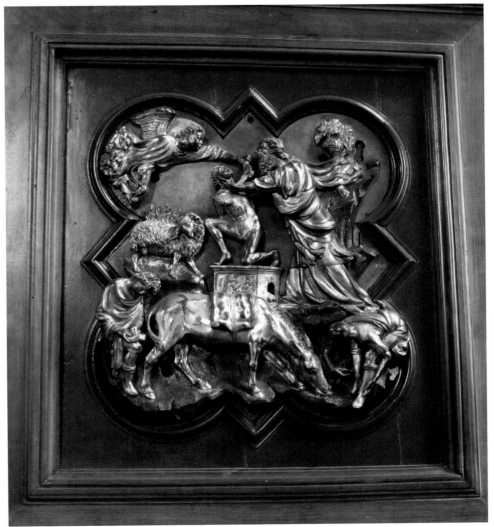

Filippo Brunelleschi, *Sacrifice of Isaac* (1401). PHOTO COURTESY OF WIKICOMMONS BY USER SAILKO.

## Borromini and Rivals after the Age of Vasari

Most of the stories of competition and rivalry that were committed to writing after 1568, the year of Vasari's second edition of *Lives*, came from biographers emulating what *Lives* had accomplished and seeking to update it. Some of these biographers were artists themselves; others had bones to pick with the artists about whom they wrote or, like Vasari, personal stylistic or political agendas to advance through their texts.

The rivalry trail continued into the Baroque era, circa 1600, a generation after Vasari's time. We have already discussed the Caravaggio versus the world dynamic in the

introduction and will continue it in the conclusion. But other contemporaries found similar rivalries, sometimes with subterfuge and fisticuffs at play. Domenichino, who trained in Bologna at the Carracci Academy, the leading painting school of the seventeenth century, traveled to Naples to fulfill an elaborate commission for frescoes in the Royal Chapel of the Treasure of San Gennaro in the Cathedral of Santa Maria Assunta. The trouble was that local painters—some Neapolitan, others foreign residents of the city (like the brilliant Spaniard Jusepe Ribera) who felt that it was their territory—saw Domenichino as an outsider stealing their commission.[15] They embarked on a gangster-style sabotage mission to ruin Domenichino's work and chase him and his family out of the city, including vandalizing his work and leaving a warning note stating, "Beware your many enemies. No door cannot be opened. Leave Naples or fear death everywhere."[16] The plan worked. He left the city in fear in the summer of 1634 and returned only after the deputies of the city said that they would personally guarantee his security. He came back in June 1635 and worked until April 6, 1641, three days after he'd drawn up a will. On that day he died—poisoned, his wife claimed, by the "cabal of Naples," a term used to reference Ribera, Greek artist Belisario Corenzio, and Neapolitan Battistello Caracciolo, who allegedly engaged in gangster-ish behavior to dissuade competitors.[17]

This was not an uncommon narrative: locals feeling threatened by outsiders with talent and some hype doing their best to chase them off. So it was in Rome, where gangs of local painters (which always sounded to me like a Monty Python sketch, as we tend not to think of painters as pugnacious) literally got into street fights with a gang of painters from the Netherlands and Belgium who had transplanted to Rome and found success painting less expensive, smaller-scale works for an upper-middle-class market.

In Rome, a rivalry unspooled in the realm of church architecture. Rome's two leading Baroque architects were equally ingenious but could not have been more different characters. Gian Lorenzo Bernini was high-strung, violent, hyperactive, and brilliant at everything from painting to sculpture to special effects he made for his own plays and for papal masses. (He made clouds billow into St. Peter's on cue, when the pope mentioned clouds in his sermon.)[18] Bernini was a highly antagonistic and quirky fruitarian who lived to the age of eighty-two; as mentioned in chapter 1, he tried to kill his brother, whom he suspected of an affair with his mistress, and disfigured the mistress in revenge for the alleged affair. He was not a nice man, but undoubtedly a genius.

Francesco Borromini, by stark contrast, was a depressive introvert who was highly specialized. He possessed an attention to detail and ignorance of the game of courtly life that meant that he was a brilliant architect and nothing else. The two chased the prime commissions of Rome, with Bernini the far better mover-and-shaker, but when it comes to architecture, historians tend to favor Borromini's detail-oriented jewel boxes.

When examining two churches side by side, each just a short stroll from the other, it is difficult to determine the "winner," if indeed there was one. Bernini's Sant'Andrea al Quirinale and Borromini's San Carlo alle Quattro Fontane do a lot of the same things well. They both feature ornate coffered ceilings defined by curved outlines of cornices. Borromini was in love with whiteness and tried his best to have only white interiors—he'd have preferred no paintings and no gilding.

Francesco Borromini, detail of San Carlo alle Quattro Fontane (1634–1635).

Gian Lorenzo
Bernini, detail
of Sant'Andrea
al Quirinale
(1658–1670).
PHOTO COURTESY
OF WIKICOMMONS
BY USER
LIVIOANDRONICO.

At San Carlo alle Quattro Fontane, he was only able to negotiate a minimalist approach by Baroque standards. It is mostly white with limited gilding, but garishly colored paintings are displayed, detracting from the almost Calvinist minimalist palette he would have preferred. Made several decades later but with his old rival firmly in mind, Bernini's church enjoys the luxurious excess of gilding and feels like a jewel-encrusted gold pinky ring to Borromini's sleek white gold wedding band. Both inspire awe, but Borromini has a sweetness and tenderness that charms, whereas Bernini wallops you over the head with bling.

## Velázquez and the *Ut Pictura Poesis* Debate

Contemporary to the Bernini versus Borromini dance was a lively debate over which artistic medium was best. It likewise starred Bernini, but now wearing his sculptor hat, and was set against the leading painter of the era, the Spaniard Diego Velázquez.

In the sixteenth and seventeenth centuries, artists and intellectuals liked to debate the relative merits of painting versus sculpture versus poetry. Which was the best art form? Today it seems clear that all are great and each does different things well. But back in the day, this was a hot topic of conversation, referred to as the *ut pictura poesis* debate, drawing from a line by the Latin author Horace, which translates roughly as "as

in painting so in poetry."[19] The curators of the Doria Pamphilj Gallery in Rome have done an admirable job setting up a special room in which this debate comes to life, juxtaposing two portraits of the same person, Pope Innocent X of the Pamphilj family (1574–1655, and pope for the last ten years of his life), in a painting by Velázquez and a bust sculpture by Bernini.

Velázquez made this portrait in 1650 during a visit to Italy, where he was sent by his patron, Philip IV, to acquire art for the royal collection in Madrid. Velázquez paints in a painterly manner—meaning that brushstrokes are evident, the painting clearly composed of blocks of color. You can imagine the feel of the garments, in linen and satin and silk, as the light glints off them. Signatures are rare in paintings prior to the eighteenth century, but Velázquez signed his name on the piece of paper he painted in the pope's hand. Based on the light weight of the pope's clothing, we can guess that the portrait was painted during the summer.

Now we might turn to the sculpted portrait in white Carrara marble of the same pope. It was made by Bernini, the favorite artist of Pope Innocent's predecessor. Ber-

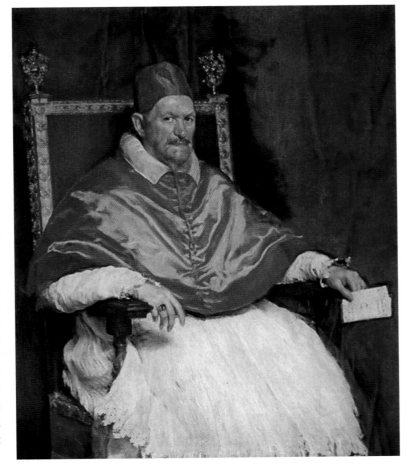

Diego Velázquez, *Portrait of Pope Innocent X* (1650). PHOTO COURTESY OF WIKICOMMONS FROM THE DORIA PAMPHILJ GALLERY.

nini was obliged to do two versions of this same bust (the other is also on display at the same museum), because he hit a fault in the marble around the beard when carving the first. (Marble sometimes has cracks or faults in it that cannot be seen from the outside, so an artist can be nearly finished with a sculpture then suddenly hit a fault and a bit breaks off.) But Bernini was not fazed. He was renowned for working very quickly and fired off another bust in no time. One of Bernini's trademarks is sculpting garments that give the illusion of a texture other than the stone out of which they are carved and also including a single button that is not quite buttoned fully—a bit of an inside joke. The fact that he could transform a cube of stone into a lifelike portrait with this incredible level of realism and delicacy (see how deeply carved the beard is, and note the vein on the skin) is remarkable. He is certainly a candidate for the title of the greatest sculptor in history.

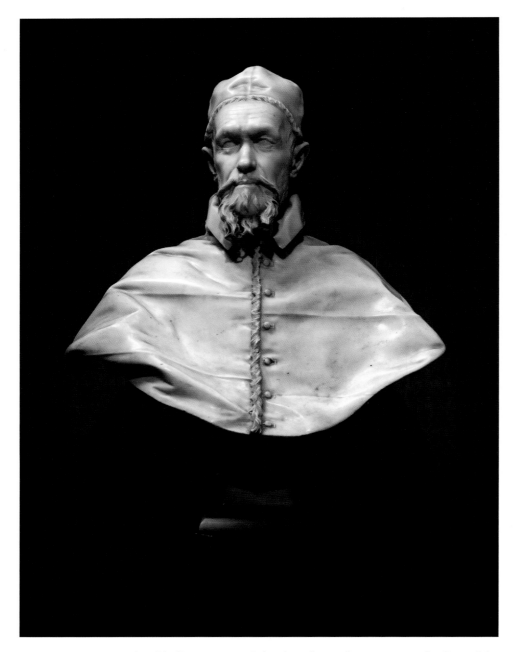

Gian Lorenzo Bernini, *Portrait of Pope Innocent X* (1650). PHOTO COURTESY OF WIKICOMMONS BY USER LIVIOANDRONICO 2013.

A great portrait should allow us to read the thoughts and emotions in the face of the subject. Can we tell what the pope is thinking in either Bernini's or Velázquez's portraits? It is up to us which we think is more successful. To me, the Bernini is more impressive in terms of the artistic skill required to transform a hunk of marble into a lifelike portrait, but I feel that I can read more about what Innocent X was like in Velázquez's painting.

But each viewer is fully entitled to their own opinion, and this pairing is an ideal way to enter into the *ut pictura poesis* debate.

## Hirst and Institutional Battles

While one realm of rivalry in art was between individuals who did not get along or between academic painters and independents (as in the Carracci Academy versus Caravaggio), others came in the form of rival institutions—academies, auction houses, salons (as we have already examined), individual artists and the state, and beyond.

A case in point took place in Paris in the seventeenth century. The Royal Academy of Painting and Sculpture was founded on January 20, 1648, under the patronage of King Louis XIV. (He was still a child at the time, so it was his council and the regent, Anne of Austria, who enacted it.) The driving force behind it was an enthusiastic collector, Martin de Charmois, who kept a cabinet of curiosities at his home in Carcassonne, and the architect Charles Le Brun. Their motto was revelatory: *Libertas artibus restitute*: "Freedom returned to artists." By this they meant that their academy should be exempt from the supervision of a rival, far more ancient organization called the Corporation of Painters, Gilders, Sculptors, and Glaziers of Paris. This rival group, formerly called the Community (rather than Corporation), had begun as a guild founded in 1391. It enjoyed a monopolistic control over the trade in paintings and sculptures according to a system of the organization of professions that dated back centuries, to the ancien régime. This approach treated artists as craftsmen, subject to rules of guilds, which regulated who could open a studio (becoming a master) and trade in art. This new Royal Academy thought of artists as of a higher social and professional standing than craftsmen and sought freedom and independence from the Corporation, which they considered old-fashioned and authoritarian.

For millennia, artists were considered akin to craftsmen, a painter of altarpieces not much different from a prized cobbler or cabinetmaker. Jan van Eyck and Raphael were among the earliest artists to shift the perspective of their profession. Their personal charisma, high level of education, political acumen, and key roles at court elevated them and, through their actions, the opinion of their profession, as painters. This had a trickle-down effect in the Lowlands and Italy, with other artists benefiting from their reputations and the accompanying association with fine art (painting, sculpture, and architecture in particular) as inhabiting a higher sphere than crafts. Early humanists supported this idea, looking to classical texts, like those by Aristotle and Horace, for references to fine art (as well as drama and poetry). In this period of the rebirth (*renaissance*) of interest in the classical world, what ancient Rome and Athens prized was thought of great value to contemporaries. But while artists in Flanders and Italy benefited, elsewhere artists struggled to distinguish themselves from craftsmen. In Spain, the greatest painter of the Golden Age, Diego Velázquez, felt obliged to take on time-consuming roles at court to pay the bills and maintain an elevated social position, resulting in the creation of far fewer paintings than he might otherwise have made. Velázquez lived from 1599 to 1660, and the

situation he faced in Spain was paralleled in France. This helps to explain why, from a social perspective, French artists wished to be distinguished from craftsmen.[20]

It was also a matter of freedom. The medieval guild system was restrictive and often nepotistic, with priority given fathers passing on their studios to sons, regardless of the interest and quality of the next generation. A board determined who could become a new member, and also which apprentice or assistants were sufficiently skilled to become masters themselves and set up their own studios. (The show artwork submitted to the guild that would determine whether an artist could become a master was called a "masterpiece," which is where we get the term still used today for any great artwork.) The guilds maintained quality and also ensured that there was a balance of competition and reasonable prices. This was the idea, but, as may be imagined, not everyone agreed with the rules, and there was room for favoritism and similar issues. Some guilds could be draconian, for instance, authorizing the destruction of works that did not meet their standards and approval but were created within their jurisdiction. Subjects and styles that were not approved of were not just discouraged but sometimes burned. Materials, techniques, and clientele all had to be corporation-sanctioned. The Community also had quite a diverse membership, with one-sixth of the members women, and membership permitted for craftsmen whose work was relevant to painting and sculpture but who were not artists: for instance, joiners, who made specially prepared wooden panels for painting, or frame makers.

The founders of the Royal Academy looked at the success and prestige of Italian art and linked it to the presence of the Accademia di San Luca (Academy of Saint Luke) in Rome, which had been founded in 1577 by a consortium of artists and was supported by the pope. It was the successor to the guild of painters and miniaturists, the Compagnia di San Luca (Company of Saint Luke). Therefore, the founders of the Royal Academy in Paris looked with admiration on the Italian system, in which this academy replaced the old Company guild.[21]

The Royal Academy, as the name suggests, was intended as a place of instruction, a means of promoting artists as elevated from more workmanlike craftsmen, and to take on the ability to empower artists who might not have been welcomed into or supported by the old Community. The finest artists in the kingdom of France were given the title of "academicians," which was considered prestigious. On the day it incorporated, it held a nude life drawing workshop, and students each paid a participation fee to cover the cost of instruction and the model. But the prices were considered high and the quality of instruction low. Great enthusiasm in February 1648 had waned by May 1649.

The Community was not impressed with this upstart rival, and it went beyond just fine arts. While the Regency and its majordomo, Cardinal Mazarin, supported the Royal Academy, the Community was supported by Parliament. This was about political alliance, not just painting.

In order to counter the Royal Academy as directly as possible, the Community reestablished its preeminence by launching a new, educational wing called the Academy of Saint-Luc. It was a purposeful way to push the Royal Academy away from the model that inspired it, the Academy of Saint Luke in Rome, by taking on the same name.

Saint Luke is the patron saint of painters (he was said to have painted a portrait of the Virgin Mary), hence the use of this name for almost all painting guilds and academies. This new, rival academy was directed by the painter Simon Vouet. The Community had the advantage in that it was well-funded thanks to contributions from members, whereas the Royal Academy relied on state funding, which was lacking at the time due to political unrest.

The rivalry ended in 1651, when the two academies joined together, against Le Brun's wishes. The arguing parties were obliged to work together, though grumbling all the way. Their members continued to quarrel until the 1770s, when the guild system in France was abolished altogether. Salons eventually emerged to replace these outdated institutions, but as we have seen, many of the inherent issues remained and simply shifted from the medieval guilds to the modern salons.

Still, the experience of having to rely on a subjective board of directors who determined an artist's livelihood, and even the materials, subject matter, and clientele available, prompted the breakaway institution and eventually a new approach altogether, with salons a good deal more democratic and less draconian, though admission was still required through gatekeepers who could be opinionated or biased.

While art academies argued and competed with one another to teach and guide their constituents, and thereby affect the direction of art, a parallel phenomenon took place among art galleries.

Damien Hirst has bounced from being represented by Jay Joplin's White Cube Gallery to Larry Gagosian's eponymous gallery chain, which led the two mega contemporary art houses into rivalry. White Cube is the gallery that launched the Young British Artists (YBA) movement, with Hirst as its frontrunner. But the lure of an even more powerful gallery, Gagosian, led Hirst to switch representation—or rather, to add Gagosian and be represented by both galleries for a time. Gallery representation is necessary for artists to sell well—galleries function as managers, exhibitors, publicists, and dealmakers. One would think that patrons would approach artists directly, but tradition carries with it inertia, and galleries have managed to insert themselves as go-betweens between artists and patrons since the first modern galleries were established in the seventeenth-century Netherlands. Gagosian has been the highest of the high-end galleries, with more exhibition space than the Tate Modern and, as quoted in 2013, annual revenues of around $1 billion. This muscle allowed Gagosian to present blockbuster exhibits of even historical artists that would rival major museums—featuring Matisse, Warhol, and Picasso, among others—with the difference being in the fact that the art on the walls was all for sale. Hirst separated from Gagosian in 2013, after seventeen years. The reason why has been something of an art world mystery.[22] But the answer may lie in an understanding of what a gallery with money can do to an artist's sales.

From 2005 until 2008, Hirst experimented with direct sales, cutting out the gallery and offering his works through Sotheby's. Galleries regularly take a 50 percent commission, so the thought was that the artist would earn a great deal more. (Auctions normally give 100 percent of the hammer price, the price at which the work sells, to the owner and add 17.5 percent to that sum as their own commission, with buyers paying 117.5 percent

of the final price.) But it has been reported that Larry Gagosian and Jay Joplin helped those lucrative auctions along by bidding up Hirst's work at the auction, buying some pieces themselves and nudging up the bidding for others. It is not clear what sort of deal they had with Hirst behind the scenes, but such activity is not uncommon in auctions, though not exactly legal—asking a colleague to bid but not buy can drive prices higher even though the buddy bidder never intends to acquire the object in question.

In the period following 2008, Hirst's sales dropped by some 30 percent, and art experts discussed how his prices were outpacing the demand. The year 2008 was also the start of the recession, but art was still selling for astronomical prices even during that period, so that alone does not account for his reduction in popularity. Hirst's only peer in terms of lifetime sales (they are the two highest-selling artists in history, by a huge margin) is Jeff Koons, and he, too, left Gagosian for another gallery in 2013. Koons likewise began to sell directly through auction houses, in this case, Christie's. The top 1 percent of artists wield enough power, are wealthy enough, and are strong enough brands in themselves that they no longer need galleries. Young artists do, and so sacrifice 50 percent of their sales in order to work with galleries that can help to make their names. The question is whether galleries can offer enough added value to retain artists when they are already stars. But that is only a question for that 1 percent. The other 99 percent of artists struggle to sell well (or at all), and galleries are their best and often only way forward, making them beholden to the gallery system.

In this example, the two highest-grossing artists in history, ostensibly rivals, in fact joined forces to promote one another. They also experimented with their power, trying out a variety of sales methods: direct, via several different high-end galleries, through auctions. This is a stark contrast to what we think of in traditional markets, including the art market. When there is a single commission at stake, as was the case in the pre-Modern era, before artists began to create work on spec, then artists truly are in competition with one another. This is akin to today's open competitions for major architectural projects, in which numerous firms submit designs and only one is selected. But in our current age of art made on spec and then sold, rivalry does not exist in the same way. A collector would gladly own both a Koons and a Hirst—or several of each.

This shifts what could be seen as a rivalry into a cornucopia, a table with space for many. Hirst and Koons, instead of competing against one another, joined forces and played with the institutions that normally subjugate artists to their terms. Galleries are used to having artists at their mercy. But Koons and Hirst jump from gallery to gallery in search of better deals, toying with the puppet masters, as it were. They see how they fare at auction, even reinvesting in their own art. It is rare in the history of art that artists had all the power, and it is primarily a phenomenon of the internet era, when an artist can be their own promoter and there is a queue of wealthy individuals eager for anything a big-name artist happens to create. Even the greatest and most popular artists of past eras were beholden to patrons and commissions. This contemporary situation means that rivalry, as it has been known to art history, may well no longer exist, at least for the top 1 percent of established artists. For the 99 percent, it remains a scramble for attention, with competition and rivalry still very much present and weighing upon one and all.

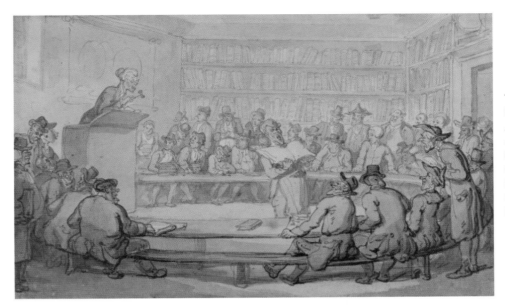

## Lysippos and Acquisition Angst

Christie's and Sotheby's are the two oldest art auction houses, with Christie's founded in 1766, Sotheby's in 1744.

While there is plenty of art to be auctioned by both, they have ever since been arch-rivals, and even occasionally coconspirators, as they were caught in a price-fixing scandal to raise the commission on works they sold through the 1990s.[23] They almost enjoy a duopoly, with far greater prestige and name recognition than any other art auction houses (included the two prominent runners-up, Phillips and Bonhams), and the finest pieces inevitably go through them. But the way they function, in the past and in the present, can be problematic and has helped shape the art market—and not always for the better. The two have scrapped with one another in the media, with Sotheby's the more tarnished for involvement in the sale of looted antiquities, though Christie's has been accused of the same practice.[24] And yet their presence keeps each other in balance. If there existed only one of the two, then it would lead to the sort of issues that have followed the e-commerce giant Amazon. Amazon began as an online bookseller but morphed into *the* online everything seller. An article about Amazon's rivals results in a list of companies that you've hardly heard of (Vipshop, JD, Overstock, Light in the Box).[25] Only recently has China's Alibaba broken into Western awareness. Amazon remains unofficially a monopoly for one-stop online buying. While Amazon's prices have been consistently low for buyers, its power is such that it has used its willingness to lose money in some exchanges to keep prices so low that competition has been driven out of business. If there were only one auction house of international significance, then the essential monopoly would mean that

all the top art would go through the one auction house, which would be worse for the art trade. That single auction house could charge whatever commission it chose and would have ultimate say over what sold well. The fact that there are two houses in competition with one another keeps the system fairer to buyers and sellers of art by keeping the commissions reasonable and always giving sellers the option of opting for the other auction house if the terms of one feel unsatisfactory.

With the rise of eBay and online galleries and auctions for fine art, there has been a concern that the internet would steal the business of selling art from the established brick-and-mortar galleries and auction houses. While mid-to-low-level art has generally shifted toward online purchase, the really good (and expensive) stuff remains in the hands of traditional galleries and auction houses for a very specific reason: There is a social dynamic to buying art, an element of conspicuous consumption and of buying into a social milieu, which is not present if one buys online. The art market at its top end features a very small cadre of power buyers, and cultivating social relationships with them is key to encouraging sales and loyalty to artists, galleries, and auction houses. Buying in a high-profile way—the sort of purchases that make the news—is part of the fun and the appeal for big collectors, and clicking "buy" on your laptop from home lacks this wine-and-dine, "It" party appeal. The eBay-style online auction can drive up prices, but the players are anonymous and the adrenaline of bidding is at a remove. In an auction room, the excitement is palpable and rival collectors may bid frantically against each other when they see who is bidding against them, which is not the case in online auctions.

The early concern that online auctions would overtake traditional auction houses was never realized. The internet has allowed artists to access their public directly, but only to a certain extent. Galleries like Saatchi Art (an online gallery open to anyone) have democratized the possibility of presenting one's work to the public directly (with the online gallery taking a commission smaller than the 50 percent of traditional galleries, but not that much smaller; at the time of writing, Saatchi Art takes 35 percent).[26] But artists aiming or already at the higher end of the market prefer the tradition, cachet, and promise of proper galleries, resulting in a false rivalry. There is market enough for both online and traditional galleries and auction houses, and the buyers and sellers from each tend not to overlap. In this case, it is the threat of rivalry that ultimately proved unfounded that benefited the 99 percent of artists (or perhaps the 95 percent, to allow for artists not quite household names but art world names). The top 1 percent remains unchanged, and one imagines that they will even remain so after the passing of the coronavirus pandemic that has shut down the world, including the art world, and still rages as I write. The possibility of selling online, directly from an artist's website via their social media following, or in an all-inclusive online gallery like Saatchi Art, provides a venue for the majority of artists to find buyers, but they remain stuck with most of the PR legwork, which traditional galleries would handle for them.

Perhaps a more direct descendant of the salon tradition, in the sense of a temporary, curated show of varying artworks that can be purchased, is the art fair. This is a young phenomenon. The large-scale art fairs began with the Venice Biennale, first established in 1893 to showcase Italian art. But the Biennale remains its own entity, with tents set up

by various nations, each sending a selected artist to showcase. Showcases of contemporary art that did not include the sales angle at the fore include the Armory Show in New York, founded in 1913 to showcase modern art, and Documenta, established in 1955 in Kassel, Germany. The annual sales-and-gallery-driven fairs began with Art Basel and Foire Internationale d'art Contemporain (FIAC) in 1974 in Basel and Paris, respectively. They focus on contemporary art, and rivals began to bloom in the 2000s, including Frieze. A certain jet-set art crowd zips from one fair to the next, enjoying the spectacle, the temporary and temporal nature of it part of the appeal—the cream of what is for sale brought together in a single glamorous location. These fairs are absurdly expensive for galleries and dealers to participate in. Typical booth prices range from $35,000 at the Armory Show to $60,000 at TEFAF (the European historical art fair in Maastricht), but that's just the start.[27]

A sample case study for setting up shop at Art Basel included wall and lights ($10,500), flights and shipping of art ($30,000), hotels ($14,400), food ($7,000), local transportation ($650), and furniture rental for the booth ($1,900), totaling $120,000 for a ten-day sales event. If the gallerist manages to sell a work, it might cover expenses and much more, as the type of art showcased at such fairs is generally worth six figures and up, but it is still a mighty investment for a pop-up sales pitch.

The fairs see themselves as rivals but are really multiple points in a constellation. They attract similar audiences, provided they do not overlap on the calendar or in geography. Proper rivalry comes when fairs set up shop in the same location and risk cannibalizing each other's audience. London's two arts and antiques fairs, Olympia and

**Photograph of TEFAF Art Fair in Maastricht (2014).** WIKICOMMONS USER KLEON3.

Grosvenor House, have similar profiles and are in the same city.[28] Grosvenor House fair was established in 1934 as a way to spark renewed interest in collecting art in the wake of the Depression. Olympia followed in 1972. Both feature art and antiquities. This is when rivalry can heat up. For decades Grosvenor House had a posher clientele and royal patronage, whereas Olympia had generally less expensive fare but was far larger in scale, "aimed more at the home decorator," as one article put it.[29] But after the 2008 recession, both art fairs struggled to reach the sales figures to which they'd grown accustomed and began to see each other, for the first time, as rivals seeking to attract the same customers: anyone with the extra wealth to invest in art.

Art fairs benefit art in terms of exposure and sales, but not in terms of creativity, and they deal almost exclusively with artists who are already the highest end, meaning the rich get richer.

The pressure artists face in presenting a single piece through their gallery at a very expensive art fair can result in a shift in what artists make in order to appeal to the peculiarities of a particular venue. Imagine thousands of people winding their way through a fair, which may be under a giant tent or series of pop-up structures. It is window shopping at the upper echelon, minus the windows—glancing at objects displayed on temporary walls and plinths, milling about, chatting over overpriced prosecco. The works most likely to be purchased are those most likely to be talked about—those that raise eyebrows, that have juicy stories or scandals behind them, that are the most eye-catching (which certainly does not imply that they are the best works). Spectacle and shock and scandal draw attention, and a busy art fair is about attention-grasping objects. Quality and, heaven forbid, subtlety are unlikely to cover expenses. This results in at least a subconscious encouragement to create eye-catchers and perhaps to behave, if not badly, then at least oddly. Hence the genius of Maurizio Cattelan's *Comedian*, the banana he duct-taped to a pop-up wall of his gallery's booth at Art Basel Miami in 2019.[30] The "did you hear" audacity of it made it a must-see work, when the work itself, in a vacuum, is of no real interest and hardly qualifies as collectible art, since it is entirely concept and the work itself will rot within a matter of days. The sale price of $120,000 is a lot for a concept alone, and yet it had no shortage of interest from buyers.

It may be trickier to argue that traditional auction houses like Christie's and Sotheby's have benefited the course of art, but they certainly help to drive and maintain a market for historical artworks, acting as promoters of past artists in a similar way to museums, which help reignite interest in art history when they promote exhibits. Traditional auction houses have also helped the art world in an indirect way. They remain the premier way to sell one's art collection, which allows money and objects to circulate among collectors. Because there is a relatively small total number of true players in the world of art collecting (*New York* magazine art critic Jerry Saltz estimated that there are only around fifteen hundred art collectors worth the name),[31] the money earned through the sale of art is often reinvested in other art, thus keeping the objects in a slow but steady movement (every few generations even objects in private collections tend to be sold) and the finances flowing.

To speak of finances in the world of museums means to name-check the Getty. John Paul Getty left an endowment so large for his eponymous museum that it can outbid any other museum, include major players like the Met. Its only rivals for acquiring works newly on the market are the wealthiest of private collectors. In the early 2000s, the Getty boasted a $100 million annual acquisitions budget at a time when the British Museum's acquisitions budget was £100,000 (around $133,000). This has made the Getty the target of envy, and the museum has also misused its wealth through acquiring looted antiquities and forgeries, as has been demonstrated in innumerable newspaper articles and books.[32]

In every era, there have been art collectors who have battled one another to buy the most exciting new artworks to come on the market, from rival bidders in contemporary auctions to the Met and the Getty bidding against one another for the infamous *Victorious Youth* bronze (aka the Getty Bronze), animosity between buyers—institutions and also individuals—has helped artists and raised the profile of the art that acted as rope in these tugs-of-war.

The Getty's muscle-flexing wealth has led to its alienating itself, and to other, less loaded institutions looking for ways to bring them down a peg. Unfortunately, the Getty has made this relatively easy due to its proclivity for acquiring looted antiquities, like the Lysippos *Victorious Youth*.

At the June 2018 Association for Research into Crimes against Art (ARCA) Conference on the Study of Art Crime, the hot topic was the Getty Bronze, and one panel revealed some breaking news about how Italy defeated the Getty in the wrestling match over *Victorious Youth*, thought to be the only extant sculpture by Lysippos, which the Getty bought for nearly $4 million in 1977. A week earlier, a judge in Pesaro, Italy, had ruled against the Getty and declared that Italy could repatriate the bronze, which had been illegally exported from Italy in 1964.[33] That was in the news, but several things were not. One of the conference speakers was Maurizio Fiorilli, retired attorney general of Italy, who was still working on key cases in retirement. He revealed how he pulled off some courtroom twists worthy of Perry Mason in defeating the Getty lawyers during the most recent trial, including catching the lawyers lying.

A Getty lawyer claimed that the bronze sculpture in a photograph taken when it was first dredged from the sea near Fano, on the Italian coast, still covered in barnacles and seaweed, was not the statue in question. But Fiorilli pointed out something the Getty lawyer apparently did not know—that the Getty's own publication had featured that very photograph, barnacles and seaweed and all, on its cover. This was a key moment that led the judge to determine that the behavior of the Getty during the trial, its overtly demonstrated disingenuity, was a sign of its guilt, which led to the Italian victory.

Another speaker laid out the probable path of the Lysippos to a shipwreck off of Fano, filling in some of the history that had been lacking of the statue as an object. A third speaker uncovered a fascinating short documentary film, made by Thomas Hoving when he was head of the Met in which he traveled Europe to interview people about the bronze, which he wanted to buy for the Met, and was clearly frustrated when the Getty

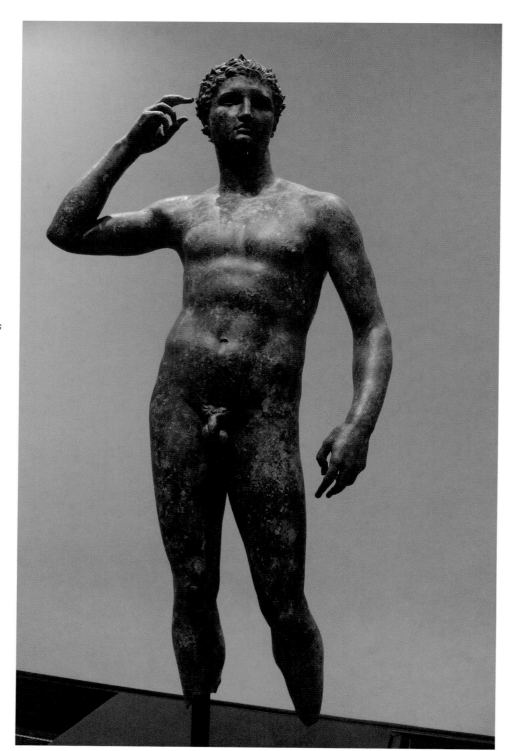

Lysippos, *Victorious Youth* (fourth century BCE).
PHOTO COURTESY OF WIKICOMMONS FROM THE J. PAUL GETTY MUSEUM, PHOTOGRAPHER UNKNOWN.

beat him to it. He questioned publicly in the film whether the Getty would be able to retain the sculpture, as he believed it was illegal.

While the benefits to art in general from the bickering of major museums may not at first be obvious, it becomes clearer when we consider the scrutiny and public humiliation of these museums that have been caught knowingly trading in looted art. This has dissuaded other museums from engaging in the practice and led to many institutions "cleaning house," returning looted antiquities to their countries of origin, with the museums to some extent competing with their rival museums to demonstrate that they are doing the right thing, taking the moral high road, particularly when it comes to restitution. This is not to say that the trade in illicit antiquities has disappeared, but it has lessened in major institutions (the occasional scandal like the Museum of the Bible notwithstanding).[34]

## Ai Weiwei and Patrons against Artists

While museums today wrestle to acquire choice pieces, art patrons have also tussled over art and even artists. François I, the sixteenth-century king of France, tried to collect not just art but artists. Leonardo, Cellini, and Rosso Fiorentino all accepted his invitation to come to his court under his patronage, with Leonardo spending the end of his life in France. For Renaissance princes, an art collection was a point of pride—it showed one's wealth and erudition. Filling your court with interesting, famous people (poets, philosophers, scientists) was a similar competition among rival princes. Rudolf II Habsburg filled his court at Prague with curiosities and wonders, from the art of Arcimboldo (who made portraits composed of mosaics of objects, like a face pieced together with flowers or vegetables) to natural wonders (he kept penguins and a giant octopus in his menagerie) to wondrous humans (the memory master and mathematician Giordano Bruno, the magician John Dee).[35]

François I was also involved in a direct competition in "bling" patronage. The Field of the Cloth of Gold was a meeting in 1520 between the two most powerful kings in Europe—François and Henry VIII of England—to determine how to deal with the third most powerful, Charles V Habsburg.

Each set up an elaborate temporary scenography in a field in Balinghem, France. It was an art installation as a backdrop for a tournament held by England and France at which the meeting could be held. The installation included not only a temporary city of decorated tents to house the entourages and soldiers of each nation, but it included an enormous "pop-up" castle among its elaborate attributes. Powerful patrons dueled one another through commissions of great art, to the benefit of artists and posterity.

Needless to say, patrons scrambling for the work of living artists is hugely beneficial to the artists. Rivalry between collectors was the tinder of the Renaissance. Each duke, prince, cardinal, king, and pope wished to surround himself with beautiful things, but also wished to consume conspicuously, to commission public works in his name of the finest artists, to have the choicest objects in his personal collection, the best minds and creators at his courts.

The opposite of patronage from a nation or city-state's leadership is opposition from it. There is a long history of censorship and repression of creativity on the part of authoritarian regimes. But what is often overlooked is that these repressive systems sometimes brought out unusual artworks and stimulated artists within them to react to (usually against) the powers that be. The highest-profile example of this is Ai Weiwei, China's most famous artist. His fame comes not only from the art itself but from his backstory. Western audiences are fascinated by and applaud rebels who were unafraid to stand up to authorities and who emerge from suffering. Ai fits this narrative, having been imprisoned in China and making a career speaking out against the Chinese government censorship of its population, controlling what they can see and access. The government has taken Ai's art as a form of revolutionary combat. Great art is often created as pearls are: trapped inside a shell and abraded to such an extent that they could either be crushed or emerge as a jewel. It's an oft-made comment that great art springs from adversity, tragedy, sadness, extreme emotion. This can be forlorn unrequited love, in which case the "tragedy" is subjective and confined to one's own heart and mind, or it can be abuse from some external source beyond the artist's control. The "rivalry," as we might call it, between Ai and the Chinese government certainly augmented the artist's profile and fueled his art. While it may seem inappropriate to look at the bright side of suffering and sadness, it must be said that much great art has emerged from these extreme emotions.

Ai Weiwei did not ask to be persecuted—no one wants to spend eighty-one days in prison—nor did he shy away from it—one of his works, *Study of Perspective*, includes him giving the middle finger in Tiananmen Square.[36] And a by-product of that persecution was his elevation to international stardom, his recognition as probably the only Chinese artist who is a household name outside of China. His career certainly benefited from his personal suffering. Even the title of a *Time* magazine article, "Top 10 Persecuted Artists" (with Ai as number one on the list), is revelatory.[37] We are used to top ten lists as being

good, positive things. This title resonates as odd the way a title like "Top Ten Murder Victims" might. Its very nature indicates how renown through suffering, through tragedy, is still renown.

## The Biennale and Modern Love-Hate Relationships

It is often the case that admiration leads to strong feelings of rivalry. This could be about admiring a sales record or about pure ability, but it takes a passionate reaction to prompt a rivalry. It also takes a feeling of encroachment on one's territory. The Red Sox (my team) and their rival Yankees (boo!) are baseball rivals because they mutually admire one another. They represent the two biggest names, are among the oldest and most storied teams, and are in the same division, therefore scrapping for the same title. Had they occupied separate divisions the rivalry would not have been the same. The two famous pizza places (Pepe's and Sally's) in my hometown of New Haven, Connecticut, are both wonderful—and are situated on the very same street, rivals in high-level execution and forced to duel for the same audience because of their proximity. Geography has become less of an issue in the postmodern era, as the internet has given everyone on the globe the chance to compete against everyone else for the attention of everyone else.

And so it is with artists. You don't find rivalry between a successful artist and a struggling one. You don't find rivalry between a video artist and a sculptor. It is when two artists cross swords in the same medium and at similar levels of success and for a similar audience that trouble brews.

Take, for example, the bizarre (or was it criminal?) coincidence in 2017 when Damien Hirst, probably the most successful and well-known contemporary artist on the planet, presented his *Treasures from the Wreck of the Unbelievable* sculpture exhibit at the Venice Biennale—suspiciously similar, aesthetically and conceptually, to another Biennale installation by a respected but not-exactly-household-name artist, Jason deCaires Taylor.

The talk of the 2017 Venice Biennale was not the brilliant idea of a great artist, but rather the brilliant idea of two great artists who happened to have had the exact same idea. It's an awkward sort of moment, like when two Hollywood starlets show up on the red carpet wearing the exact same glamorous gown that each thought was a unique, bespoke piece of couture. But the question on everyone's mind, once the awkwardness passed, was whether anything illegal or immoral had taken place. Had one of the artists stolen the idea from the other? Or was this just a monumentally weird coincidence?[38]

The drama was heightened by the fact that while both artists are renowned, one is arguably the most famous artist alive and is in a close race for the title of the highest-earning artist in history: Damien Hirst. The naughty imp of the contemporary British art scene is known for a dark and incubus-like sense of humor. If there were any artist who might pull some sort of stunt like this on purpose, he seemed like a good candidate. But the reaction of his camp suggests nothing of the sort. There was genuine concern and official statements from lawyers and nothing particularly fun or funny about it.

Damien Hirst, *Treasures from the Wreck of the Unbelievable* (detail, 2017).
PHOTO COURTESY OF WIKICOMMONS BY SAILKO.

Both Hirst and Taylor, the artist presenting at the Grenada Pavilion, presented installations at the Biennale that were meant to look like ancient sculptures that had been lodged for centuries at the bottom of the ocean, after a shipwreck or natural disaster, and which had been recently salvaged but not cleaned: naturalistic life-size statues of humans covered in various oceanic growth, coral, and debris. Both are accompanied by murky underwater photographs of the statues in situ, underwater where they were "discovered." In Hirst's case, these photos are staged, as the sculptures were never actually underwater. In the case of Taylor, his shtick as an artist is to actually sink new sculptures into the sea and allow them to be partially swallowed up by the undersea world, then to photograph them. Weird coincidence, right?

Hirst's installation is entitled *Treasures from the Wreck of the Unbelievable*, while Taylor's is called *The Bridge*. Anyone who sees both shows, or reads about both shows, logically asks: Well, who thought of it first, and did whoever came up with it second steal the idea from the first guy? This is a fair enough question, but a complicated one to answer.

Art sometimes, but not always, emerges with a "eureka moment" or is made all in one go. But just as often ideas gestate for years, sketches are made, concepts toyed with, works partly created then set aside, and so on, piecemeal. Taylor is pretty much the go-to guy when it comes to underwater sculpture installations, the first artist to take the Land Art movement, which is associated with man-made (or man-arranged) terrestrial installations

Jason deCaires
Taylor, *Vicissitudes*
(detail, 2006,
Grenada, West
Indies). PHOTO
COURTESY OF JASON
DECAIRES TAYLOR.

that the artist permits nature to engage with and erode as nature sees fit. In 2006, he set up the world's first underwater sculpture garden, which visitors can admire by snorkel or scuba, in the sea beside the island of Grenada. So it is reasonable of him to feel that this is his territory and that it has been encroached upon. For his part, Taylor has taken the high road and issued a statement that is just about devoid of hard feelings, saying, "After viewing Hirst's latest exhibition, it seems I have certainly created an art genre that has been responded to." He goes on to say that the message behind his art is very different from Hirst's. He tries to send environmental messages, and the main sculptures in his Biennale show, entitled *Bleached I* and *Bleached II*, refer to coral bleaching, a damaging by-product of global warming.

Hirst, on the other hand, is in it for the fun and the spectacle. As he is a big enough gun to speak through spokespeople, a statement was issued on his behalf saying, "Damien has always been fascinated by what he describes as 'the action of the world on things' and he became interested in coralized works in the late 90s, when he sunk some objects off the coast of Mexico." Both artists can claim to have been into sinking sculptures underwater for decades. The art looks different, even if the broad stroke concepts are strikingly similar. So there is no question of direct replicas or forgeries.

But did one person steal the other's intellectual property? Can the concept of a work of art be protected? You certainly could not claim intellectual property theft when more than one artist thought to sculpt the execution of the first-century Jewish *tekton* who thought he was the Messiah. There are a good deal more crucifixes around the world than you could shake many sticks at, and though the concept and subject matter are extremely specific, no one is suing anyone else for making crucifixion sculptures.

Edgar Tijhuis, an Amsterdam-based art crime specialist and lawyer, said of this issue, "It is definitely a rare coincidence that potentially raises questions about intellectual property. But it is doubtful whether there is any objective legal basis for action on the side of Jason deCaires Taylor against Damien Hirst, especially since Taylor himself stressed the differences between their respective works and Hirst claimed (through a spokesperson) to have been interested in this kind of work since the late 1990s."[39] Unless some document surfaces that overtly demonstrates otherwise, this will remain just a coincidence, even if a suspicious one, and not an idea theft that could be proven in court.

It is interesting that no one seems worried that Taylor got the idea from Hirst. It has been his calling card as an artist, whereas Hirst dips into this and that, with that middle-finger-wielding naughty prankster attitude being the most consistent element in his oeuvre. Hirst is also one of the richest artists ever to have lived, and has a vast staff promoting and protecting him, so he's the one who feels vulnerable to attack. This was evident from his reticence, allowing a spokesperson to make a statement for him, whereas Taylor joked on social media and appeared to be the one with nothing to hide.

Ideas float (or in this case, perhaps sink), and the history of art is largely populated with a relatively small number of concepts and scenes that artists use and reuse, repeat and reinterpret, ad infinitum. This has to do with the textual inspirations for most historical Western art (the Bible, the *Golden Legend*, pagan mythology, Ovid, true history) and the limited scope of imagination of most commissioners of older Western art, who liked to

patronize religious art and portraits of themselves and their families. A visual lexicon of just a few hundred subjects fills a good 80 percent or more of Western art history books. Overlap is part of the game.

With this in mind, perhaps the best we can take out of this is to look at the two shows side by side and determine which we deem most successful. The ideas are the same, but what of the execution and the refinement, the use of the general concept? In a courtroom, there would be no winner in this case. But gallery versus gallery, show versus show, who did a better job with the raw conceptual material, transmuting it into tangible art? That's up to the viewer.[40]

The medium of these two exhibits was the same: sculpture. The concept was the same: new statues meant to look as though they were ancient objects lost for centuries at the bottom of the sea. The geography was the same: both artists were showing at the same mega show, the Venice Biennale, at the very same time. The only thing lacking is that the two artists are not on the same level in terms of fame: Taylor is respected and successful, but Hirst sits atop the Olympus of the Art Gods. The only potential rivals he has in terms of inhabiting the same altitude are the likes of Tracey Emin, Jeff Koons, Ai Weiwei, Marina Abramović, Gerhard Richter, and company. And of those, only Koons is in the same income stratosphere.

The three out of four components meant that this incident was more scandal than rivalry. It could indeed have been featured in chapter 1. Because Taylor was not going to be an enduring rival to Hirst, it was a one-off event in which the two were set, by critics and the public, in competition with one another: Who took the chosen medium, venue, and theme and made the better artwork of it? That most critics preferred Taylor's work over Hirst's was largely overshadowed by the spectacle Hirst introduced in this show, the biggest and most expensive in the history of the Biennale, and one in which almost all the objects displayed had already been sold before the show even opened, making the show more a showcase of already captured trophies than a platform for potential buyers.

Each of these aspects of rivalry has numerous historical case studies as cases in point. Some we've already mentioned. The great rivalry introduced by Vasari between Duccio and Giotto came to a head when they painted the same subject, *Maesta*. Both were painters (check) in the same style (international gothic, though Giotto was more progressive, so check) in the same territory (Siena and Florence were neighboring city-states and already political rivals, so check), and both were at the same level of success, that is to say, the two most famous artists of the time and place (check). We might introduce a fifth element: what the artists or their subject matter convey symbolically. Because Siena and Florence were rival cities, the leading artist of each symbolized and embodied that rivalry. Their status became about more than the art alone. It was a sort of civic duty to prefer one over the other, like cheering for a sports team out of habit or geographic proximity, regardless of who is on the team and how they are playing. This type of symbolic rivalry can be seen, for instance, in American presidential campaigns. Whoever the Republican and Democratic candidates are, their status takes on far more weight than a simple, clean comparison of the potential of each to lead the country, if you examined them in a vacuum with no idea to which party they belonged. As soon as one of them dons the

Republican or Democratic colors, the other party's supporters are guaranteed not to like them. Only the symbolism has changed, but it changed everything.

Rivalries can form when the same venue features two artists vying for headlines. Ingres and Delacroix were the two leading painters of early 1800s France. Their fame was similar, but their styles were very different. Ingres was neoclassicist, painted in the Raphaelesque vein, with invisible brushstrokes (unpainterly) and a polished marble finish to his realistic paintings. Delacroix was a Romanticist, with a quicker, sketchier approach, visible brushstrokes (painterly), and more dynamism and passion. They squared off in public and in private, from nasty confrontations at dinner parties to arguments over space in exhibition halls like the Exposition Universelle. They represented different political and philosophical ideals. Ingres was seen as part of the elite, the aesthete of the recently beheaded nobility, a favorite of Napoleon, who had replaced the nobles as leader. Delacroix was more of a hipster poet, in love with the Orient (as he would've called it).[41] As with so many rivalries, it's not an objective question of who is better. That doesn't really exist in the realm of great art. But it makes for an entertaining game to decide which you prefer, subjectively, and the stories of rivalry add pepper to the sometimes-bland history. What brought Ingres and Delacroix to loggerheads and made of their competition a proper rivalry was the Exposition Universelle, in which both wished to feature with the best location for the show.

It was similar with J. M. W. Turner and John Constable. Where works are hung at public exhibition has been the source of much anger, from Leonardo and Michelangelo at the Sala dei Cinquecento to the feud between Turner and Constable, the two leading landscape painters of England. They were equally successful painters, one who loved landscapes, the other seascapes. At an 1832 Royal Academy show in London, Constable displayed his seven-foot-wide *The Opening of Waterloo Bridge* and Turner his *Helvoetsluys*, which was half the size. Constable had not been certain that his work would be embraced—the Royal Academy had a bias against genres it deemed "less important," and landscape was only a step preferable to still life, while portraiture and history paintings (which included real history as well as biblical and mythological subjects) was seen as what serious painting was all about. Turner was a step ahead in that seascapes were seen as more noble than landscapes, and his paintings often featured ships—real, historically important ships, and this gave Turner's seascapes the weight of history paintings. This preference for Turner made Constable wonder if he might be placed at intentional disadvantage when it came to mounting the show and garnering public opinion.[42]

A Freudian analysis would likely claim that Constable felt underequipped and with something to prove. His submission of a gargantuan painting shouted for attention, and he was said to have been touching it up until the last minute, just prior to the opening of the exhibition, adding vermillion pigment to spice up the color scheme in contrast to Turner's painting, which was subdued and almost grisaille (grayscale) in comparison. The story goes that Turner was playing it cool but visited the exhibition space on many occasions before opening day, always looping back to Constable's painting and sizing it up. Just before the deadline for touch-ups, Turner opted for a single action—a dot of red lead pigment in the foreground of his painting, which he brushed into a buoy.

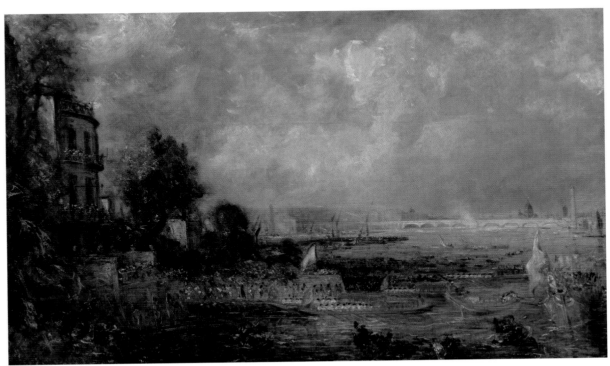

That pop of red was considered by contemporaries to have undone Constable's *Waterloo* and led, in this exhibit, to Constable's Waterloo. When Constable saw Turner add the buoy, he is said to have whispered to his friend, "Constable has been here and he has fired a gun."[43] Turner was thought to have come out ahead in this competition. The two rarely encountered each other in person, and there were enough commissions and riches to go around in England at the time. But Constable repeatedly made somewhat immature comments about Turner to his friends (he once said, "Turner is very grand . . . but some of his best work is swept up off the carpet every morning by the maid and put in the dust hole"), while Turner took the high road—or simply wasn't bothered by Constable enough to mention him.

But Constable was more a thorn in Turner's side than the latter let on. In 1831, when Constable was a member of the Royal Academy's Hanging Committee (which sounds potentially lethal but means that they chose where to display works at the exhibition), he used his authority to put Turner's work in a poor location. David Roberts, a Scottish painter, wrote:

> Turner opened upon him like a ferret; it was evident to all present that Turner detested him. . . . Constable wriggled, twisted and made it appear, or wished to make it appear that, in his removal of the picture, he was only studying the best light or the best arrangement for Turner. . . . I must say that Constable looked to me, and I believe to everyone else, like a detected criminal, and I must add that Turner slew him without remorse.[44]

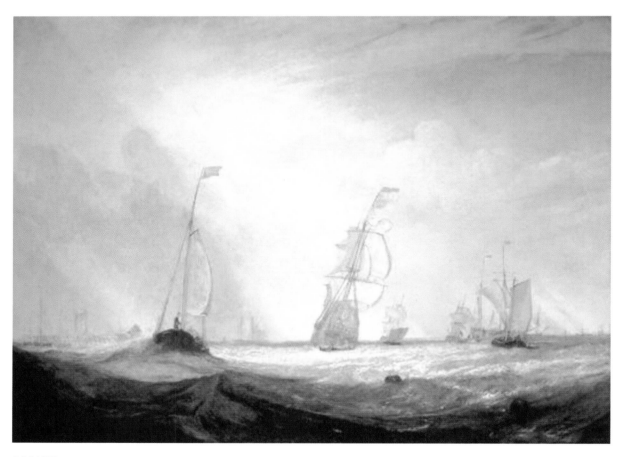

J. M. W. Turner,
*Helvoetsluys* (1832).
PHOTO COURTESY OF
WIKICOMMONS BY
ALAIN TRUONG.

Exhibitions were a real chance for artistic throwdowns, and vying for the best location, then touching up your work to make it appear better in direct contrast to the work of another displayed at the same venue was common. The Royal Academy exhibit was often the venue for such dynamics, with other rival pairs, like John Singleton Copley and Benjamin West, presenting similar stories.

This dynamic fits the argument that rivalry prompts artists to up their game. Without the direct competition, Constable would not have added vermillion to his *Waterloo*, and had he left it alone, Turner would not have added that red buoy to *Helvoetsluys*. That red buoy has often been described as the best element of the painting, adding aesthetic tension and drama. Without a heated rivalry, *Helvoetsluys* would be a fine but less successful seascape.

## Banksy and Rivalry in Economic Theory

Competition theory is a basic tenet of economics. Absence of competition leads to higher prices and lower quality, since the provider of a good or service does not see the need

to put in any particular effort or to lower prices. This is why monopolies are bad for the public and in some countries are illegal. Competition encourages innovation, lower prices, and better quality—all tactics to encourage the public to choose your good or service over those of your competitors. This is at a very basic level, and there are twists, of course. By intentionally setting your prices high, you can attract a certain percentage of the public who have more disposable income and prefer high-end goods for prestige and the implied assurance of quality. Targeting this audience means a smaller potential public, but a wealthier one.

When it comes to fine art, the sort of art about which we write books, we're almost inevitably talking about this highest of the high end: the revolutionaries, the innovators, the artists who changed what art could be. Not all were compensated appropriately to their genius. Recall the oft-told story that Vincent van Gogh lived in poverty and sold only a single painting during his lifetime. But artists can sometimes determine their market based on the prices they set. Claude Lorraine, a French painter based in Rome in the seventeenth century who did revolutionary things with perspective and vanishing point, used a clever pricing system in that he did not name his price. A patron would commission a painting from him and, when it was finished and presented to the patron, Claude would tell him to pay whatever he thought it was worth. Placed in a somewhat awkward position and not wanting to appear cheap, the patrons would volunteer to pay the high end of the market price. Claude was likely the most expensive painter in Baroque Rome thanks to this tactic.[45]

Competition in the art discussed in art history books is normally in the form of overt contests (as in the ones Brunelleschi lost to build the Gates of Paradise but won to build the dome on Florence's cathedral), or as prominent artists vying for patronage. It's said that Titian and Tintoretto, the leading painters of Venice in the first half of the sixteenth century, tried to outdo each other for the choicest commissions. Price was not an issue for this highest end of patronage, so it was down to innovation. It was an all-out battle for the commission to decorate the Scuola Grande di San Rocco, a two-story meeting place for a religious confraternity that would feature dozens of paintings. Normally each artist would be asked to prepare a cartoon, a preparatory full-sized drawing that demonstrated what the finished painting would look like. This was quicker and cheaper to make than a painting on spec, but some artists would pull out all the stops and prepare a finished painting as their demo piece. Tintoretto supposedly went a step further: He snuck into the Scuola Grande the night before the competition and hung a finished *St. Roch in Glory* on the ceiling, then snuck out again. The next day, when he and Titian showed up to reveal their cartoons to the selection committee, Titian presented his. When the committee turned to Tintoretto, he had no cartoon with him, but just pointed up to a corner of the room in which they stood. There was his finished demo painting, hung in place. He played dirty, but he won the commission, though it was given to him begrudgingly. His tactic also included gifting *St. Roch in Glory* to the Scuola and offering to paint the rest of the ceiling gratis, a gift they felt they couldn't refuse but could hardly then have said, "Thank you for this gift, but we don't want you to paint the walls." Tintoretto, as he surely calculated he would be, was paid to paint the rest of the premises, and it worked

out well for both patron and painting: The Scuola Grande di San Rocco is his master-piece, one of the greatest complete spaces in the history of painting.[46]

Direct rivalry, as we have discussed, emerges when competition between a pair of artists of roughly the same ability takes place over an extended time in the same geographic space. Titian and Tintoretto were the rivals of Venice, though Titian also worked extensively elsewhere while Tintoretto did not, which is why, beyond the confines of the canals, Titian's real Europewide rivalry was with Michelangelo, Leonardo, and Raphael.

But rivalry can also launch careers out of obscurity. Such was the case for an anonymous graffiti artist called Banksy. Banksy is now a household name, but back in 2009 in the Camden Town neighborhood of London, King Robbo was the monarch of graffiti art and far more famous. King Robbo, as he liked to be called (his real name was John Robertson), believed he had the oldest tag in London, the words ROBBO INC spray-painted on a wall in 1985, when he was fifteen years old. But now this new graffiti artist, who went by the tag Banksy, had spray-painted over it with a stencil of a worker in overalls applying wallpaper to a gray background. One graffiti artist had obliterated the prized work of another. To counteract this, King Robbo made another tag, now atop Banksy's work. The worker applying wallpaper was changed into a worker writing KING ROBBO onto the paper. But that wasn't the end. A few months later, the painted text, KING ROBBO, was transformed into FUCKING ROBBO through the deft application of three additional letters by—you guessed it!—Banksy. Then Robbo painted out the FUC.

If this sounds childish, well, it is. But it also captured public attention and vaulted the visibility of both graffiti artists out of the realm of graffiti circles and onto the pages of major newspapers. The rivalry continued in a tag at Regent's Canal in London, where Banksy's tag "I DON'T BELIEVE IN GLOBAL WARMING" was shorted by Robbo and his friends to "I DON'T BELIEVE IN WAR." They then added, "It's too late for that, sonny. Team Robbo." Banksy then erased that and tagged, "BANKSY HE'S NOT THE MESSIAH HE'S A VERY NAUGHTY . . . ROBBOTEAM." This battle of tags continued and was codified in the 2009 book *London Handstyles*, which solidified the oral tradition of the King Robbo versus Banksy rivalry. Banksy was defter with the media (possibly because of his real identity, which has been reasonably argued to be Robert Del Naja, a member of the hugely popular band Massive Attack), but both graffiti artists found success.[47] Pure Evil Gallery in London helped launch Banksy's mainstream career and later staged a solo show for King Robbo, too. Robbo was on the rise, with commissions in Berlin, Milan, Rome, and Paris—the highest possible level for anonymous graffiti artists. But then a tragedy and a mystery occurred. In April 2011, Robbo was found near his apartment in London, unconscious and in a pool of blood. He'd fallen down a flight of stairs and fractured his skull. He remained in a coma for three years before passing away. It remains an art world mystery whether this was an accident or murder. Robbo's identity came out after his death, and the legacy of the two rivals was made even more mainstream in a TV show, *Graffiti Wars*, which ran on the UK's Channel

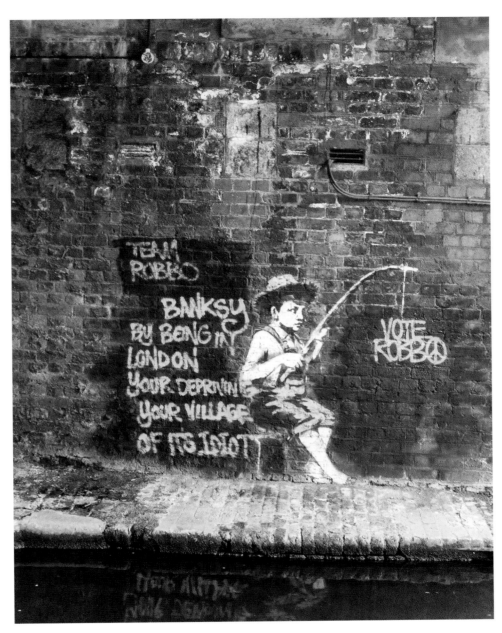

King Robbo and Banksy, *Village Idiot* **(2010).** PHOTO COURTESY OF WIKICOMMONS BY JAVIER VTE REJAS.

4. What drove the story was not the art but the rivalry. It catapulted forward the fame of both artists.[48] Had Robbo not met with his tragic fate, he might have ascended to a level similar to what Banksy enjoys today. Without each other as rivals, and the resulting media interest that their duel prompted, neither might have ascended from their relative renown among graffiti circles in London.

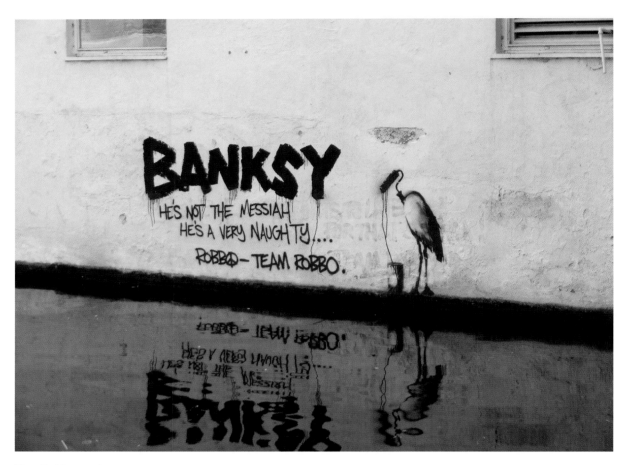

King Robbo and Banksy, *Naughty Boy* (2009). PHOTO COURTESY OF WIKICOMMONS BY JOHN W. SCHULZE FROM TEJAS.

## Ulay and the Frenemies

While Constable and Turner expressed their mutual dislike (despite the obvious subcurrent of mutual admiration as talented painters), art history was also pocked with frenemies, rivals who were either superficially friendly (while actually disliking one another) or deeply friendly (with a superficial dislike).

The latter could describe Picasso and Matisse, two very different painters who truly admired and liked each other but had superficial arguments along the way. In the definition of a love-hate relationship, Matisse and Picasso were great friends, great rivals, and mutual admirers. In 1907, the year that both of them made their careers (Matisse with *The Joy of Life,* Picasso with *Les Demoiselles d'Avignon*), each artist selected a work by the other to keep as a souvenir.

Matisse chose Picasso's *Pitcher, Bowl and a Lemon,* while Picasso chose Matisse's *Portrait of the Artist's Daughter, Marguerite.* Gertrude Stein said that each artist had

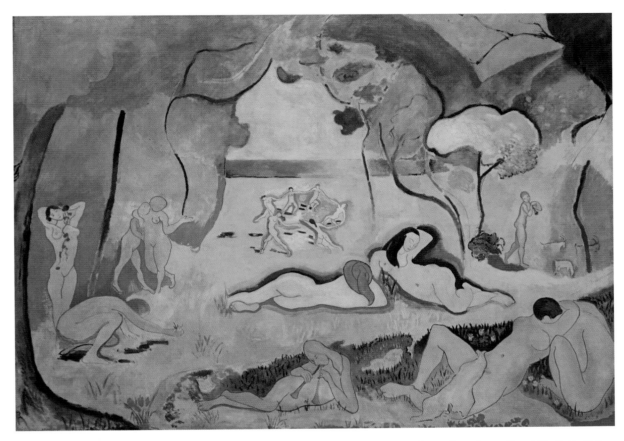

chosen his rival's weakest work in order to show off its flaws. Picasso was later found to have used Matisse's painting as a target for playing darts. But there was genuine affection between the two, so the rivalry was playful and beneath the surface and psychologically most complex. It influenced both artists' work, with Matisse urging Picasso away from Cubism, and each recommended the other for influential commissions, particularly from Russian patrons.[49]

Henri Matisse, *The Joy of Life* (1906). PHOTO COURTESY OF WIKICOMMONS, BY REGAN VERCRUYSSE, FROM PHELPS, NEW YORK.

There are numerous other case studies in rivalry that we might have discussed, but those chosen are useful exemplars that reinforce the thesis that rivalry benefited the course of art and made artists better.

Of all the frenemies in the history of art, the most famous were the lovers and partners in art Ulay and Marina Abramović. They loved each other deeply, argued, and turned rivals, loving each other all the same beneath the surface while arguing and suing one another above it, and ultimately finding a platonic love again in the end. They are also one of the very few artist couples in history. Since art was, until the twentieth century, a male profession (for no good reason, simply tradition of studios and bottegas occupied by men only, to reduce sexual distraction), the window for fine art couples of note is relatively small compared to the history of art. Other famous art couples include

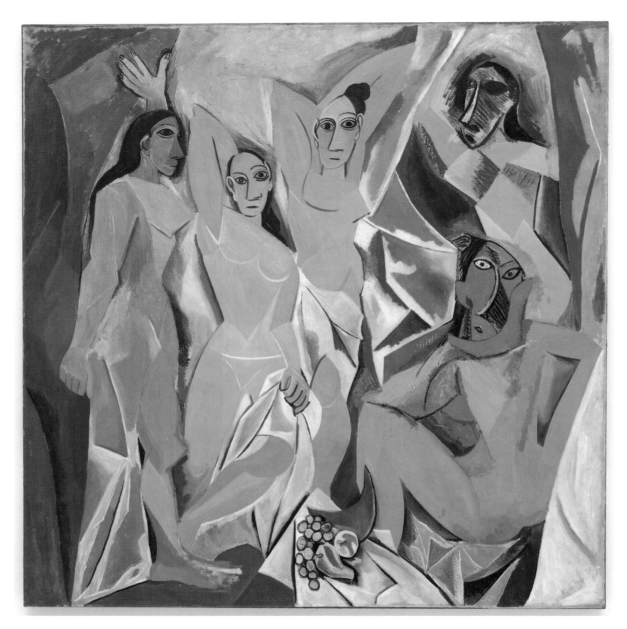

Pablo Picasso, *Les Demoiselles d'Avignon* (1907). PHOTO COURTESY OF WIKICOMMONS, IMAGE FROM THE MUSEUM OF MODERN ART, NEW YORK.

Jackson Pollack and Lee Krasner, Camille Claudel and Auguste Rodin, Björk and Matthew Barney. But none were of the scale, symbiosis, and public art rivalry of Ulay and Abramović.

A tall, bearded old man with the weathered, craggy face of a handsome, kindly sea captain stands in a pale pink negligée in a gallery in Amsterdam's Stedelijk Museum. As part of his January 15, 2015, performance, portentously entitled *A Skeleton in the Closet*, he inscribes clusters of numbers onto a pale pink square upon the wall: 252, 253,

288, 289. The sellout 120 spectators who made it in ahead of the 500 or so hopefuls outside the gallery try to discern what it all could mean: Is Ulay referencing astrology? Cryptonumerology?

The tall old man was born as Frank Uwe Laysiepen but has worked for more than fifty years as Ulay. He is one of the most important artists of the second half of the twentieth century, so influential that he is one of only three or four conceptual artists included in most standard introduction to art history textbooks. The only twentieth-century conceptual artist who is perhaps better known is Marina Abramović, Ulay's partner in life and art from 1976 until 1988, when they dramatically and poetically split up after a performance in which they set out from opposite ends of the Great Wall of China and met in the middle for a farewell. Ulay is a legend in the contemporary art world but never sought more mainstream acclaim. Abramović, on the other hand, shot from the status of important artist to household name thanks to a 2010 retrospective at MOMA in New York and a major documentary film (*The Artist Is Present*, 2012), after which she began hanging out with people like Jay-Z and Lady Gaga and making Adidas commercials. It is Abramović who is the subject of those numbers that feature in Ulay's pale pink performance.

What was once the storybook romance of the art world had long ago soured. Ulay won a lawsuit against Abramović that argued she was in breach of a contract they signed in 1999 detailing how to handle their joint oeuvre.

The most famous works in the oeuvres of Abramović and Ulay are those they did together, and there are scores of them. These include *Incision* (1978), in which a naked Ulay repeatedly runs toward a clothed Abramović but is blocked and pushed back by an elastic rope; *AAAAAA* (1978), in which Ulay and Abramović, face-to-face, scream "AAA" at one another at the top of their lungs; *Relation in Space* (1976), in which they ran into each other, naked, across a gallery space for an hour; *Imponderabilia* (1977), in which they stood naked opposite each other in the narrow doorway of a gallery so that visitors had to turn sideways to squeeze past them and choose which one to face in doing so; and the wonderfully inflammatory *Irritation: There Is a Criminal Touch to Art* (1976), in which they stole a painting from a Berlin museum and documented the process.

Their relationship is such a key part of the history of performance and body art that their knot can never be unwoven, symbolized (though surely inadvertently) through their 1977 *Relation in Time*, in which they performed bound together by their braided hair, but facing away from one another. Evidence of the endurance of the very idea of their relationship (even among those unfamiliar with their art) may be seen in a viral video of a moment during Abramović's performance at MOMA in 2010, in which visitors were invited to sit quietly opposite her.[50] As a surprise, Ulay stood in line and eventually took his place before her. Both grew teary over the few minutes during which they sat, staring at one another. The editor of the video (which was made and distributed without the permission of either artist) added some explicatory text and dramatic music, making the video seem like the reunification of long-lost lovers. The video has twenty-four million viewers and counting. But matters were not quite as romantic as the video would lead one to believe.

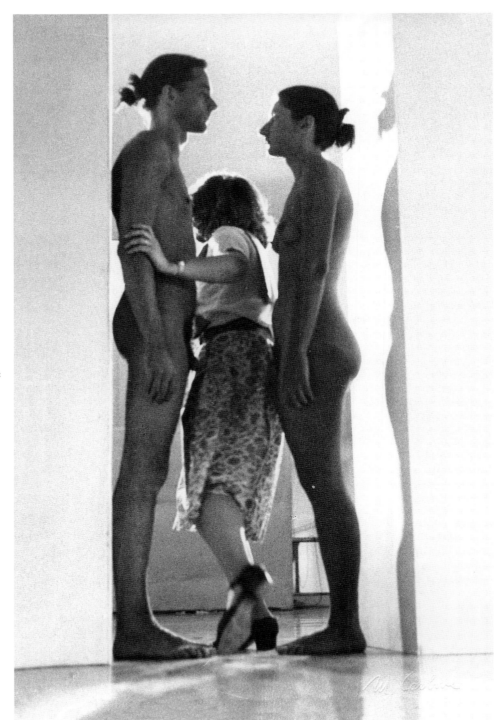

Ulay/Abramović,
*Imponderabilia*
(1977). COURTESY OF
ULAY FOUNDATION.

Until he passed away in March 2020, Ulay lived through his seventies in Amsterdam and Ljubljana (where he and I met and struck up a friendship).[51] Warm and soft-spoken, with a haggard, bearded handsomeness, Ulay seems to have more stories in his life than could fit in one biography. He was born in Germany but is synonymous with the art scene in Amsterdam, where he lived for decades and still kept an apartment. His art career began with his role as an official photographer for Polaroid, using their colossal 20 x 24 camera to take pictures as he traversed Europe. The majority of his oeuvre remains photographic, but he shot to fame through his performances, which have often brought gender roles into question, with Ulay frequently cross-dressing. He was the subject of a 2013 documentary film, *Project Cancer*, which followed him for a year after he was diagnosed with cancer—which he managed to beat twice before it took him in 2020. In 2014, *Whispers: Ulay on Ulay* came out, which contains numerous interviews with him and essays about his work as well as images of his complete works—or at least it was *supposed* to contain images of his complete works.

From 1988 to 1999, Abramović and Ulay did not speak. Having fallen out and separated, the onetime partners needed to find a way to manage their combined oeuvre, which was considerable in extent, importance, and financial worth. During that time, the large works (like the oversized 20 x 24 Polaroids) were in Abramović's possession, while Ulay had the smaller archival objects (like photographic negatives). Ulay managed their joint archive, but it required a lot of administration, and he was less than proactive on the business side of things. At the encouragement of Abramović's New York gallerist, Sean Kelly, a contract prepared by a Dutch lawyer and an American law firm was drawn up and filed in Amsterdam, where Ulay had long resided, that laid out how their oeuvre should be dealt with. Ulay sold his physical archive of their joint projects to Abramović for a flat fee, which included exploitation rights. That physical archive, now entirely in Abramović's possession, could be used to produce saleable work—for instance, photographs made from negatives or copies of video art—at her discretion. But Abramović would have to inform Ulay of any of their joint material that was either sold or to be exhibited. Any net income generated would go 50 percent to the gallery (standard in the art world), with 20 percent going to Ulay and 30 percent to Abramović. It was all fairly straightforward, and both parties seemed satisfied, although when the agreement was made, Ulay did not want to meet with Abramović in person, so Kelly acted as intermediary.

From 1999 until the lawsuit, this contract was only loosely adhered to. As Ulay described during our conversations in Ljubljana, "There is a lot of money going through her accounts, and of course they have a very good accountant." But Ulay had received surprisingly little, for Abramović had occasionally sent Ulay his cut of the earnings on their joint works calculated in a very different way from the contract stipulations.

But the money, while a breach of contract, was the least of it. What really concerned Ulay was his perception that Abramović was trying to rewrite history and airbrush him out of it. The contract stipulates how their joint works must be credited: the artists listed as "Ulay/Abramović" for works made in their earlier period, from 1976 to 1980, when Ulay was the more prominent name, and as "Abramović/Ulay" for works made from 1981 to 1988. This, Ulay claimed, she has rarely done, taking sole authorship credit for some of their

reperformances: "She's not just a former business partner. The whole oeuvre has made history. It's now in schoolbooks. But she has deliberately misinterpreted things or left my name out. But I had never reacted, because I wanted to have peace of mind." Until the lawsuit.[52]

Ulay said that he might never have reacted had she not tried to interfere with his book. He was shaken from his torpor in 2013. Abramović had given an interview to be included in Ulay's book, which was published in December 2014 by the small Dutch art publisher Valiz. But when she received the PDF proofs of the book in April 2013, something happened. "When she saw the PDF," Ulay explained, "she engaged a lawyer and approached the publisher, not me." Abramović had her lawyer send an official letter to the publisher claiming that she had not given permission to use either the interview or the images (though technically Ulay did not require her permission to use the images, only to inform her of their use). This was particularly spiteful, because the book was originally conceived as a possible elegy to Ulay. One of its authors, Maria Rus Bojan, explained, "Ulay commissioned me to make this book before he started the chemotherapy for his lymphoma. We were all very much afraid that he would not survive the treatment." Rus Bojan flew to New York to personally ask Abramović to be interviewed for the book. "She was extremely kind," Rus Bojan recalled. "That was in 2012, during Ulay's treatment." It is that much stranger, then, that Abramović would make such a sudden about-face and threaten the publisher with litigation.

**Ulay/Abramović,** *Great Wall Walk* **(1985).** COURTESY OF ULAY FOUNDATION.

The publisher panicked and, fearing a lawsuit, quickly established a foundation that would officially publish *Whispers*—a foundation with no capital to lose, as a tactical measure, and distinct from the rest of the publishing house. The interview had been undertaken expressly for the book, and this was very late in the day to make objections, with the book scheduled for printing. In consultation with Ulay's lawyers, it was determined that Abramović did not have the right to block the publication of images from their joint oeuvre. But to avoid a potentially messy and expensive lawsuit, which the publisher was particularly keen to steer clear of, it was decided that a certain number of the images of their joint works had been published and republished so many times that citation rights applied, and their inclusion was beyond objection. No explanation was offered in the book itself of this striking oddity, aside from a brief note hidden in the acknowledgments at the back: "Marina Abramović has objected to the use of the images of the joint works Ulay/Abramović or Abramović/Ulay for this publication. Although we believe that a book about Ulay would be incomplete without a selection of their joint works, and the use of such images is permitted under the citation right, we have nonetheless felt obliged to cover a number of the images with pink or black fields."[53]

Art professor Amelia Jones said of this, "It's impressive, actually, the degree to which she has been able to produce narratives of the history of performance that serve to build up her position in that history. For example, the media repeatedly calls her the 'mother' or 'grandmother' of performance art, as if Carolee Schneemann, Shigeko Kubota, Yoko Ono, Valie Export, and many other women weren't already doing performance art in the 1960s and early 1970s before Abramović emerged!"[54] Could the "grandmother of performance art" really wish to diminish, if not erase, the role of the "grandfather"?

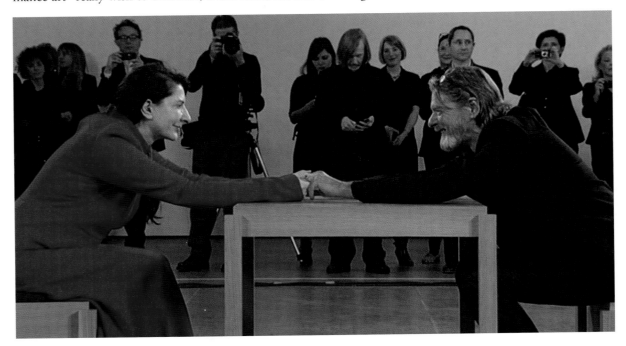

Photograph of Ulay and Abramović meeting at Abramović's performance *The Artist Is Present* (2010). COURTESY OF AGORA GALLERY.

Of course, Abramović could never completely erase Ulay from the history of art—he has been written about so often, over so many decades, that his presence will be everlasting. As curator Tevž Logar said, "Marina cannot overpower Ulay and take credit, because every single person in the art world knows that the Relation Works [their most famous collaborative series] worked because of the balance between them, and of their equal and joint efforts. That is how it entered the history of art and performance." All she could do was try to throw a wrench into the gears of his personal projects, his attempts to write his own story and tend to his own legacy, independent of her. Logar continued, "I actually think that Marina's agenda here is more banal and pragmatic. Unlike Marina, Ulay never cared about maintaining his position in the contemporary art world and was never really a presence on the market. So when Ulay only recently started to be represented by MOT International, a progressive gallery in London and Brussels, that meant that he started to enter Marina's symbolic space, space that until now she ruled over." This was exemplified by Ulay's featured role at the world's most important contemporary art fair, Art Basel. As Logar concluded, all of a sudden, the "grandmother of performance," after more than twenty years alone at the top of the market, was confronted by the "allegedly lost grandfather."

The tall old man in the pink negligée writes numbers upon the pale pink square on the wall of the Stedelijk Museum. What are those numbers? Neither cryptonumerological nor astrological, they are something altogether more straightforward but at the same time more emotionally complicated. They are the image and page numbers of the pinked-out, censored works in Ulay's book, the collaborative projects that half of the most influential tandem of conceptual artists in history refused to permit to be seen.

**Photograph of Piran cemetery.** COURTESY OF THE AUTHOR.

Ulay won the suit, proving that Abramović was in breach of the contract signed in 1999 that laid out how they were to handle their joint oeuvre. Ulay described this protracted legal battle, with lawyers wrangling for two years before the courtroom drama began, as "three most unpleasant and distressful years." He continued, "I won the case on the most crucial points. The relief was like shedding my skin, physical and mental."

Photograph of Ulay's grave at Piran cemetery. COURTESY OF ROMAN URANJEK.

Ulay likened this battle over artistic recognition to his own successful victory over cancer: "My cancer ordeal was aggressively threatening my life and the massive legal battle with Abramović was threatening my existence. To my opinion, the court verdict was fair and just to the truth."

The title of Abramović's 2010 MOMA exhibition, *The Artist Is Present* was, ironically, referenced in the lawsuit. As Ulay explained, "*The Artist Is Present* borrows from our epic 90-day performance series *Nightsea Crossing*, which we performed between 1981 and 1987. For the MOMA performance, she just cut the table in half and invited visitors to sit opposite her instead of me, though I did show up."

And then, a strange but beautiful punchline.

Mere weeks after the lawsuit, the two met by chance, or fate, at an ayurvedic retreat in rural India. Ulay was there with his wife, Lena Pislak, who had been his constant companion, support, and driving force for years. But what could have been very awkward was not. The two artists decided to put the issue aside and became friendly again, against all odds. Years later, they even discussed writing a joint memoir together.

On March 2, 2020, Ulay passed away. I attended his funeral, in an idyllic seaside cemetery in the coastal Slovenian town of Piran, where he had chosen to be buried.

> Sea breeze weaves
> Through cypress trees

I wrote this in my notebook while at the funeral. He was surrounded by a clutch of friends; the dominant sound, a palpable one, was the sea breeze weaving through the cypress trees.

Abramović could not attend (due to the pandemic), but sent a short, moving, loving letter of grief and admiration for her partner, rival, and love. In retrospect, their partnership and rivalry spurred on their art. They helped each other to reach the highest level of contemporary artistry, but their separation also ignited their solo careers. Abramović did not reach the pinnacle of renown that she currently enjoys until very late, with the 2010 MOMA exhibit and documentary solidifying it. Ulay never sought a seat at the table with the high rollers, retaining his hippie antiestablishmentarianism. Though his art historical legacy, within the art world, was glowing and ironclad long ago, it is ironic that his highest-profile action from the perspective of the general public was sitting at the table opposite Abramović at MOMA in 2010, rivals staring at each other and both moved to tears of joy.[55]

# Conclusion
## WHEN THE BEST ARTISTS ARE "BAD"

Our story of scandal, shock, and rivalry in art history began with Caravaggio, in whom all three throbbed and bloomed into wondrous creations. So it is fitting, then, that we end with another pair of Caravaggio case studies that will help conclude and establish the point of the thesis that scandal, shock, and rivalry are ultimately beneficial to the course of art.

August in Rome is hot and heavy, and those who can are likely to leave for cooler climes. The popes head off to Castel Gandolfo outside the city. Emperor Hadrian built a villa at Tivoli, likewise beyond the city confines, in order to escape the sun. It's not exactly prime time for artists to sell works, which is why an impromptu exhibit was set up by a handful of Roman artists in 1602. The hope was to drum up a bit of work during a quiet period. But it was a big day for Giovanni Baglione, a solid B-level, though not ingenious, Baroque painter who got into scuffles with Caravaggio. On this day, as art historian Clayton Schuster wrote, the fact that Caravaggio was not at the exhibition likely saved Baglione's life.[1]

Recall that, unlike most artists throughout history, who cultivated studios that would carry on their style, Caravaggio threatened, attacked, and sued artists who emulated his unique brand of dynamic hyperrealism with dramatic chiaroscuro lighting. He had killed a rival gang member, ostensibly over a game of tennis but actually in anger over their shared love for a prostitute.

This exhibit proved important because Baglione exhibited a painting that would become his best known, and it drew raves from those who saw it that August day and beyond. It was large and impressive, showing a dramatic armored Archangel Michael triumphing over Cupid, the embodiments of divine or sacred love (a pure, chaste love for God) over profane love (the lusty, earthy variety, embodied by Cupid). Michael wields a thunderbolt like a spear, driving Cupid away from the devil, a monstrous form whose back and face are turned away from the viewer, into the inky darkness of the background. The style was borrowed—or he might say stolen—from Caravaggio. Tenebrism, as it would later be called, or as it was more often termed, a Caravaggesque style, featured overall shadow darkness from which figures emerge into controlled spotlighting. It had

revolutionized art in Rome. It was immediately the most avant-garde, talked-about style, so vivid, so dynamic and dramatic, so realistic that it defied expectations of what art could and should be.

Caravaggio had first made a splash four years earlier, in 1598, with his three large-scale public paintings for the church of San Luigi dei Francese, the Saint Matthew Cycle. Caravaggio was rich and haughty, pugnacious and mean-spirited, talented and mercurial, and certainly divisive. Bellori, one of his biographers a generation later, wrote, "Because Caravaggio put an end to dignified art, every artist did just as he pleased, destroying all reverence for Antiquity and for Raphael."[2] Bellori and other artists in the traditional, classical, academic vein idolized Raphael (fair enough) and cultivated a version of his style. This is what was taught at academies and what was considered proper. Caravaggio, the badass of Baroque Rome, was anything but.

Baglione was trained in this Raphaelesque style but saw the effect of Caravaggio's tenebrism, particularly in the sales. So he adopted Caravaggio's style. This didn't go over well. Nor did it go over well that this painting, generally called *Sacred and Profane Love*, appeared to be a riff on (or rip-off of) and negative commentary on Caravaggio's painting *Vincit Amor Omnia*, finished in 1602.[3]

There is more to this work by Caravaggio than meets the eye. A smiling, nude adolescent Eros (Eros is the name for Cupid in adolescent, often eroticized, form) grips arrows (to be pierced by one is to fall in love), but his manner and body do not look like this refers to divine love. The painting was commissioned by Cardinal Vincenzo Giustiniani, one of Caravaggio's earliest patrons, who favored paintings of nude boys, which inspired his erotic preferences.[4] Homosexuality was illegal and frowned upon as morally unacceptable, but it was an open secret that it was practiced, and two cardinals, Giustiniani and Francesco del Monte, Caravaggio's first two patrons in Rome, were enthusiasts—there is some thought that Caravaggio himself worked as a young male courtesan, and several of his early paintings, like *The Musicians* (1595), show such professionals.

So when Baglione unveiled his latest painting mere months after Caravaggio's *Vincit Amor Omnia, and* it was in Caravaggio's style, *and* it showed a similar theme, but with profane love cowed and overcome, rent away from the devil by the morally upright angelic knight, Michael, as sacred love, it was not only a stylistic issue, which was enough to enrage Caravaggio and provoke a throwdown. It was an arch, prudish commentary on Caravaggio's immoral painting for his immoral patron. It was a slap in the face. To top things off, it had been commissioned by Vincenzo Giustiniani's brother, Benedetto, in what seems to have been a repudiation of Vincenzo's sexual proclivities through a work of art.

Caravaggio's friends, particularly the similarly ornery Orazio Gentileschi, confronted Baglione before Caravaggio reached him. Baglione was not intimidated (though perhaps he should have been) and prepared a second painting of the same theme later that year, with one difference: The devil's face is no longer turned away but turned to the viewer, and the face is a monstrous caricature of Caravaggio's own.

Caravaggio did not manage to physically attack Baglione (at least, it has not been recorded), but a rivalry boiled. Through Benedetto Giustiniani, Baglione received a major

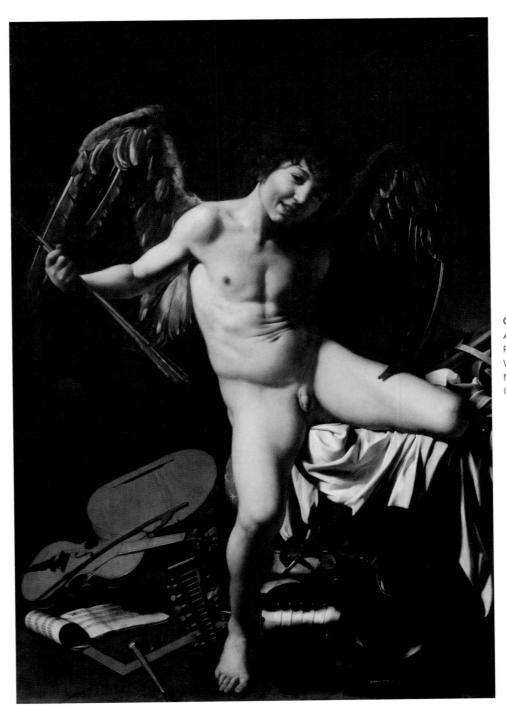

Caravaggio, *Vincit Amor Omnia* (1602). PHOTO COURTESY OF WIKICOMMONS, BY MIGUEL HERMOSO CUESTA.

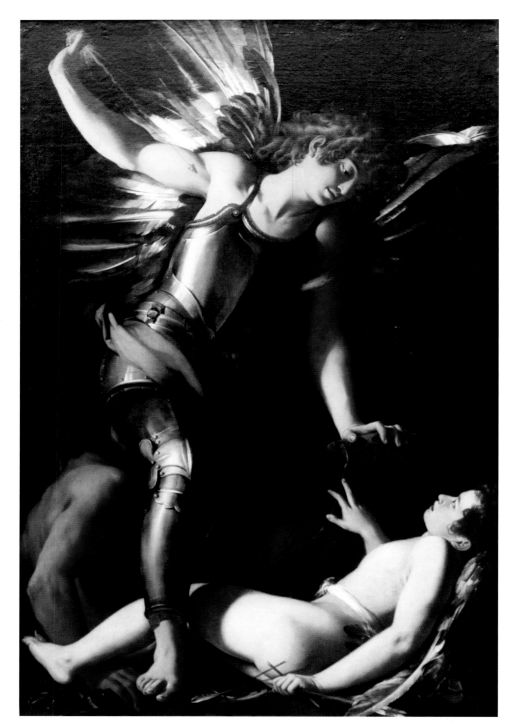

Giovanni Baglione,
*Sacred and
Profane Love*
(version 1, 1602).
PHOTO COURTESY
OF WIKICOMMONS,
FROM THE WEB
GALLERY OF ART.

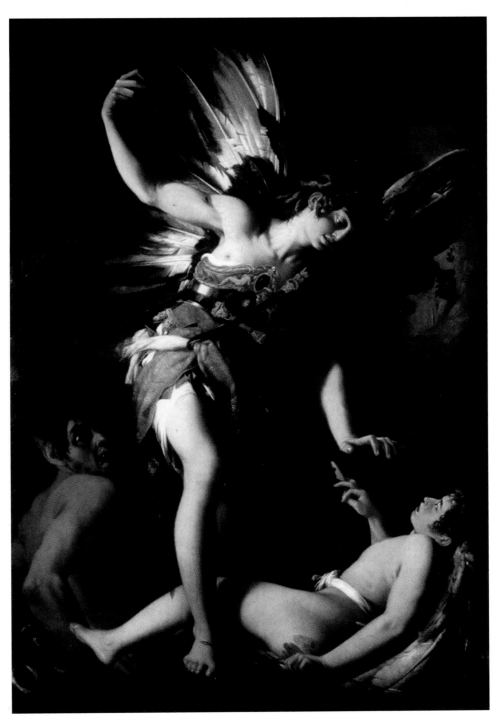

Giovanni Baglione,
*Sacred and
Profane Love*
(version 2, 1602).
PHOTO COURTESY
OF WIKICOMMONS,
PHOTOGRAPHER
UNKNOWN.

commission that was much desired in Rome, for an altarpiece at the Jesuit church Il Gesu. Baglione created *Resurrection* in 1603, but this painting, now lost, was unpopular and fell flat in terms of popular reception. It could have made Baglione's name and career, but it instead relegated him to B-level status. Caravaggio saw this as an opportunity for revenge and began to publish poems—ostensibly anonymously—that were merely a laundry list of insults against Baglione (using the light epithets that might be translated as Johnny Baggage and Johnny Balls), not only mocking his mediocrity in art but commenting on his similar mediocrity in bed. These verses, it must be said, were not exactly subtle in their mockery.[5]

This was no small issue. Publishing libelous texts was a serious crime in seventeenth-century Rome, and the punishment was a life sentence as a slave rowing on galleys owned by the pope. Baglione and his friends brought a lawsuit against Caravaggio and his friends, accusing them of libel. On trial, Caravaggio claimed to have never heard about the poems. (He also claimed not to have seen his close friend Orazio Gentileschi, also on trial, for three years.) The judicial magistrates asked for Caravaggio's opinion of Baglione's paintings, and he kept his cool but was clear in his dismissive attitude. The trial records indicate that he said, "I do not know of any painter who thinks that Giovanni Baglione is good. . . . I've seen almost all of his works. . . . *The Resurrection of Christ* at the Gesu . . . [is] the worst he has done and I've not heard any painter say a good word about it."[6] The trial ended with a slap on the wrist—Caravaggio was imprisoned for two weeks. But the rivalry, which had been a hot one, continued.

One might think that Baglione would have had enough of Caravaggio, but in fact he became one of his earliest biographers. Decades later, in 1642, he wrote a sort of update on Vasari's *Lives*, entitled *The Lives of Painters, Sculptors, Architects and Engravers (active 1572–1642)*, which includes a biography of Caravaggio. One might think it would be knives out when he came to write about his onetime rival, but this was forty years later. Caravaggio was long dead, and Baglione's words about him are remarkably unbiased, considering the circumstances. Baglione clearly admired Caravaggio's art, if not his personality and proclivities. Ironically, we have Baglione to thank, along with a few other contemporary biographers, for preserving Caravaggio's story in such vivid detail that we know much more about him than we do so many of his contemporaries.

Caravaggio did not really think highly enough of Baglione as a painter for this to be an actual rivalry. There was mutual dislike, but Baglione would likely have been largely ignored by Caravaggio and his crew had he not picked a fight with his painting. But Annibale Carracci—someone Caravaggio respected—was a different story.

In the early 1600s, the Carracci Academy in Bologna—founded by two brothers and a cousin, Annibale, Agostino, and Ludovico Carracci—represented the traditional, academic, art that was considered the solid foundation of baroque painting. It is perhaps easiest to describe their style in terms of how it differed from what the revolutionary Caravaggio was doing, for the Carracci were excellent painters but not involved in an aesthetic revolution. Their work, and what they taught their students, began first with an absolute focus on, and primacy of, drawing (*disegno*). Their students would draw and draw and draw, far out of proportion with the time spent painting. Imagine the work

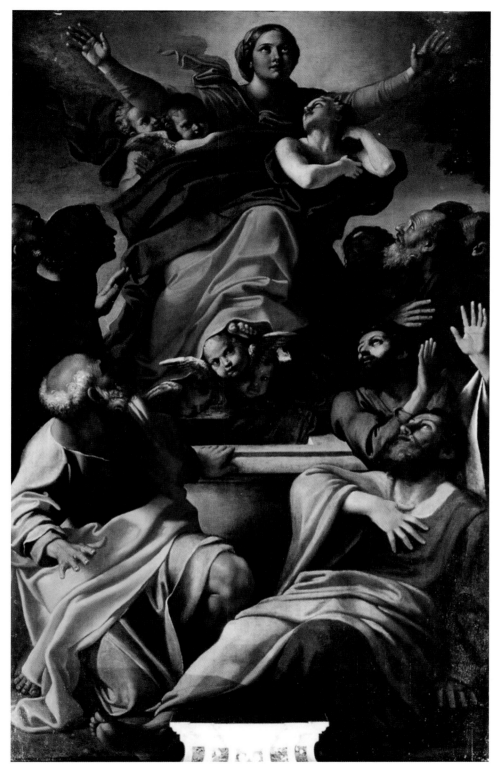

Annibale Carracci,
*Assumption of
the Virgin* (1601).
PHOTO COURTESY
OF WIKICOMMONS,
PHOTOGRAPHER
UNKNOWN.

of Raphael in darker, moodier lighting, often with single light sources imagined just outside the painting, resulting in plenty of shadow, chiaroscuro, with more movement and dynamism and more portraitlike faces, and you have the Carracci style. This was the academic, traditional, safe style for commissions. It was part of a long, rich artistic continuum resonating with the painting of the classical world and a passing of the baton from the prince of painters, the poster boy, Raphael, whom many in the sixteenth and seventeenth centuries looked upon as the ideal painter, from both personal (he was handsome, charming, educated, and helped elevate the social status of painters through his lead) and aesthetic angles. In contrast, Caravaggio was doing something entirely new, edgy, and not to everyone's taste, but hugely exciting to those who admired him.

One of the best places to see these rival styles is from a single vantage point in the church of Santa Maria del Popolo in Rome. This church, rebuilt after the Sack of Rome in 1527, was the first inside the city proper when travelers approached Rome from the northern road. This gave it pride of place and meant that millions of pilgrims every year would stop there.

Enter the church and you'll pass a Raphael painting and an oddball sculpture group by Bernini featuring Habakkuk, whose story involves miraculous transportation via picnic basket. On the left side of the main altar stands the small Cerasi Chapel, containing a pair of Caravaggios, one on either side of the central chapel altar, and Annibale Carracci's *Assumption of the Virgin* (1601) above the altar.

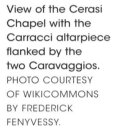

**View of the Cerasi Chapel with the Carracci altarpiece flanked by the two Caravaggios.**
PHOTO COURTESY OF WIKICOMMONS BY FREDERICK FENYVESSY.

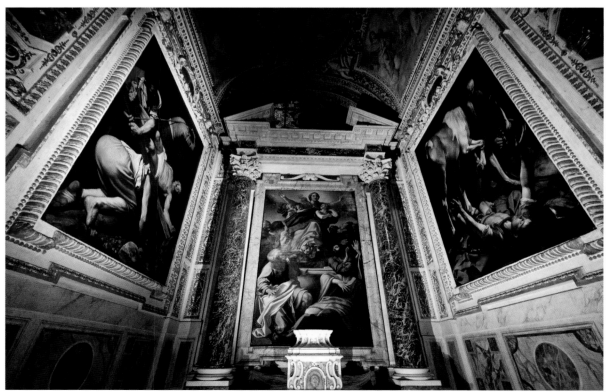

Perpendicular to it, and therefore seen at extreme angles (because the public cannot approach the altar but must admire the chapel from beyond a balustrade), are the two Caravaggios: *The Crucifixion of Saint Peter* and *The Conversion of Saint Paul* (1601). Without moving, the public can view the two styles and make a direct judgment as to which they prefer.

For the Cerasi Chapel, where Caravaggio's first works were rejected by the patron, both Caravaggio and Annibale Carracci were commissioned in 1600: Carracci was assigned a painting over the altar in the center of the chapel, while Caravaggio was charged with two paintings on the lateral walls on either side of the altar. The patron, Tiberio Cerasi, the treasurer-general to Pope Clement VIII, set up an intentional "artist's duel" of sorts. Carracci's *Assumption of the Virgin* is, stylistically, in keeping with the traditional, classicist, academic standards of the time. The work looks like late Raphael, but with some faces painted a bit more naturalistically (that is, more recognizable as an individual, rather than a generic, stock visage) and a bit more dramatic lighting. Caravaggio, on the other hand, was radical in his choices.

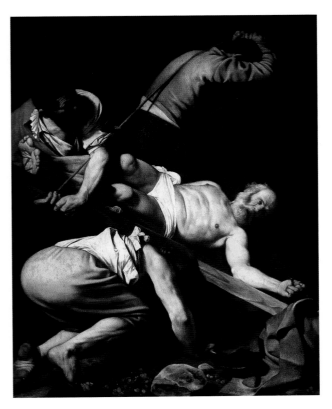

Caravaggio, *The Crucifixion of Saint Peter* (1601). PHOTO COURTESY OF WIKICOMMONS, PHOTOGRAPHER UNKNOWN.

Annibale Carracci and Caravaggio were the two hottest and most popular artists at the time, the former favored by a more conservative audience, the latter by avant-gardists. There was plenty of work to go around, but the twin peaks of Roman painting, with very different styles, would have seen themselves as rivals at least in competition for the top commissions. At the time, Carracci was more established and ahead, in the midst of painting his masterpiece, the fresco cycle at the Palazzo Farnese across town. Caravaggio was the brash new guy in the spotlight.

To the left, we see *The Crucifixion of Saint Peter*. Peter asked to be crucified upside down, so he would not appear equal to Christ, and so Caravaggio shows the moment after Peter has been affixed to the cross but before the cross is upright, the executioners struggling under its weight. Because we see the Caravaggio paintings on either side wall at a very sharp angle, what appears in the bottom left corner of the painting is nearest to us and roughly at eye level. In the case of this painting, it is the dirty feet of the executioner who is bent under the cross, trying to lift it into the air with his back. These dirty feet might have gone unnoticed, or dismissed as unimportant, but for the fact that our position with relation to the painting is such that they are right in our faces. It was a Caravaggio shock tactic to paint with such realism. It is logical enough, a barefoot executioner would have dirty feet (exactly why he's out executing

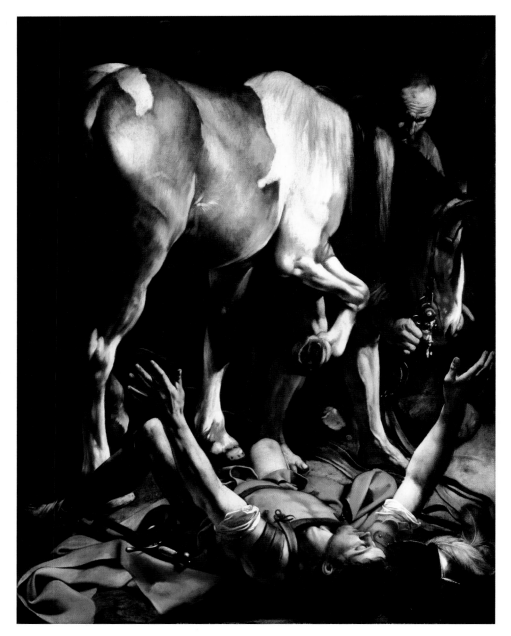

Caravaggio, *The Conversion of Saint Paul* (1601). PHOTO COURTESY OF WIKICOMMONS, PHOTOGRAPHER UNKNOWN.

while barefoot may be the better question). But to show figures in a holy scene, even the "bad guys," with dirty feet was a step too realistic for the expectations of the Roman public in 1600. (Peter, too, has dirty feet, although somewhat less so.) It was "indecorous," a term often used to describe Caravaggio's approach, which defied expectations. If we follow Peter's sight line, he appears to stare in dismay at the altarpiece painted by Carracci. His eyes are focused there; whether or not you read dismay in them, he is

certainly looking at the altarpiece. The Baroque trope was for the martyr on the cusp of death to look upward, into the heavens, where their death would shortly take them. Peter is not looking up at all but sideways at the altarpiece, where stands Carracci's *Assumption of the Virgin Mary*, with its traditional presentation, oddly overcrowded and with slightly awkward foreshortening of the two foremost figures (on the left is likely Saint Peter himself, so it appears that the crucified saint is staring directly at himself in a painting on the altar).

On the wall opposite *The Crucifixion of Saint Peter* is *The Conversion of Saint Paul*. It shows Paul prior to his conversion, when he was a Roman legionnaire called Saul, as he saw a blinding light while riding to Damascus. He fell off his horse and was converted in that moment to Christianity, a religion that did not yet exist but which he would largely create, leading the followers of Christ after Christ's death. Saul/Paul is shown beardless, which Caravaggio liked to do in order to illustrate a physical difference in someone prior to their conversion or a revelation. The star of the painting, though, is the gorgeously painted horse, revelatory light glinting off its hide. But the positioning of its body in relation to the Carracci altarpiece seems to contain a hidden message of rivalry: The horse's rear end is rather pointedly pointed at the altarpiece.

Caravaggio's seems to think that Carracci was a horse's ass.

These paintings were the first major public works in which Caravaggio strutted his revolutionary technique in direct contrast to traditionalist Carracci. A year earlier, he had made his big splash on the scene in Rome with his Saint Matthew Cycle, but this was his chance to show his approach vis-à-vis what was considered the best and most traditional art to date. He used shock tactics to distinguish himself from his rivals.

\*    \*    \*

Outside of the realm of photography, can a negative really result in a positive? Such has been the thesis of this book: that three things that are associated only with negativity—scandal, shock, and rivalry—have actually been beneficial to the development and path of art through the ages. In order to conclude and definitively determine whether this is the case, it may be useful to examine the history of art through negative space. What would it look like if we expunged from it scandal, shock, and rivalry?

The biggest benefit of scandal and its cousin, shock, is media coverage, which spreads the notoriety of the artist involved, and through it their art and art in general. Someone who does not identify as interested in art or museums might enjoy a good scandal story in the newspaper, and if it happens to involve outrageous (seeming) sums of money for simple (seeming) scribbles and splotches that our hypothetical reader doesn't think of as art ("because *I* could make something like *that*"), they will nonetheless be exposed to the artist's name and some images of their work, and join the discussion of art in general through the scandalous story. In this way, scandals and shock (recall that shock is a scandal intentionally provoked by the artist) remind the non-art-loving world that art exists and may pull in the odd recruit, the convert to interest in art, even if that interest is superficial or initially lascivious because the individual desires only to learn more about the scandalous goings-on, looking for fuel for personal outrage. Within the art world, scandal

and shock provide delicious peaks above the waterline for cocktail party discussions and gossip sessions. They provide spice.

A world without them would still have art, but it would likely have uncomplicated, "safe" art. Scandals have usually arisen when an artist tried something new, creative, outside the box, pressing against or ripping through boundaries. This action was perceived as indecorous or outrageous or simply not the done thing, and waves crested in its wake. But rising out of the smoke of dismay came the phoenix. The artist was more famous for having ruffled these feathers, and the art world expanded. What art could be, how it could be done, was altered thanks to the pressing of those boundaries, the stepping outside of the box. Art without revolutionaries, without avant-gardists, will recycle and remain fine, with highly tuned but constant aesthetic, with perhaps interesting and changing content, but always within the framework of the acceptable. Inadvertent scandal and advertent shock are the dynamite that blows away the rock walls embowering what art can be. They expand art's capability and often blaze trails that other artists embrace and follow until what was once outrageous becomes a new norm. And so art must blow away more territory to find what is new, what provokes. Because art, aside from the purely decorative, is all about provoking emotion in the viewer.

An art world without rivalry would still have competition. If there are twenty painters in your city and all of them can paint a fine Annunciation, how do you choose which to commission? Competition would take the form of price wars (prices being driven down to answer this question of potential patrons). It can take the form of stylistic differences ("I prefer International Gothic style, so I'll commission Lorenzo Monaco instead of the edgy Domenico Veneziano") or quality, as perceived by the market and the individual patron. These are all elements of competition, but they are cerebral and lack a key ingredient to great art: passion. The best art conveys the passion and feeling of the artist through the artwork as a medium and passes it forward to the viewer. Whether it is abstract or formal, you can *feel* great art. It is imbued with the heightened emotion of the artist. This does not have to be emotionally melodramatic formal art, like van der Weyden's *Deposition*, which shows a gallery of possible emotive responses to the death of Christ (sadness, anguish, remorse) with crystalline painted tears and reddened eyes. There is, of course, entirely cerebral art. Conceptual art is often a clever idea that makes you think, and no more. That is okay, but it's not what stirs the soul. The conceptual art that resonates is that which is charged with emotion. This is why Marina Abramović and Ulay's *The Great Wall Walk* (1988) is so powerful. It is cerebral (two artists start at opposite ends of the Great Wall of China and start walking toward each other to meet in the middle), but if that were it, end of story, it wouldn't be much more than an expedition, a holiday hike. When we learn that they had once been madly in love, partners in life and art, but they had grown apart, that they'd originally planned to marry at the middle of the wall but in the end decided to break up there, the action is kicked up to a whole new level.

Rivalry pumps the passion into art, flushes the capillaries, dilates the pupils. It inserts urgency, thanks to a dose of anger, jealousy, and even hatred, and that prompts artists to up their game. Flooding the artists with hot blood leads to their wholehearted attempts

to do better, to do more, to make new, in order to outdo—and not to be outdone by—their rivals.

Art history without scandal, shock, and rivalry would have evolved far more slowly and less expansively. It would have come to the attention of a far narrower public. It would have been primarily decorative and constant, rarely if ever wild or edgy. Art would be a tamed beast. And so we have three negatives to thank for the positive, feral creature that is great art.

There is a devil lurking in the gallery. And thank goodness.

# Notes

## Introduction

1. The primary source of Caravaggio's biography is Helen Langdon's *Caravaggio: A Life* (Chatto & Windus, 1998), though Andrew Graham-Dixon's *Caravaggio: A Life Sacred and Profane* (Penguin, 2011) is also good.
2. This is primarily illuminated in Graham-Dixon, *Caravaggio.*
3. This theory is developed in Vincenzo Pacelli, *L'Ultimo Caravaggio, 1606–1610* (EdiArt, 2002).
4. Noah Charney, "Caravaggio the Criminal: The Violent Life and Crimes of an Artistic Genius," *Salon*, September 3, 2017, https://www.salon.com/2017/09/03/caravaggio-the-criminal-the-violent-life-and-crimes-of-an-artistic-genius/.

## Chapter 1

1. The original case was *Anderson v. Cryovac* (1986), in which a class action suit was brought by residents of the town of Woburn against several large companies, including Cryovac, which were found guilty of dumping chemicals that contaminated groundwater and led to numerous illnesses and deaths in the region.
2. Boris Groysberg, Eric Lin, George Serafeim, and Robin Abrams, "The Scandal Effect," *Harvard Business Review* (September 2016).
3. John M. Vincent, "How Badly Has the VW Diesel Scandal Hurt VW?," *U.S. News & World Report*, October 21, 2016.
4. Perhaps the most egregious recent example is the Flint, Michigan, water scandal, but one could choose from any of Donald Trump's scandals to show that bad behavior is not always punished and does not always result in a sea change for the better. Still, we associate scandal with a change that follows it, and the lack of consequences for Trump is seen as that much more unusual because, especially among politicians, a significant scandal *should* end a career.
5. Vincent, "How Badly Has the VW Diesel Scandal Hurt VW?"

6.  Rene G. Cepeda, "Brecht and Picasso, Art as Weapon for Social Change," *Museologician Rene G. Cepeda*, March 12, 2014, https://ragc.wordpress.com/2014/03/12/brecht-and-picasso-art-as-a-weapon-for-social-change/.

7.  This section is based on an article of mine that first appeared in *Salon*: "Picasso's Weapon against Fascism: Why 'Guernica' Is the Greatest of All War Paintings," April 30, 2017, https://www.salon.com/2017/04/30/picassos-weapon-against-fascism-why-guernica-is-the-greatest-of-all-war-paintings/.

8.  Michael T. Kaufman, "'Guernica' Surives a Spray-Paint Attack by Vandal," *New York Times*, March 1, 1974.

9.  David Grogan, "Once He Vandalized Picasso's Guernica, but Now Tony Shafrazi Is a Successful Patron of the Arts," *People*, March 26, 1984.

10.  For more detail on this, see my book *The Art of Forgery* (Phaidon, 2015).

11.  Geoff Edgers, "One of the World's Most Respected Curators Vanished from the Art World. Now She Wants to Tell Her Story," *Washington Post*, August 22, 2015.

12.  Wendy Gray, "The 'Degenerate' World of Otto Dix," *Daily Art*, August 3, 2017.

13.  Alina Cohen, "Why 'Degenerate' Artist Otto Dix Was Accused of Plotting to Kill Hitler," *Artsy*, February 11, 2019.

14.  Attributed to Olaf Peters as quoted in Alina Cohen, "Why 'Degenerate' Artist Otto Dix Was Accused of Plotting to Kill Hitler," *Artsy*, https://www.artsy.net/article/artsy-editorial-degenerate-artist-otto-dix-accused-plotting-kill-hitler.

15.  This was institutionalized in 1669 by the secretary of the Académie, André Félibien. See Robert J. Belton, "The Elements of Art," in *Art History: A Preliminary Handbook* (1996), https://fccs.ok.ubc.ca/student-resources/arth/.

16.  The situation ran parallel to the story of Arthur Sullivan, the wonderful composer of light operettas alongside the lyrics of W. S. Gilbert (authors of *The Pirates of Penzance* and *The Mikado* among many other huge popular successes). Sullivan enjoyed wealth, fame, and popular acclaim, but always felt he was wasting his abilities on the unimportant (though wildly popular) comic operetta genre, when a composer of substance should really work on proper, pompous operas. This is an oft-told dynamic in any biography of Gilbert and Sullivan, including Hesketh Pearson, *Gilbert & Sullivan: A Biography* (House of Stratus, 2015).

17.  For a complete biography of Greuze, see Anita Brookner, *Greuze: The Rise and Fall of an Eighteenth-Century Phenomenon* (HarperCollins, 1972).

18.  This story is told in a number of sources, including Anita Brookner, "Jean-Baptiste Greuze," *Burlington* 98, no. 638 (May 1956).

19.  This is an oft-told tale, but one of the better versions of it can be found in James Henry Rubin, *Courbet* (Phaidon, 1997).

20.  Phrase Finder, "There is no such thing as bad publicity," https://www.phrases.org.uk/meanings/there-is-no-such-thing-as-bad-publicity.html.

21.  Sue Aran, "The Genius of Haussmann: Paris Urban Planning in the 19th Century," *Bonjour Paris*, July 24, 2015, https://bonjourparis.com/history/the-genius-of-haussmann-paris-urban-planning-in-the-19th-century/.

22.  Ross King, *The Judgment of Paris: The Revolutionary Decade That Gave the World Impressionism* (Walker and Co., 2006).

23.  National Gallery of Art, "James McNeill Whistler, *Symphony in White, No 1: The White Girl*," https://www.nga.gov/collection/highlights/whistler-symphony-in-white-no-1-the-white-girl.html.

24. Pamela Fletcher, "1862 The *Paragone*," *The Royal Academy Summer Exhibition: A Chronicle, 1769–2018*, https://chronicle250.com/1862.

25. William Powell Frith, R.A. (1819–1909), "*The Derby Day*: The 'First Study' for the Celebrated Painting," in Christie's catalogue, April 2013.

26. "This nude woman has scandalized the public, who see only her in the canvas. My God! What indecency: a woman without the slightest covering between two clothed men! That has never been seen. And this belief is a gross error, for in the Louvre there are more than fifty paintings in which are found mixes of persons clothed and nude. But no one goes to the Louvre to be scandalized. The crowd has kept itself, moreover, from judging *Le Déjeuner sur l'Herbe* like a true work of art should; they see in it only some people who are having a picnic, finishing bathing, and they believed that the artist had placed an obscene intent in the disposition of the subject, while the artist had simply sought to obtain vibrant oppositions and a straightforward audience. Painters, especially Edouard Manet, who is an analytic painter, do not have this preoccupation with the subject which torments the crowd above all; the subject, for them, is merely a pretext to paint, while for the crowd, the subject alone exists. Thus, assuredly, the nude woman of *Le Déjeuner sur l'Herbe* is only there to furnish the artist the occasion to paint a bit of flesh. That which must be seen in the painting is not a luncheon on the grass; it is the entire landscape, with its vigors and its finesses, with its foregrounds so large, so solid, and its backgrounds of a light delicateness; it is this firm modeled flesh under great spots of light, these tissues supple and strong, and particularly this delicious silhouette of a woman wearing a chemise who makes, in the background, an adorable dapple of white in the milieu of green leaves. It is, in short, this vast ensemble, full of atmosphere, this corner of nature rendered with a simplicity so just, all of this admirable page in which an artist has placed all the particular and rare elements which are in him." Émile Zola, *Edouard Manet, Biographical and Critical Study* (1867), English translation accessed at http://www.cahiers-naturalistes.com/Salons/01-01-67.html.

27. Rolf Laessoe, "Edouard Manet's *Le Déjeuner sur l'herbe* as a Veiled Allegory of Painting," *Artibus et Historiae* (January 2005).

28. Laurence Shafe, "Why Did Manet's Olympia So Shock the Critics of 1865?," *History of Art*, September 24, 2005, https://history-of-art.blogspot.com/2005/09/why-did-manets-olympia-so-shock.html.

29. Quoted in Mary Elizabeth Williams, "Manet's 'Olympia,'" *Salon*, May 14, 2002, https://www.salon.com/2002/05/13/olympia_2/.

30. Quoted in ibid.

31. Quoted in ibid.

32. Quoted in Frits Andersen et al., *Reinventions of the Novel: Histories and Aesthetics of a Protean Genre* (Rodopi, 2004), 79.

33. The Getty story is told, for instance, in Jason Felch and Ralph Frammolino, *Chasing Aphrodite: The Hunt for Looted Antiquities as the World's Richest Museum* (Houghton Mifflin, 2011). The story of the Sotheby's scandal is told, for instance, in Peter Watson and Cecilia Todeschini, *The Medici Conspiracy* (PublicAffairs, 2007), and Peter Watson, *Sotheby's: The Inside Story* (Bloomsbury, 1997).

34. Joy Yoon, "The 15 Richest Living Artists," *Complex*, February 3, 2012.

35. Julia Halperin and Brian Boucher, "Jeff Koons Radically Downsizes His Studio, Laying Off Half His Painting Staff," *Artnet*, June 20, 2017.

36. Anita Singh, "Damien Hirst: Assistants Make My Spot Paintings, but My Heart Is in Them All," *Telegraph*, January 12, 2012.

37. Reference, "How Do You Find the Value of a Thomas Kinkade Painting?," last updated March 28, 2020, https://www.reference.com/world-view/value-thomas-kinkade-painting-b9c0eef a47a0ca9.

38. Alexander Larman, "Sebastian Horsely Obituary," *Guardian*, June 20, 2010.

39. Christo and Jeanne-Claude website, https://christojeanneclaude.net/index.html.

40. https://prague.tv/en/s72/Directory/Business/c1397-Press-Releases/n930-poland-censorship (accessed in August 2020; the link has since been lost).

41. Jemmiah Steinfeld, "When Is a Nipple Not Just a Nipple?," *Telegraph*, September 1, 2017, and Noah Charney, *Museum of Lost Art* (Phaidon, 2018).

42. Sarah Bond, "Medieval Censorship, Nudity and the Revealing History of the Fig Leaf," *Forbes*, October 27, 2017, https://www.forbes.com/sites/drsarahbond/2017/10/27/medieval -censorship-nudity-and-the-revealing-history-of-the-fig-leaf/.

43. Bernardine Barnes, *Michelangelo's Last Judgment: The Renaissance Response* (University of California Press, 1998).

44. Scott Simon, "What Might Rouhani Have Missed When Rome Boxed Up the Nudes?," *Weekend Edition*, January 30, 2016, https://www.npr.org/2016/01/30/464893994/what-might -rouhani-have-missed-when-rome-boxed-up-the-nudes?t=1607418835948.

45. Michael Kimmelman, "After a Much-Debated Cleaning, A Richly Hued Sistine Emerges," *New York Times*, May 14, 1990.

46. Sue Moncure, "The Case of the Missing Masterpiece," *University of Delaware Archive*, November 14, 2006.

47. Julian Barnes, *A History of the World in 10½ Chapters* (Knopf, 1989), 127.

48. *Florence Inferno*, "For the Love of God," July 9, 2013, https://www.florenceinferno.com/ for-the-love-of-god/.

49. Noah Charney, "Art Imitates Art? Damien Hirst's Venice Biennale Installation Looks a Lot Like Another's," *Salon*, June 4, 2017, https://www.salon.com/2017/06/04/art-imitates-art -damien-hirsts-venice-biennale-installation-looks-a-lot-like-anothers/.

50. Jonathan Jones, "Costanza Bonarelli, Gianlorenzo Bernini," *Guardian*, August 9, 2003.

51. Hannah Furness, "BBC Investigates Whether Lewis Carroll Was a 'Repressed Paedophile' after Nude Photo Discovery," *Telegraph*, January 26, 2015.

52. Fiona McCarthy, "Written in Stone," *Guardian*, July 22, 2006.

53. See, for example, Noah Charney, "The Artist behind Slovenia's New Donald Trump Statue Explains Its Symbolism," *Observer*, September 4, 2019.

54. The artist told this to me in person in September 2019.

# Chapter 2

1. The full story of this work is found in William Camfield, *Marcel Duchamp: Fountain* (Houston, 1989), but a concise and clear version appears on the Tate website, https://www.tate.org.uk/ art/artworks/duchamp-fountain-t07573. Duchamp's authorship is somewhat contentious. Some believe that Baron Elsa Hildegard von Freytag-Loringhoven was the actual creator of the work or at least an uncredited collaborator in it. She may have been the first owner of the urinal, having used it as a drinking trough for her pets before declaring it an artwork and gifting it to Duchamp. Whatever the case, Duchamp was certainly the "front man" of the presentation of the urinal as a work of art and so is the protagonist of the story of *Fountain* as it relates to shock in art. Siri Hustvedt, "A Woman in the Men's Room: When Will the Art World Recognise the Real Artist behind Duchamp's Fountain?," *Guardian*, March 29, 2019, https://www.theguardian.com/books/2019/ mar/29/marcel-duchamp-fountain-women-art-history.

2. Francis M. Naumann, *The Recurrent, Haunting Ghost: Essays on the Art, Life and Legacy of Marcel Duchamp* (Readymade Press, 2014), 74.

3. Anon., "The Richard Mutt Case," *Blind Man* 2 (May 1917).

4. As defined in the Merriam-Webster Dictionary online.

5. As defined in the Cambridge Dictionary online.

6. Cody Lee, "Maurizio Cattelan's La Nona Ora (The Ninth Hour)," *codylee.co*, June 3, 2014, http://codylee.co/2014/06/maurizio-cattelan-la-nona-ora/.

7. Jordan Hoffman, "Interview: 'It Is Something Deeper': David Datuna on Why He Ate the $120,000 Banana," *Guardian*, December 11, 2019, https://www.theguardian.com/artanddesign/2019/dec/11/david-datuna-120000-banana-interview-art-basel-miami.

8. Perrotin, "Maurizio Cattelan, *Untitled*, 1999," https://www.perrotin.com/artists/Maurizio_Cattelan/2/a-perfect-day/5394.

9. Hoffman, "Interview."

10. Perrotin, "Maurizio Cattelan, *A Sunday in Rivara*, 1991," https://www.perrotin.com/artists/Maurizio_Cattelan/2/a-sunday-in-rivara/1429.

11. "The title, and the work itself, has a touch of ironic humor and is a form of wordplay. The 'Grass Mud Horse,' or *caonima*, is a Chinese internet meme that resembles an alpaca and is a popular symbol of defiance against censorship in China. In Mandarin, *caonima* can also be translated as an insult. The animals' image has become an internet phenomenon worldwide, frequently appearing in the media and even on merchandise." Hirshhorn, "Ai Weiwei: Trace at Hirshhorn, Jun 28, 2017–Jan 01, 2018," https://hirshhorn.si.edu/exhibitions/ai-weiwei-trace/.

12. See Pussy Riot, *Pussy Riot! A Punk Prayer for Freedom* (Feminist Press, 2013).

13. Various reports on this statue were published by the author in the *Art Newspaper* and the *Observer* as "hot takes" as the events unfolded. This summary was written after the fact based on the previously published material.

14. The statue was commissioned by American artist Brad Downey in July 2019 and built by a local Slovenian artist. Jack Guy, "Melania Trump Statue in Slovenia Removed after Being Set on Fire," CNN, July 9, 2020, https://edition.cnn.com/style/article/melania-trump-statue-slovenia-removed-scli-intl/index.html.

15. Brian Boucher, "Did ISIS Smash Fake Sculptures in Mosul? Experts Say Many of Them Were Replicas," *Artnet*, February 27, 2015, http://news.artnet.com/art-world/did-isis-smash-fake-sculptures-in-mosul-271776.

16. Alice Ross, "Man Charged over Attack on Gainsborough Painting at National Gallery," *Guardian*, March 19, 2017, https://www.theguardian.com/artanddesign/2017/mar/19/man-charged-damage-to-gainsborough-work-at-national-gallery-evacuation.

17. See Lynda Nead, *The Female Nude, Art, Obscenity and Sexuality* (London: Routledge, 1992), and for a briefer account, "Why Would Anyone Want to Deface a Painting?," *Guardian*, March 5, 1999, http://www.guardian.co.uk/books/1999/mar/06/books.guardianreview3.

18. Interestingly, Hinckley was found not guilty by virtue of insanity and was sentenced to confinement in a mental health facility. Devan Cole, "John Hinckley Jr. to Seek Unconditional Release by End of Year," CNN, September 10, 2019, https://edition.cnn.com/2019/09/10/politics/john-hinckley-unconditional-release-motion/index.html.

19. Eno said, in an interview: "I thought, how ridiculous that this particular . . . piss pot gets carried around the world at—that it costs about thirty or forty thousand dollars to insure it every time it travels. I thought, how absolutely stupid the whole message of this work is, 'You can take any object and put it in a gallery.' It doesn't have to be that one, that's losing the point completely.

And this seemed to me an example of the art world once again covering itself by drawing a fence around that thing, saying, 'This isn't just any ordinary piss pot, this is THE one, the special one, the one that is worth all this money.' So I thought, somebody should piss in that thing, to sort of bring it back to where it belonged. So I decided it had to be me." Colin Marshall, "When Brian Eno & Other Artists Peed in Marcel Duchamp's Famous Urinal," *Open Culture*, September 24, 2015, http://www.openculture.com/2015/09/when-brian-eno-other-artists-peed-in-marcel -duchamps-famous-urinal.html.

20. In 1993 a South African artist whizzed on a *Fountain* replica displayed in Venice. Chinese art duo Jian Jun Xi and Yuan Chai did the same, in tandem, when the work was on show in London in 2000. A French artist peed on *Fountain* when it was displayed in Nimes, France, in 1993 and then, at a 2006 exhibit in Paris, he attacked it with a hammer, though he later excused himself, saying that the hammer attack was "a work of performance art that Duchamp himself would have appreciated." Paul Ingram, "Pissing in Duchamp's Fountain," *3:AM Magazine*, June 23, 2014, http://www.3ammagazine.com/3am/pissing-in-duchamps-fountain/.

21. Interview with the author, August 2020.

22. Noah Charney, "The 5 Craziest Art Investments Ever," *Esquire*, August 26, 2014, https:// www.esquire.com/entertainment/a23496/crazy-art-investments/.

23. I recall where I was when 9/11 was happening: I was at a greasy spoon diner in Maine, near Colby College, where I was a student. The planes crashing into the World Trade Center were on a television there, and I didn't really give them a second thought, because I assumed that it was an ad for a new movie, or footage from it. I'd seen something like it before under the guise of fictional entertainment, and so I chalked it up as more of the same.

24. David Ng, "Virgin Mary Portrait Using Elephant Dung Sells for $4.5 Million," *Los Angeles Times*, July 1, 2015, https://www.latimes.com/entertainment/arts/culture/la-et-cm-elephant -dung-virgin-mary-20150701-story.html.

25. Sarah Pruitt, "Why Priceless Lapis Lazuli Was Found in a Medieval Nun's Mouth," History, January 10, 2019, https://www.history.com/news/medieval-woman-lapis-lazuli-teeth-study -discovery.

26. William Anastasi, "Alfred Jarry and *l'Accident* of Duchamp," *tout-fait* 1, no 1 (December 1999), https://www.toutfait.com/issues/issue_1/Articles/Glass.html.

27. Quoted in William Anastasi, "Duchamp on the Jarry Road," *Artforum* (September 1991).

28. Tate, "Piero Manzoni, Artist's Shit, 1961," https://www.tate.org.uk/art/artworks/manzoni -artists-shit-t07667.

29. Amanda Holpuch, "Andres Serrano's Controversial Piss Christ Goes on View in New York," *Guardian*, September 28, 2012, https://www.theguardian.com/artanddesign/2012/sep/28/ andres-serrano-piss-christ-new-york.

30. Quoted in ibid.

31. Ibid.

32. Ibid.

33. V&A, "Effigy of Henry VII," http://collections.vam.ac.uk/item/O41708/effigy-of-henry -vii-plaster-cast-torrigiano-pietro/.

34. Marc Quinn, "Artworks: Self, 1991–Present," http://marcquinn.com/artworks/self.

35. Alastair Smart, "Damien Hirst and Gabriel Orozco, Two Conceptual Artists, Create Two Very Different Skulls," *Phaidon*, March 2011, https://www.phaidon.com/agenda/art/articles/2011/ march/07/damien-hirst-and-gabriel-orozco-two-conceptual-artists-create-two-very-different-skulls/.

36. Denver Art Museum, "The Cutting Scene, Mandan O-kee-pa Ceremony, 1832," https:// denverartmuseum.org/edu/object/cutting-scene-mandan-o-kee-pa-ceremony.

37. Stuart Jeffries, "Orlan's Art of Sex and Surgery," *Guardian*, July 1, 2009, https://www.theguardian.com/artanddesign/2009/jul/01/orlan-performance-artist-carnal-art.

38. Tate, "Marina Abramovic, Rhythm O, 1974," https://www.tate.org.uk/art/artworks/abramovic-rhythm-0-t14875.

39. Guggenheim, "Marina Abramović, Lips of Thomas," https://www.guggenheim.org/artwork/5176.

40. Yoko Ono, *Cut Piece*, https://www.youtube.com/watch?v=Zfe2qhI5Ix4.

41. This is described in Marina Abramović's *Walk through Walls* (Crown Archetype, 2016) and referenced in Nadine Wojcik, "Blood and Pain: Extreme Performance Artist Marina Abramovic Turns 70," *DW*, November 30, 2016, https://www.dw.com/en/blood-and-pain-extreme-performance-artist-marina-abramovic-turns-70/a-36583787.

42. Wojcik, "Blood and Pain."

43. MOMALearning, "*The Lovers*, René Magritte (Belgian, 1898–1967)," https://www.moma.org/learn/moma_learning/rene-magritte-the-lovers-le-perreux-sur-marne-1928/.

44. Personal interview, March 1, 2020.

45. Personal interview, 2014.

46. Criss Angel, *Mindfreak,* season 1, episode 5 (2005).

47. Personal interview, 2020.

48. Ibid.

49. Ibid.

50. Nathan H. Lents, "Why Are Symmetrical Faces So Attractive?," *Psychology Today*, July 8, 2019, https://www.psychologytoday.com/us/blog/beastly-behavior/201907/why-are-symmetrical-faces-so-attractive.

51. Robert Fahrner and William Kleb, "The Theatrical Activity of Gianlorenzo Bernini," *Educational Theatre Journal* 25, no. 1 (March 1973), https://doi.org/10.2307/3205831.

52. Malcolm Moore, "Bernini the Sculptor Is Revealed as a Playwright after 30-Year Search," *Telegraph*, April 5, 2007, https://www.telegraph.co.uk/news/worldnews/1547716/Bernini-the-sculptor-is-revealed-as-a-playwright-after-30-year-search.html.

53. As defined in the Cambridge Dictionary online.

54. The origin story of sexually stimulating art is the Hellenistic sculpture called *Aphrodite at Her Bath* (sometimes called *Crouching Venus*). The nude goddess of love crouches beside a bathtub, about to get in, but is suddenly started by a (presumably male) presence. She quickly tries to cover her breasts and glances over her shoulder. Male viewers of the art are stand-ins for this startling presence, and her attempt at hiding her nudity only heightens it—we feel the tingle of excitement at seeing something we feel we weren't supposed to see. An ancient viewer was said to have been so aroused by this statue that he felt compelled to release a "money shot" upon it. Who said that art history lectures were boring?

55. Bette Talvacchia, *Taking Positions on the Erotic in Renaissance Culture* (Princeton University Press, 2001).

56. Tadeu Bijos, "Chris Burden's Last Stand," *Counter Punch*, June 12, 2015.

57. Gerard Couzens, "Outrage at 'Starvation' of a Stray Dog for Art," *Guardian*, March 29, 2008, https://www.theguardian.com/artanddesign/2008/mar/30/art.spain.

58. Gregor Schneider, "There Is Nothing Perverse about a Dying Person in an Art Gallery," *Guardian*, April 25, 2008, https://www.theguardian.com/artanddesign/2008/apr/26/art.

59. Ibid.

60. Shaun Walker, Kareem Shaheen, Martin Chulov, and Patrick Wintour, "Russian Ambassador to Turkey Shot Dead by Police Officer in Ankara Gallery," *Guardian*, December 20, 2016,

https://www.theguardian.com/world/2016/dec/19/russian-ambassador-to-turkey-wounded-in
-ankara-shooting-attack

61. Personal interview, 2020.

62. Conversation with JAŠA, August 2020.

63. Anika D., "7 Most Expensive & Explicit Jeff Koons Made in Heaven Pieces: Ponies, 1991," *Widewalls*, October 30, 2015, https://www.widewalls.ch/jeff-koons-made-in-heaven-most -expensive-pieces/ponies-1991/.

64. Jason Farago, "Jeff Koons: A Retrospective Review—Great, Good, Bad and Terrible Art," *Guardian*, June 25, 2014, https://www.theguardian.com/artanddesign/2014/jun/25/jeff-koons -retrospective-review-whitney-museum-good-bad-art.

65. MOMA, "Jeff Koons, *Three Ball 50/50 Tank (Two Dr. J. Silver Series, One Wilson Super-shot)*, 1985," https://www.moma.org/collection/works/81173.

66. Jonathan Jones, "The 10 Most Shocking Performance Artworks Ever," *Guardian*, November 11, 2013, http://www.guardian.co.uk/artanddesign/2013/nov/11/scrotum-top-10-shocking-performance-art.

67. Jones, "The 10 Most Shocking Performance Artworks Ever."

68. Ibid.

69. Personal interview, 2020.

70. Deborah Vankin, "Why Damien Hirst Is Seeing Dots in His New Work on View in Beverly Hills," *Los Angeles Times*, March 23, 2018, https://www.latimes.com/entertainment/arts/ la-et-cm-damien-hirst-20180323-htmlstory.html.

71. Guggenheim, "Jeff Koons: Easyfun-Ethereal," https://www.guggenheim.org/exhibition/ jeff-koons-easyfun-ethereal-3.

72. Hettie Judah, "Damien Hirst's Jeff Koons Show Reeks of Power Play," *Artnet*, May 19, 2016, https://news.artnet.com/market/jeff-koonss-exhibition-damien-hirsts-gallery-suffers-lack -curator-500267.

73. Sean O'Hagan, "The Art of Selling Out," *Guardian*, September 5, 2009, https://www .theguardian.com/artanddesign/2009/sep/06/hirst-koons-murakami-emin-turk.

74. Ibid.

75. Adam Broomberg, "Hands Off Our Revolution," *frieze*, November 16, 2016, https://frieze .com/article/hands-our-revolution.

76. Hands Off Our Revolution website, http://handsoffourrevolution.com/.

77. Alice Morby, "Anish Kapoor and Wolfgang Tillmans form Coalition against 'Rise of Right-Wing Populism,'" *dezeen*, February 17, 2017, https://www.dezeen.com/2017/02/17/anish -kapoor-wolfgang-tillmans-form-coalition-against-rise-right-wing-populism/.

78. Andy McLaverty-Robinson, "Walter Benjamin: Art, Aura, and Authenticity," *Ceasefire*, June 14, 2013, https://ceasefiremagazine.co.uk/walter-benjamin-art-aura-authenticity/.

79. Walter Benjamin, "The Work of Art in the Age of Reproduction" (1936), a translation of which can be accessed at https://www.marxists.org/reference/subject/philosophy/works/ge/ benjamin.htm.

80. Tim Adams, "Interview: Chris Ofili: 'Being in Trinidad Is Still Really Exciting . . . I Think It Is Working for Me," *Guardian*, April 16, 2017, https://www.theguardian.com/artand design/2017/apr/16/chris-ofili-trinidad-is-really-exciting-tapestry-the-caged-bird-sings-interview.

81. *Artlyst*, "Tracey Emin Survey Exhibition Opens at Vienna's Leopold Museum," April 24, 2015, https://www.artlyst.com/news/tracey-emin-survey-exhibition-opens-at-viennas-leopold -museum/.

82. Henri Neuendorf, "Tracey Emin Marries a Stone in Romantic South of France Ceremony," *Artnet*, March 25, 2016, https://news.artnet.com/market/tracey-emin-marries-stone-458894.

# Chapter 3

1. Jessie Szalay, "Amerigo Vespucci: Facts, Biography & Naming of America," *Live Science*, September 21, 2017, https://www.livescience.com/42510-amerigo-vespucci.html.

2. Ronald Lightbown, *Sandro Botticelli: Life and Work* (Thames & Hudson, 1989).

3. Noah Charney, "The Affordable-Art Paradox: Do Reasonable Prices Make Pieces of Art Less Desirable?," *Salon*, March 19, 2017, https://www.salon.com/2017/03/19/the-affordable-art-paradox-do-reasonable-prices-make-pieces-of-art-less-desirable/.

4. Vasari referred to the work as *The Story of Niccolo Piccinino*. Artworks were rarely given titles until the nineteenth century, and those titles were often given retrospectively by art historians. Artists would normally refer to works by some attribute of them rather than a portentous title. Regarding the medium, Leonardo loved to experiment, which resulted in many works deteriorating rapidly. Wall paintings, traditional frescoes, were made by applying fresh plaster to a section of wall and painting with tempera, pigment with an egg yolk binder, which is an opaque paint. Oils, which use natural oil (like linseed) as a binder, result in translucent paints that do not transfer well to wall painting. Leonardo here used an experimental encaustic technique, mixed media, which was unsuccessful, deteriorating almost immediately. He used "hot wax painting," in which heated beeswax was mixed with pigments. This quick deterioration was one of the reasons the work was unfinished and considered in a bad enough state to get rid of through the remodeling of the room. However, enough of it must have survived for Vasari to consider it worth preserving.

5. For the complete story of this competition, see Jonathan Jones, *The Lost Battles: Leonardo, Michelangelo and the Artistic Duel that Defined the Renaissance* (Simon & Schuster, 2010), or Ingrid Rowland and Noah Charney, *The Collector of Lives: Giorgio Vasari and the Invention of Art* (Norton, 2017).

6. This is an obvious story to tell in this chapter, but it is dealt with it at great length in Rowland and Charney, *The Collector of Lives*, so I will instead point you there. There is no definitive proof of the false wall, but sufficient evidence has accrued that completing the search efforts that were paused in 2012 for bureaucratic reasons seems reasonable.

7. The story can be found in Giorgio Vasari, *Lives of the Most Eminent Painters, Sculptors and Architects*, which is available online at http://onlinebooks.library.upenn.edu/webbin/metabook?id=livespainters.

8. This is another story that I skim over here to focus on others, since I tell it in a previously published book: Noah Charney, *Stealing the Mystic Lamb: The True Story of the World's Most Coveted Masterpiece* (PublicAffairs, 2010).

9. Pliny the Elder, *Natural History*, 35.29, translated by Ingrid Rowland; first published in Rowland and Charney, *The Collector of Lives*.

10. Giorgio Vasari, *Le Vite . . .* "Vita di Giotto," Vol. 2, translated by Ingrid Rowland; first published in Rowland and Charney, *The Collector of Lives*, 111.

11. My translation.

12. Rona Goffen, *Renaissance Rivals: Michelangelo, Leonardo, Raphael, Titian* (Yale University Press, 2002).

13. See Charles Robertson, "Bramante, Michelangelo and the Sistine Ceiling," *Journal of the Warburg and Courtauld Institutes* 49 (1986): 91–105.

14. Giorgio Vasari, *Vita di Filippo Brunelleschi scultore e architetto fiorentino*, Vol. 3 (Florence: Sansonni, 1881), 137. Translation by Ingrid Rowland.

15. Elizabeth Cropper, *The Domenichino Affair: Novelty, Imitation and Theft in 17th Century Rome* (Yale University Press, 2005).

16. Clayton Schuster, *Bad Blood: Rivalry in Art History* (Schiffer, 2018), 93.

17. Haldane Macfall, *A History of Painting: Later Italians and Genius of Spain* (Kessinger, 2004), 60.

18. Jake Morrissey, *The Genius in the Design: Bernini, Borromini and the Rivalry That Transformed Rome* (HarperCollins, 2006).

19. Rensselaer Lee, *Ut Pictura Poesis: The Humanistic Theory of Painting* (Norton, 1967).

20. This story is told in detail in Ludovic Vitet, *The Royal Academy of Painting and Sculpture: Historical Study* (Michel Levy Freres, 1861), and in Joseph Jurt, *Les Arts Rivaux: Literature and Visual Arts from Homer to Huysmans* (Classiques Garnier, 2018).

21. Nathalie Heinich, *From Painter to Artist: Painters and Academics in the Classical Age*, collection Paradoxe (Minuit, 1993).

22. David Batty, "Damien Hirst's Split from Larry Gagosian Turns Heads in Art World," *Guardian*, January 6, 2013, https://www.theguardian.com/artanddesign/2013/jan/06/damien -hirst-larry-gagosian-art#.

23. Andrew Osborn and Maev Kennedy, "Sotheby's Fined £13m for Price-Fixing Scandal with Christie's," *Guardian*, October 31, 2002, https://www.theguardian.com/uk/2002/oct/31/arts .artsnews.

24. Peter Watson, *Sotheby's: The Inside Story* (Bloomsbury, 1997).

25. Troy Segal, "Who Are Amazon's (AMZN) Main Competitors?," *Investopedia*, February 4, 2020, https://www.investopedia.com/ask/answers/120314/who-are-amazons-amzn-main -competitors.asp

26. Saatchi Art, "Payments," https://support.saatchiart.com/hc/en-us/articles/115003366567.

27. ARTINFO, "The Art Fair Cheat Sheet: Typical Booth Prices for 13 Art Fairs, from Basel to Dallas," *Huffington Post*, updated December 6, 2017, https://www.huffpost.com/entry/the-art -fair-cheat-sheet-_b_1930118.

28. Colin Gleadell, "Grosvenor House and Olympia: Rival Art Fairs," *Telegraph*, June 1, 2009, https://www.telegraph.co.uk/culture/art/artsales/5423634/Grosvenor-House-and-Olympia -rival-art-fairs.html.

29. Colin Gleadell, "Grosvenor House and Olympia: Rival Art Fairs," *Telegraph*, June 1, 2009, https://www.telegraph.co.uk/culture/art/artsales/5423634/Grosvenor-House-and-Olympia-rival -art-fairs.html.

30. Luke O'Neil, "One Banana, What Could It Cost? $120,000—If It's Art," *Guardian*, December 6, 2019, https://www.theguardian.com/artanddesign/2019/dec/06/maurizio-cattelan -banana-duct-tape-comedian-art-basel-miami.

31. Jerry Saltz, "The Last Days of the Art World . . . and Perhaps the First Days of a New One," *Vulture*, April 2, 2020, https://www.vulture.com/2020/04/how-the-coronavirus-will-transform -the-art-world.html.

32. This is told in numerous books and articles, including Jason Felch and Ralph Frammolino, *Chasing Aphrodite: The Hunt for Looted Antiquities at the World's Richest Museum* (Houghton Mifflin, 2011).

33. Elizabeth Povoledo, "Italy Presses Its Fight for a Statue at the Getty," *New York Times*, January 16, 2010, https://www.nytimes.com/2010/01/16/arts/design/16bronze.html.

34. Candida Moss, "Hobby Lobby Scandal Widens as Museum of the Bible Admits Oxford Prof Sold Illicit Papyri to Green Family," *Daily Beast*, updated October 17, 2019, https://www

.thedailybeast.com/hobby-lobby-scandal-widens-as-museum-of-the-bible-admits-oxford-prof-sold-illicit-papyri-to-green-family.

35. Jacob Wisse, "Prague during the Rule of Rudolf II (1583–1612)," The Met, November 2013, https://www.metmuseum.org/toah/hd/rupr/hd_rupr.htm.

36. Elliot J. Reichert, "The Very Real Case of Ai Weiwei's Persecution," *Indiana University Cinema*, January 23, 2020, https://blogs.iu.edu/aplaceforfilm/2020/01/23/the-very-real-case-of-ai-weiweis-persecution/.

37. Kayla Webley, "Top 10 Persecuted Artists," *Time*, April 5, 2011, http://content.time.com/time/specials/packages/article/0,28804,2063218_2063273_2063222,00.html.

38. Noah Charney, "Art Imitates Art? Damien Hirst's Venice Biennale Installation Looks a Lot Like Another's," *Salon*, June 4, 2017, https://www.salon.com/2017/06/04/art-imitates-art-damien-hirsts-venice-biennale-installation-looks-a-lot-like-anothers/.

39. Ibid.

40. Ibid. This case study was originally published, in a differing format, in *Salon* magazine.

41. Delacroix thought of himself as a classicist, not a Romantic. His politics were conservative and pro-aristocracy.

42. Michael Rosenthal et al., *Turner and Constable: Sketching from Nature* (Tate Publishing, 2013).

43. This is an oft-told anecdote, but a good, detailed version appears in Schuster, *Bad Blood*.

44. Boris Johnson, "Boris Johnson's 'Life of London': Exclusive Extract," *Telegraph*, June 2, 2012, https://www.telegraph.co.uk/culture/art/art-features/8853846/Boris-Johnsons-Life-of-London-exclusive-extract.html, quoting Boris Johnson, *Johnson's Life of London: The People Who Made the City That Made the World* (HarperPress, 2011).

45. Robert Echols et al., *Titian, Tintoretto, Veronese: Rivals in Renaissance Venice* (Lund Humphries, 2009).

46. "Sala Dell'Albergo," Scuola Grande di San Rocco, http://www.scuolagrandesanrocco.org/home-en/tintoretto/sala-dell-albergo/.

47. Emily Shugerman, "Banksy: 8 Signs Massive Attack's Robert Del Naja Is Mystery Artist," *Independent*, October 6, 2018, https://www.independent.co.uk/arts-entertainment/music/news/banksy-robert-del-naja-massive-attack-art-who-is-he-identity-real-name-graffiti-music-similarities-a7805741.html.

48. Simon Freeman and Alice Hutton, "Stairs Fall That Killed Graffiti Star 'King Robbo' Still a Mystery," *Standard*, December 5, 2014, https://www.standard.co.uk/news/london/stairs-fall-that-killed-graffiti-star-king-robbo-still-a-mystery-9905926.html.

49. Jack Flam, *Matisse and Picasso: The Story of Their Rivalry and Friendship* (Basic Books, 2004).

50. "Marina Abramović e Ulay—MoMA 2010," posted December 15, 2012, https://www.youtube.com/watch?v=OS0Tg0IjCp4

51. The material on Ulay comes from personal interviews with him.

52. This section is based on an article of mine in the *Guardian*, which has been updated: Ben Quinn and Noah Charney, "Maria Abramović Ex-partner Ulay Claims Victory in Case about Joint Works," *Guardian*, September 21, 2016, https://www.theguardian.com/artanddesign/2016/sep/21/ulay-claims-legal-victory-in-case-against-ex-partner-marina-abramovic.

53. Ulay, quoted in Maria Bojan et al., *Whispers: Ulay on Ulay* (Valiz, 2018).

54. This was stated to Ulay in a personal correspondence with Amelia Jones, and Ulay conveyed it to me in one of our many personal interviews in 2016.

55. *Marina Abramović e Ulay—MoMA 2010*; this video has more than eighteen million views.

# Conclusion

1. Clayton Schuster, *Bad Blood: Rivalry in Art History* (Schiffer, 2018). I wrote the foreword for this excellent book, which dramatizes certain famous rivalries in art history with cinematic narratives. It was, in part, the inspiration for the book you are reading now, though my approach is quite different and rivalry is, of course, just one of the components I deal with.

2. Quote translation from Erenow, "Caravaggio: A Passionate Life," https://erenow.net/biographies/caravaggio-a-passionate-life/16.php.

3. Paintings were not normally named, with art historians in the nineteenth century usually assigning names, so the title of this painting can vary.

4. See the exhibit and catalogue *Caravaggio e I Giustiniani*, curated by Silvia Danesi Squarzina, https://www.repubblica.it/online/cultura_scienze/giustiniani/giustiniani/giustiniani.html.

5. Excerpts might be translated as Caravaggio suggesting that the painting was only fit to "wipe your ass with," that they should be "stuffed up the c**t" of Baglione's friend's wife because the friend in question wasn't "f**cking her anymore with his donkey c**k." Yes, that Caravaggio was a real charmer. . . . This translation appeared in Andrew Graham-Dixon, *Caravaggio: A Life Sacred and Profane* (Norton, 2011).

6. Trial records; my translation.

# Selected Bibliography

Brookner, Anita. *Greuze: The Rise and Fall of an Eighteenth-Century Phenomenon*. HarperCollins, 1972.

Barkan, Leonard. *Unearthing the Past: Archaeology and Aesthetics in the Making of Renaissance Culture*. Yale University Press, 2001.

Bojan, Maria, et al. *Whispers: Ulay on Ulay*. Valiz, 2013.

Charney, Noah. *The Art of Forgery*. Phaidon, 2015.

———. *Museum of Lost Art*. Phaidon, 2018.

———. *Stealing the Mystic Lamb: The True Story of the World's Most Coveted Masterpiece*. PublicAffairs, 2010.

Chipp, Herschel B. *Picasso's Guernica: History, Transformations, Meanings*. University of California Press, 1988.

Echols, Robert, et al. *Titian, Tintoretto, Veronese: Rivals in Renaissance Venice*. Lund Humphries, 2009.

Felch, Jason, and Ralph Frammolino. *Chasing Aphrodite: The Hunt for Looted Antiquities at the World's Richest Museum*. Houghton Mifflin, 2011.

Goffen, Rona. *Renaissance Rivals: Michelangelo, Leonardo, Raphael, Titian*. Yale University Press, 2002.

Graham-Dixon, Andrew. *Caravaggio: A Life Sacred and Profane*. Penguin, 2011.

Hughes, Robert. *The Shock of the New: The Hundred-Year History of Modern Art*. Knopf, 2013.

Jones, Jonathan. *The Lost Battles: Leonardo, Michelangelo and the Artistic Duel that Defined the Renaissance*. Simon & Schuster, 2010.

King, Ross. *The Judgment of Paris: The Revolutionary Decade That Gave the World Impressionism*. Walker and Co., 2006.

Ladis, Andrew. *Victims and Villains in Vasari's Lives*. University of North Carolina Press, 2008.

Langdon, Helen. *Caravaggio: A Life*. Chatto & Windus, 1998.

Lee, Rensselaer. *Ut Pictura Poesis: The Humanistic Theory of Painting*. Norton, 1967.

Lightbown, Ronald. *Sandro Botticelli: Life and Work*. Thames & Hudson, 1989.

Morrissey, Jake. *The Genius in the Design: Bernini, Borromini and the Rivalry That Transformed Rome*. HarperCollins, 2006.

Pacelli, Vincenzo. *L'Ultimo Caravaggio, 1606–1610*. EdiArt, 2002.

Rosenthal, Michael, et al. *Turner and Constable: Sketching from Nature*. Tate Publishing, 2013.

Rowland, Ingrid, and Noah Charney. *The Collector of Lives: Giorgio Vasari and the Invention of Art*. Norton, 2017.

Rubin, James Henry. *Courbet*. Phaidon, 1997.

Schuster, Clayton. *Bad Blood: Rivalry in Art History*. Schiffer, 2018.

Vasari, Giorgio. *The Lives of the Artists*. Oxford World Classics, 2008.

Watson, Peter. *Sotheby's: The Inside Story*. Bloomsbury, 1997.

Westcott, James. *When Marina Abramović Dies: A Biography*. MIT Press, 2014.

# Index

# About the Author

Dr. **Noah Charney** is the internationally best-selling author of more than a dozen books, translated into fourteen languages, including *The Collector of Lives: Giorgio Vasari and the Invention of Art*, which was nominated for the 2017 Pulitzer Prize in Biography, and *Museum of Lost Art*, which was the finalist for the 2018 Digital Book World Award. He is a professor of art history specializing in art crime, and has taught for Yale University, Brown University, American University of Rome, and University of Ljubljana. He is founder of ARCA, the Association for Research into Crimes against Art, a groundbreaking research group (www.artcrimeresearch.org), and teaches on their annual summer-long postgraduate program in Art Crime and Cultural Heritage Protection. He writes regularly for dozens of major magazines and newspapers, including the *Guardian*, the *Washington Post*, the *Observer*, and the *Art Newspaper*. He lives in Slovenia with his wife, his children, and their hairless dog, Hubert van Eyck. Learn more at www.noahcharney.com.